A HISTORY OF

Jewish Youngstown

AND THE STEEL VALLEY

THOMAS WELSH, JOSHUA FOSTER & GORDON F. MORGAN
with the Mahoning Valley Historical Society

To Ellen & Jim,

THE
History
PRESS

Published by The History Press
Charleston, SC
www.historypress.net

First published 2017

Manufactured in the United States

ISBN 9781467118965

Library of Congress Control Number: 2016945830

List of Patrons

This book was made possible through the generosity of the following patrons:

- Sherry and Gary Clayman
- The Kessler and Mulne families, in honor of their parents and grandparents
- Jeanne and Ken Fibus, with Amy and Bob Hendricks, Annie and Elle
- Bill and Sandra Lippy
- The Irv and Bea Ozer Endowment Fund
- Judy and Sam A. Roth
- Terry and Sam D. Roth
- The Schwebel family
- The Suzi Solomon Philanthropic Fund
- Doris Tamarkin
- Kay and Jerry Tamarkin
- The Thomases Family Endowment of the Youngstown Area Jewish Federation
- Marty White
- An anonymous patron

To see in history a moral purpose and a task for a people on earth is a great discovery, far more important than the accounts of battles and intrigues that have plagued humanity from time immemorial.
—Dr. Jacob Singer

Contents

Acknowledgements

The authors would like to thank the generous patrons of this project, as well as the many people who contributed their time, expertise and encouragement. We owe a special debt of gratitude to H. William Lawson, executive director of the Mahoning Valley Historical Society, who ensured that his organization's resources were available to us. At the same time, Pam Speis, archivist at the Mahoning Valley Historical Society, helped us navigate the organization's Jewish Archives, while spending hours reproducing articles and scanning images. We would also like to express our appreciation to William Philson, executive director of the Mercer County Historical Society, who assisted us in our research of Jewish communities in western Pennsylvania. Further help was provided by the research staff at Cincinnati's Hebrew Union College—Jewish Institute of Religion. We also benefited from the cooperation of local news publications, including the *Jewish Journal Monthly Magazine*, the *Vindicator* and the *Catholic Exponent*. In addition, we received invaluable assistance from the researchers at the Public Library of Youngstown and Mahoning County, including Sara Churchill, Sally Freaney, Stuart Gibbs, Suzette Hinson, Judy Jones, Michele Mellor, Kathy Richter and Tim Sieman. We also received critical assistance from the staff members at the Warren-Trumbull Public Library's Local History & Genealogy Center, including Elizabeth Glasgow, Michael Homlitas, Marisa Minich and Lucy Parker. As we wrote up the research, individual chapters were reviewed by H. William Lawson and Dr. Paul McBride, emeritus professor of history at Ithaca College. Local photographer Nea

Bristol enhanced the project through her documentation of relevant landmarks. Meanwhile, Ronna Marlin, program director at Levy Gardens Assisted Living, facilitated interviews with residents and other members of the community. Throughout this journey, scores of individuals shared their memories and impressions of the Youngstown area's Jewish community. Given the scope of this project, it was not possible to incorporate all of their voices into the narrative. Nevertheless, we would like to thank the following individuals who enhanced our understanding of the community's unique history: Louis Epstein, Brynna Fish, Daniel Greenfield, Rabbi Mitchell Kornspan, Solomon "Jack" Kravitz, Dr. Lawrence Kutler, George Livingston, Seth Malkin, Richard and Ronna Marlin, the Honorable Harry Meshel, Rabbi David Powers, Robert Rusnak, Bruce Sherman, Sonya Shultz, Elyse Silverman, Rabbi David Steinhardt and Dr. Milton Yarmy.

THOMAS G. WELSH, JOSHUA FOSTER AND GORDON F. MORGAN
May 25, 2016, Youngstown, Ohio

Introduction

You Will Always Be Welcome in These Walls

On a sunny afternoon, June 4, 1886, members of the congregation of Rodef Sholom gathered for the dedication of their new temple, an elegant Moorish-style edifice that graced the corner of two main thoroughfares on Youngstown, Ohio's North Side. The temple featured stained-glass windows and a domed turret. The spire could be spotted from the city's downtown retail district, a few blocks to the south.

For some observers, the building of Youngstown's first Jewish temple may have seemed overdue. Jewish immigrants had been present in the bustling manufacturing center since the late 1830s, when European-born Jacob Spiegel opened a general store in the city's downtown.[1] The congregation of Rodef Sholom had been established almost nineteen years earlier, in May 1867, when fifteen men gathered at the home of Abraham Walbrun and approved the congregation's bylaws and constitution. At a meeting held later that month, the charter members agreed on a name for the new congregation: "Pursuer of Peace."[2]

Among those on hand was the president of the congregation, David Theobald, who, in 1868, opened a subscription list and established a sinking fund for the purchase of property on which a temple would be built.[3] Eighteen years later, as Rodef Sholom's gas-jet lights dimmed, a clear signal that the temple's first service was about to begin, Theobald must have felt a strong sense of personal satisfaction.

Suddenly, the silence that enveloped the darkened interior of Rodef Sholom was broken, as Rabbi Henry Bloch knocked three times on the temple's west door and shouted, "Open ye the gates of righteousness, that

we may enter and praise God." As the doors flew open, the officers of the temple, including Theobald, proceeded toward a raised platform, upon which stood a semicircular pulpit and a carved wooden sanctuary containing the first five books of the Hebrew Bible.

As the members of the procession seated themselves in chairs that were arranged on the platform, three young girls, each dressed in white and carrying a bouquet, approached Theobald and presented him with the key to the temple. Theobald lifted the key from a pillow held in the girls' outstretched hands and stated, "My dear little children: To receive this emblem of God's trust, the key of this temple, from your hands, little daughters of Israel, is indeed a happy omen." He then turned to a crowd that included many of the community's leading citizens and said, "To the kind visitors and citizens of Youngstown—to the authorities of this beloved city who show your kind sympathy by your presence—I have a right to appeal to you to look upon this edifice with looks of grace and consideration."

The words that followed were undoubtedly heartfelt, given the reports of vicious pogroms then coming out of Imperial Russia. "Beside the array of other houses of prayer, this simply proves that we live in a happy land of divine peace and religious liberty," Theobald continued. "You will always be welcome in these walls, and our prayers will be as much for your welfare as for ours."[4]

Youngstown, with its diverse population and expanding economy, had indeed proven a hospitable venue for Jewish immigrants like David Theobald, who were welcomed into some elite spheres, even as they were excluded from others. Overall, these mainly German and Austrian immigrants had benefited from their relocation to a country where Jews held a relatively favorable (if rather ambiguous) position in an overwhelmingly non-Jewish society. This is not to suggest that cases of ethnic and religious intolerance were unknown. A particularly ugly incident that occurred in Youngstown's downtown district drew the concerned attention of a national Jewish journal. In 1873, thirteen years before the dedication of Congregation Rodef Sholom, a gang of youths accosted a young Jewish boy and tried to set him afire, stopping only when witnesses arrived on the scene. When questioned on their motives, the youths reportedly explained, "We did it to punish the Jews for crucifying our Lord."[5]

Such incidents were rare, however, and German-born Jews were soon joined by newer immigrants from Russia, Poland, Lithuania, Hungary and Romania, who brought with them unfamiliar languages, different traditions and varying religious perspectives. Not surprisingly, the Orthodox Jews who

arrived from Eastern Europe received a cool reception from the mostly German and Austrian Jews who had organized the Reform congregation of Rodef Sholom. Notably, Reform Judaism, which developed in nineteenth-century Germany, sought to modify Orthodox tradition in line "with the exigencies of contemporary life."[6]

Meanwhile, the newly arrived Orthodox Jews were themselves divided between those who anticipated the arrival of a "Messianic Age" and those who perceived Zionism (an ideology espousing the establishment of a Jewish homeland) as the only logical response to seemingly intractable anti-Semitism.[7] Yet, despite any initial tensions and controversies, the Jewish community gradually integrated and went on to experience an extraordinary era of institution building. In 1893, just seven years after the dedication of the Rodef Sholom temple, a community of primarily Hungarian Jews built a synagogue on Youngstown's North Side to house the Orthodox congregation of the Children of Israel, which had been organized perhaps a decade earlier.[8] Twelve years later, in 1905, a group of Polish and Russian Jews organized the Conservative congregation of Temple Emanu-El, eventually erecting a brick building a couple of blocks to the northwest of Children of Israel.[9]

By the early twentieth century, the U.S. Conservative Movement had gained a following among those who felt constrained by the traditionalism of Orthodox Judaism but at the same time sensed that crucial aspects of Jewish practice and identity (including the concept of Jewish nationality) were downplayed within the Reform Movement.

In 1912, the same year members of Temple Emanu-El dedicated their new building, Hungarian and Lithuanian immigrants living on the city's East Side organized what eventually became known as the Conservative congregation of Shaarei Torah.[10] Then, in 1919, the Conservative congregation of Anshe Emeth was organized by mainly Hungarian immigrants, who, in 1922, built an impressive temple in the fashionable North Side neighborhood surrounding Youngstown's Wick Park.[11] In 1920, the Orthodox congregation of Ohev Tzedek was organized on the South Side, with a permanent synagogue dedicated in 1926.[12]

Keeping pace with the rise of congregations was the explosive growth of social, political and service organizations. These included local chapters of the National Council of Jewish Women, Pioneer Women and *Arbeiter Ring* ("Workmen's Circle"), a Yiddish-oriented group dedicated to social justice. At the same time, a once fledgling Zionist movement gained strength, largely in response to intensifying anti-Semitism in Europe and the rise of racialized

anti-Jewish sentiment in the United States. By 1921, a movement that traced its origins in Youngstown to 1904 (when fifteen men met at the downtown residence of local baker Louis Ozersky) had gained enough momentum to attract the attention of Zionist leader and future Israeli president Dr. Chaim Weizmann, who spoke at a mass meeting in Youngstown's Hippodrome Theater on the need to establish a Jewish homeland.[13]

In time, the rapid expansion of Youngstown's Jewish community, which included two thousand families by the late 1930s, prompted some local leaders to call for the creation of an organization capable of meeting its varied needs, while also providing assistance to beleaguered Jewish communities overseas. This movement culminated, in 1936, with the formal incorporation of the Jewish Federation of Youngstown, which established departments dedicated to family welfare, education and social and recreational activities. A comparable wave of institution building and organizational activity could be seen in the Jewish communities of neighboring Warren, Ohio, and Sharon and Farrell, Pennsylvania.

While Youngstown's bustling economy attracted a wide array of immigrant groups in the late nineteenth and early twentieth centuries, it soon became apparent that much of what made the city distinctive had been contributed, in one way or another, by its Jewish residents. In 1901, Russian immigrant William Wilkoff was among the incorporators of Youngstown Sheet and Tube, an enterprise that became one of the nation's largest steel producers. Nineteen years later, in 1920, two Jewish scrap dealers, Robert and Jacob Carnick, organized Commercial Shearing & Stamping, a manufacturing firm that continued to flourish years after their departure from the board of directors.[14]

Youngstown's elegant downtown retail district, which stretched westward from the city square, featured thriving (and iconic) businesses, many of which had been established by local Jewish entrepreneurs. Indeed, area residents of a certain age still affectionately recall hours spent at the Strouss-Hirshberg Department Store (later known as Strouss's), Livingston's women's clothing store, Levinson's jewelers, Lustig's shoe store, Haber's furniture store and Frankle Bros. cigar shop. Many local residents depended on bread produced at Schwebel's Bakery, purchased their formal wear at Hartzell Brothers' clothing store and bought tires at Leo Levinson's shop in the eastern downtown area. Meanwhile, local moviegoers frequently stopped at Friedman's Candy Store, a beloved fixture that shared space with the Palace Theater, located just north of the city's central square.

By the early 1930s, the Warner Brothers Theater, erected as a memorial to one-time Youngstown resident Sam Warner, bore witness to the success of

the city's most famous alumni—and few Youngstown residents missed the fact that the brothers' signature films were often celluloid recreations of the city they had left behind, with its paternalistic magnates, enterprising immigrants, combative unionists and fast-talking gangsters.[15] During the height of World War II, local radio listeners tuned in as national war correspondent Cecil Brown, a one-time editor of Youngstown's *Jewish Journal*, offered riveting accounts of battles that shaped the conflict's outcome.[16]

About two decades later, in 1964, another team of fraternal business partners, Forrest and Leroy Raffel, opened the first Arby's fast-food restaurant in the Youngstown suburb of Boardman, Ohio, thereby helping to usher in a new era in U.S. consumer culture.[17] Time and again, often with the assistance of its Jewish residents (or former residents), Youngstown has reentered the national consciousness. In recent years, however, it has done so primarily as a symbol of deindustrialization—a development that has posed serious challenges to the local Jewish community.

As recently as the late 1960s and early 1970s, many local residents regarded Youngstown as a vibrant community, though signs of economic decay were evident to those who tracked the migration of capital from the urban core to outlying townships, a trend that began at the close of World War II. In time, the forces of suburbanization overlapped with a gradual disinvestment in the local steel industry on the part of corporate and industrial leaders. A devastating economic blow came in September 1977 with the closure of Youngstown Sheet and Tube's massive plant in neighboring Campbell, Ohio—the first in a crippling series of steel plant shutdowns throughout the Youngstown-Warren area.

For many local residents, the rapid decay of Youngstown's once-glittering downtown retail district reflected the heavy toll deindustrialization had taken on the community. Between 1980 and 2000, the city's population fell from 115,423 to 82,026.[18] Meanwhile, throughout the industrial zone comprising Youngstown and Warren, Ohio, and Sharon, Farrell and New Castle, Pennsylvania, more than forty thousand jobs were lost during the late 1970s and early 1980s alone.[19] The city's Jewish community was scarcely immune to such developments, and between the 1940s and 1970s, the population fell from 8,000 to 4,000.[20]

By the early twenty-first century, perhaps as few as 2,500 Jews resided in the Youngstown-Warren Metropolitan Area. That number continued to drop, and a trend toward depopulation ensured that the once-autonomous Jewish communities of Warren, Sharon and Farrell would fall under the auspices of the Youngstown Area Jewish Federation. Youngstown's dramatic

decline (along with the economic collapse of the region eventually known as the "Steel Valley") could not have been anticipated by late nineteenth-century civic leaders like David Theobald, who viewed their community as a burgeoning boomtown. Nor could Theobald and his contemporaries have imagined the difficulties attending widespread assimilation, a phenomenon that has left a growing number of American Jews with "feelings of loss" as they seek to maintain a sense of group identity "in a world resistant to seeing them as a group apart."[21] Hence, the challenges facing local Jewish leaders in the late twentieth and early twenty-first centuries have differed substantially from those their predecessors encountered in previous decades.

Although the Greater Youngstown area's Jewish community has contracted, it has nonetheless maintained a healthy tradition of institution building, while taking steps to affirm a distinctive collective identity. Moreover, Jewish leaders have played a role in the task of rebuilding the local economy. Even as the Youngstown area's industrial infrastructure showed obvious signs of decay, these leaders continued to invest in the future, and the community's most salient characteristics remain its vitality and creativity. Testaments to these qualities include institutions such as the Jewish Community Center, which remains a hub of local Jewish life; Heritage Manor Jewish Home for the Aged; Levy Gardens, the federation's assisted-living center; and Altshuler Akiva Academy, which maintains a Jewish day school and Sunday school.

Drawing upon *These Are the Names*, a historical overview published by the Youngstown Area Jewish Federation in 1994; a broad range of materials from the Jewish Archives at the Mahoning Valley Historical Society; and scores of interviews, this book covers the period stretching from the late nineteenth century, which witnessed the development of a recognizable Jewish community, to the present day. Given the growing cohesiveness of the region once known as the Steel Valley, this narrative also tracks the development of neighboring Jewish communities in Warren, Sharon and Farrell, a project that has benefited from the assistance of the Public Library of Youngstown and Mahoning County, the Warren-Trumbull County Public Library, the Mercer County Historical Society and a number of individual informants. Additional material on the history of the Youngstown-Warren area's Jewish community was provided by Cincinnati's Hebrew Union College—Jewish Institute of Religion.

It is worth noting that, in certain respects, the story of Greater Youngstown's Jewish community overlaps with the narratives of many other communities based in the northeastern United States that have

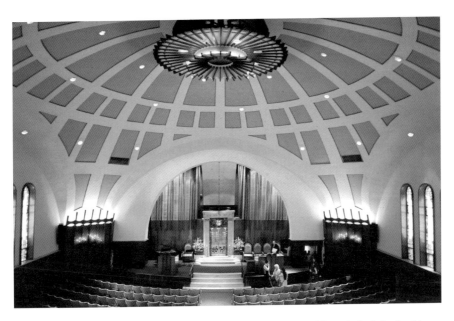

The sanctuary of Congregation Rodef Sholom remains a powerful symbol of the Jewish community's long presence in the Youngstown-Warren area. The congregation marks its 150th anniversary in May 2017. *Courtesy of Nea Bristol.*

also struggled with the challenges of shrinking numbers and declining resources. Nevertheless, the story of Greater Youngstown's Jews is bound to strike readers as refreshing, perhaps even inspirational. The historical narrative that follows is intended as a tribute to the scores of individuals who played a role in the development of this remarkable community over the past century and a half.

1

Origins of a Jewish Community

On the evening of November 5, 1881, Jacob Spiegel, known as "one of the oldest businessmen of the city and section," took his final breath.[22] Newspaper accounts indicate the eighty-one-year-old merchant was surrounded by relatives, who kept vigil at the Youngstown residence of Spiegel's son-in-law Emmanuel Mittler.[23] At a time when death notices of all but the most prominent featured a couple of lines, Spiegel's obituary in the *Youngstown Daily Register* included almost four hundred words.

Intelligent, resourceful and alert to new opportunities, Spiegel had achieved much since his arrival in the United States almost fifty years earlier. Since the early 1840s, Spiegel and his family had operated a successful general store in Youngstown, and they became valued members of the community. If Spiegel was admired for his business skills, he also earned respect for his philanthropy. His obituary states, "He was a liberal minded as well as a liberal handed man, giving much but saying little of his charities."[24] Furthermore, he held a unique status within the community, since he was regarded as the first Jewish resident of the Mahoning Valley.

While Spiegel's activities in the United States are outlined in his lengthy obituary, his European origins remain elusive. Various sources suggest he was born in places as far-flung as France,[25] Germany[26] and Hungary[27]—an inconsistency that cannot be fully attributed to the shifting borders of nineteenth-century Europe. There is no mystery, however, concerning the factors that drew Spiegel and scores of other immigrants to northeastern

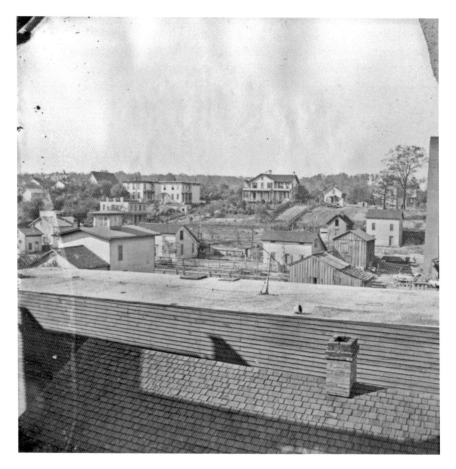

This 1870 photograph shows central Youngstown during a period when the former pioneer outpost was becoming a regional industrial center. *Courtesy of Mahoning Valley Historical Society.*

Ohio. In order to better understand Spiegel's motivations, and the world he inhabited, it is important to discuss the trends that helped to turn a wilderness outpost into a regional economic hub.

The Rise of the Mahoning Valley

In June 1797, when John Young and his party of four arrived in Range Two, Township Two of New Connecticut, they encountered a primeval forest that was bereft even of a native population. Despite these daunting conditions,

the stretch of wilderness Young surveyed was soon home to a community of mostly transplanted New Englanders and Scots-Irish pioneers. Then, in 1799, just three years after the establishment of Young's settlement, another pioneer, Moses Warren, arrived from Connecticut to survey an area of the Mahoning Valley to the northwest. A year later, in 1800, Warren, Ohio, the settlement named for him, was designated the capital of the Connecticut Western Reserve.

The course of the valley's economic development was set three years later, in 1803, when two brothers, James and Daniel Heaton, discovered a deposit of iron ore in the community of Poland, just south of Youngstown. Encouraged by the availability of natural resources, the Heatons erected what local industrialist Joseph G. Butler later called "the first blast furnace in the Mahoning Valley, if not indeed the first west of the Allegheny River."[28]

Significantly, the "Young's Town" settlement's rapid growth in the early nineteenth century owed much to the development of the nation's western territories. One of the greatest beneficiaries of westward expansion of the 1830s was the state of Ohio. Indeed, by 1830, Ohio's population had reached 937,901, nearly 7.3 percent of the nation's 12.8 million, overtaking North Carolina as the fourth most populous state. This was due in part to the completion of the Ohio and Erie Canal in 1832, which gave Ohio merchants and farmers direct access to eastern markets. The canal system also facilitated improved communication among the state's communities, fostering the growth of transportation and business enterprises.

As westward expansion blossomed, counties in the mineral-rich districts of eastern Ohio and western Pennsylvania witnessed a period of unprecedented growth. Among those areas that held vast deposits of coal and iron were Ohio's Trumbull and Columbiana Counties and Pennsylvania's Lawrence and Mercer Counties. During that time, coal was the preferred heating fuel for most Americans, and it was also a key component in the production of iron and steel. Rising demand for coal led to an upsurge in regional mining operations, as well as a demand for workers. This rise in industrial hiring attracted not only laborers from nearby Ohio and Pennsylvania communities but also transient workers from eastern U.S cities and newly arrived immigrants.

Genesis of a Community

The earliest known reference to Jews in the region is found in General Thomas W. Sanderson's 1907 book, *20th Century History of Youngstown and Mahoning County, Ohio, and Representative Citizens*, which indicates Spiegel settled in Ohltown in approximately 1837.[29] A 1908 article by Dora Brown that appeared in the Jewish periodical the *Reform Advocate* agreed with Sanderson. Moreover, Brown incorporated much of the former's research, indicating it reflected a "careful search through original records."[30] In his 1921 book, *History of Youngstown and the Mahoning Valley, Ohio*, Joseph Butler generally concurs that Jewish migration to the region "began in the '30s."[31] A less reliable source, a 1928 news article from the *Jewish Daily Bulletin*, pegged the community's origins slightly earlier, at "the early thirties of the nineteenth century."[32] Assuming the Sanderson date to be the most historically accurate, this places the Jewish community of Greater Youngstown as the second-oldest Jewish community in the state of Ohio, after Cleveland.[33]

Sanderson observed that "Jewish immigration made but slow progress" after Speigel's arrival, perhaps due to a severe economic depression set off by the Panic of 1837. Spiegel remained the area's lone Jewish resident for several months, quietly conducting a small country store near the border of present-day Austintown Township.[34] That would change when he hired a newly arrived seventeen-year-old German Jewish youth named Emanuel Hartzell (Herzog) to work in his store in late 1837.[35] A year later, Spiegel and Hartzell were joined by Simon Lowenstein, who settled in what became the Brier Hill neighborhood of Youngstown, near the outskirts of Girard, Ohio. Perhaps seeking greater economic opportunity, Spiegel and his family eventually relocated to the bustling village of Youngstown, while Emanuel Hartzell moved to neighboring Liberty Township.

By the end of the 1840s, the village of Youngstown had grown in size and influence. Within ten years, the town's population had increased by more than 300 percent, rising from 654 residents in 1840 to 2,802 in 1850. Interestingly, Youngstown had experienced only modest growth before 1835, largely due to its "limited access to markets and its depletion of local iron and fuel resources."[36] In 1841, however, new markets opened with the completion of the Pennsylvania and Ohio Canal, linking Youngstown to other communities in the state. Five years later, in 1846, the availability of cheap transportation was among factors that led local industrialist David Tod (later governor of Ohio) to finance the building of the "Eagle," the largest blast furnace in the Midwest.[37]

While the Mahoning Valley had gained a reputation for economic opportunity, Ohio, in general, was starting to attract larger numbers of Jewish immigrants. By the 1850s, Ohio had gained more recognition for furthering Jewish equality, largely due to the pioneering efforts of Cincinnati-based Rabbi Isaac Wise. Born in the Austrian Empire in 1819, Wise had immigrated to the United States in 1846 and become the leader of Cincinnati's oldest and most influential synagogue, K.K. B'nai Yeshurun, in 1854. Over the next two decades, Rabbi Wise fought tirelessly for Jewish causes, and he was widely recognized as the person most responsible for shaping the Reform Judaism Movement in America. Perhaps encouraged by the state's reputation for religious tolerance and economic opportunity, several more Jewish immigrants found their way to Ohio and settled in the Mahoning Valley.

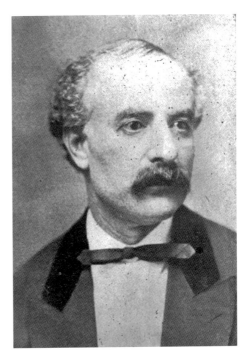

An immigrant from Bavaria, Germany, David Theobald emerged as a regional civic and business leader in the 1850s. His status was reflected in Ohio governor George Hoadly's decision, in the 1880s, to appoint him as an aide-de-camp. *Courtesy of Hebrew Union College.*

A notable member of this new group was David Theobald, a young Jewish merchant from Ilbersheim, Bavaria. In 1852, twenty-six-year-old Theobald settled in Youngstown, migrating from nearby New Castle, Pennsylvania. Upon his arrival in Youngstown, he established the retail firm of D. Theobald & Company, introducing the "one price" philosophy to local business owners, who still engaged in bartering.[38] Shrewd and enterprising, Theobald operated the first local business to specialize exclusively in men's attire. His venture proved so successful that, by the end of the first year, he introduced a tailoring department.[39] By the late 1850s, in a classic example of chain migration, David Theobald had recruited his wife's brothers, Ferdinand and Edward Ritter, to join him in Youngstown.[40] Ferdinand Ritter formally entered into a partnership with Theobald in 1858 and married his sister, Minnie Theobald, later that year.[41] The Ritter brothers, natives of

Kerzenheim, Bavaria, had operated a clothing business in Philadelphia, and they soon became fixtures of Youngstown's business community. Edward Ritter chose not to join his brother and Theobald and, instead, opened a small clothing concern in downtown Youngstown.[42]

IMPACT OF THE CIVIL WAR

In 1861, as the country braced for war, American Jews were as divided as their Gentile neighbors on the issue of slavery. Northern Jews usually opposed the institution, while Southern Jews were often in favor of it and, in some cases, owned slaves. While the individual views of the Mahoning Valley's Jewish residents remain a mystery, it is possible to make reasonable assumptions about the community's general attitude toward slavery. The group's heavily Germanic ethnic makeup and Republican affiliations lend weight to the theory that most held antislavery views. This view is supported by Alison Clark Efford's observation that German Americans, unlike their English and Irish compatriots, rarely displayed racist tendencies and actually "celebrated ethnic pluralism."[43]

With the state's Democratic Party divided between "War Democrats" (Unionists) and "Copperheads" (Confederate sympathizers), the steady leadership of Youngstown-born governor David Tod helped keep Ohio firmly on the side of the Union. Amid such turbulence, Jewish migration to the Youngstown area slowed considerably. Nevertheless, examples exist, such as Simon Eis Hartzell, who arrived from Hessloch, Germany, in 1854.[44]

Cabinetmaker Herman Rice is believed to have arrived from Monsk, Austro-Hungary, in 1860;[45] and businessman Abraham Printz immigrated to the Youngstown area from Kashau, Austro-Hungary, in 1862.[46] Likewise, Mecklenburg, Germany–born jeweler William Jonas came to Youngstown in 1863.[47]

When the Civil War ended, Jewish immigration to the region gradually increased. David Theobald's seventeen-year-old cousin, Isaac Strouss, arrived from Hahnheim, Rheinhessen, Germany, in 1865.[48] That same year, teenaged brothers Isaac and Emanuel Hartzell left their native Hessloch, Germany, and settled in nearby Girard, Ohio, where they worked as apprentices for their uncle Emmanuel Hartzell and his partner, Samuel Lambert.[49] Several years later, in 1869, nineteen-year-old Bernard Hirshberg arrived in Youngstown from New Brighton, Pennsylvania, seeking employment.[50]

The South's Reconstruction brought an era of heightened prosperity to the region, as the need for coal and metal building materials increased. Apart from a new crop of European Jewish immigrants, the area attracted Jews from other regions of the country, including the South. Among those seeking a fresh start was former Confederate soldier Emanuel Guthman, who had immigrated to Tennessee from Hesse-Darmstadt, Germany, in 1854 and moved to Youngstown in 1867.[51] Similarly, Samuel Weil, a thirty-year-old Jewish southerner from Keysville, Virginia, came to the region in the late 1860s, after having served with distinction as a captain in the Confederate army.[52]

BIRTH OF CONGREGATION RODEF SHOLOM

By the late 1860s, the growth of the Youngstown area's Jewish community spurred plans to establish a formal congregation. Up to that point, most Jewish families had been resigned to worshipping in private homes, joining services at local Protestant churches or attending Christian Sunday schools.[53] As with many other Ohio Jewish communities, the cultural identity of the Greater Youngstown community was decidedly German—primarily Hessian and Bavarian, with minor Austro-Hungarian influences. Many of the area's Jewish citizens had become distinguished members of the regional community.

Deeply entrenched in the fabric of American society, they were nevertheless committed to their faith and sought to establish a congregation that addressed their needs. On May 12, 1867, a group of prominent Jewish citizens—including David and Henry Theobald; Charles, Edward, Ferdinand and Abraham Ritter; M. Ullman; Abraham Shafner; Samuel Lambert; Samuel Lowenstein; Emanuel Hartzell; Abraham Walbrun; William Jonas; Abraham Printz; and Emanuel Guthman—met in Abraham Walbrun's home and laid the foundation for Rodef Sholom, one of the earliest congregations of Reform Judaism in Ohio.

Although in its infancy in Ohio, the Jewish Reform Movement had been steadily percolating across the United States for several decades. First instituted in Charleston, South Carolina, in 1824 by Spanish and Portuguese Jews from England, Reform Judaism had its roots in German-Jewish intellectualism of the late eighteenth and early nineteenth centuries.[54] It was, in part, a reaction against European Jewish segregation. Reform advocates sought to bring Judaism "out of the ghetto," deemphasizing elements such as

religious clothing and the role of the rabbi in daily religious life, encouraging the use of their adopted country's language over Yiddish and reviving Hebrew as the primary religious language. Furthermore, the movement took a more inclusionary stance on faith, including liberal interpretations of Jewish beliefs, such as the Torah being divinely inspired rather than the literal word of God.

In the weeks before that initial meeting in May 1867, policies for the congregation were created and officers elected, with David Theobald serving as its first president, Edward Ritter as vice president, Abraham Walbrun as treasurer and Emanuel Guthman as secretary. In line with the rigorous standards of the time, the newly elected officers approved strict regulations. Fines were imposed for late reports, absenteeism and failing to meet accepted social standards. By July 1867, the congregation had secured a permanent place to hold meetings and religious services; in August, burial grounds in Brier Hill were purchased. The congregation's final challenge, and arguably the most important one, was procuring a *Sefer* Torah, a hand-inscribed scroll containing the first five books of the Hebrew Bible. This was accomplished in January 1869, and a formal dedication ceremony was held on February 27, 1869. With the installation of their Torah complete, the members of Congregation Rodef Sholom set their sights on finding a proper rabbi to lead them.

Seeking Religious Leadership

Initial attempts to secure a religious leader for the congregation were fraught with challenges. The first confirmed religious leader of the congregation was Rabbi Friedenthaler, who arrived in the city from Germany in late 1867. Almost immediately, however, the newly appointed rabbi came into conflict with members of the congregation. Not surprisingly, Rabbi Friedenthaler was dismissed from his duties at Rodef Sholom in February 1868. As a notably polite gesture, the congregation purchased a railroad ticket to facilitate the rabbi's departure.[55]

After months without a rabbi, the members of Rodef Sholom empowered their president, David Theobald, in April 1868 to place an advertisement in newspapers such as the *American Israelite* and the German-language *Die Deborah* for a suitable replacement. Several months later, on August 2, 1868, the congregation received correspondence from Rabbi Lippman Liebman

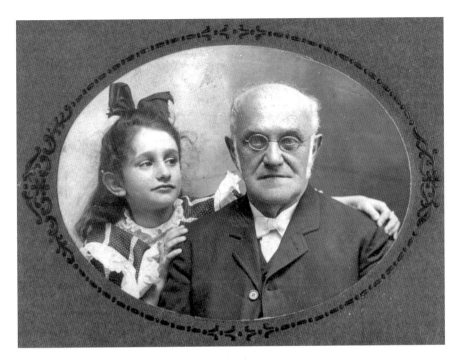

Rabbi Lippman Liebman, shown with his granddaughter, is regarded as the first official spiritual leader of Congregation Rodef Sholom. During his tenure, he introduced reforms in the areas of liturgy and religious education, while serving as the community's *schochet* (ritual butcher). *Courtesy of Mahoning Valley Historical Society.*

of Hamilton, Ohio, inquiring about the position. The son of a clergyman, Rabbi Liebman was born in Karlsruche, Baden, Germany, in 1832 and came to the United States as a child.[56] The thirty-six-year-old rabbi was invited to Youngstown to preside over services the following Saturday, and the congregation approved his installation the following week.

In addition to overseeing the region's only synagogue, Rabbi Liebman's responsibilities included maintaining a religious school and facilitating the teaching of Hebrew. As the only rabbi between Cleveland and Pittsburgh, he performed marriages and conducted funerals in communities across the region, including Akron, Warren and Niles, Ohio, as well as New Castle and Sharon, Pennsylvania. Beyond his duties as teacher and officiant, Rabbi Liebman played an integral role in laying the foundations of Jewish religious life in Youngstown. In October 1868, Liebman suggested that "a regular mode of worship" be adopted and a committee appointed to "consult with him and choose such prayers in Hebrew, English, and German, as suitable."

Furthermore, Rabbi Liebman often acted as the region's kosher butcher, or *shochet*, to ensure Jewish dietary laws could be properly maintained. This inevitably brought him into conflict with local butchers, who viewed his involvement in their trade as direct competition. Since butchering was not part of his official duties, there was also a serious debate over who was financially responsible for Rabbi Liebman's services. The matter was eventually settled several years later, when members of the congregation agreed to purchase their meat from local butchers, on the condition that Rabbi Liebman be allowed to perform the necessary ritual slaughtering. Any member caught purchasing meat from an unauthorized vendor would be fined. In return, approved butchers were prohibited from selling kosher meat to customers who were not members of Rodef Sholom.[57]

Formalizing a Congregation

In January 1869, the so-called *Cultus* Committee (Worship Committee) submitted its final report, which offered recommendations on almost every conceivable topic: procedures for Friday and Saturday services, guidelines for holy day worship, sequences for choir songs and lists of recommended prayers. After reviewing the committee's report, the voting membership of the congregation accepted the proposal and adopted the measures. Nearly six months later, in May 1869, the leaders of Rodef Sholom received an invitation to attend a conference to be held in Cincinnati the following June. Among topics to be discussed at the conference were religious and Hebrew instruction, the organization of Young Men's Hebrew Association chapters, the distribution of Hebrew literature, creating a fund for seminary education and proposals for marriage and divorce laws. Some of the most prominent Reform rabbis of the time had requested their attendance, including Rabbi Wise of Cincinnati and Rabbi Max Lilienthal of Cleveland, and the membership promptly sent delegates to the conference. Likewise, when called in 1873, the congregation answered by sending representatives to the historic conference from which the Union of American Hebrew Congregations (UAHC) was formed.[58]

As the Jewish community grew in size, the need for larger accommodations became increasingly evident. The first such upgrade occurred in January 1870, when a committee was formed to locate more suitable quarters. The committee voted to rent the second story of Spiegel's store for three

years, with the understanding that the owner would be responsible for all maintenance and repairs during that period.[59] Then, in November 1874, a special meeting was called by temple president David Theobald to consider a committee proposal to lease "Mrs. Gerstle's room" at the corner of Federal and Hazel Streets, in downtown Youngstown. The chairman of the committee, Abraham Schwab, observed that the move would be costly due to the need for improvements. Nevertheless, the members unanimously agreed to secure the property.

THE ASCENT OF YOUNGSTOWN

When Mahoning County was created in March 1846, the municipalities of Youngstown and Canfield engaged in a bitter rivalry over the right to the county seat. At that time, Youngstown held a distinct economic advantage, with its wide variety of industry. Canfield, though less industrious, was nevertheless the geographic center of the county and home to most of the area's municipal buildings. Therefore, in 1846, state officials regarded it as a more appropriate choice for the county seat. By the mid-1870s, however, it was clear that the political winds were shifting. During the two decades after county incorporation, Canfield had experienced little demographic or economic development, adding just a few hundred residents to its census rolls by 1870. By contrast, Youngstown had become an industrial powerhouse, and between 1850 and 1870, its population jumped from 2,802 to 8,075 residents.[60] Moreover, Youngstown now represented nearly a quarter of the county's population, was home to more than half the county's litigation, paid nearly half of the county's taxes and was a major railroad center with connections to virtually all parts of the county.[61] Over the strenuous objections of Canfield officials and residents, the state granted Youngstown the honor of county seat in 1876.[62]

During this period of expansion, Youngstown witnessed the establishment of a variety of businesses that would become local icons. One example occurred in 1875, when David Theobald, owner of the region's largest retail clothing store, decided to sell his interest in the Woolen Store to his younger cousin Isaac Strouss. Several years earlier, Theobald had purchased the business from his partner, Abraham Walbrun, for whom Strouss was acting as general manager.[63] Strouss's business partner in the new venture was his friend, former Theobald employee Bernard Hirshberg. Together, the

two enterprising young men established the Strouss-Hirshberg Company on West Federal Street in Youngstown on March 9, 1875. Within two years, the company had outgrown its original venue, and the partners relocated to a larger facility down the street.[64]

As the decade of the 1870s came to a close, it was evident that Youngstown and its Jewish community were growing more rapidly than their counterparts elsewhere in the Mahoning Valley. The city of Warren, the de facto regional power at the start of the century, was experiencing a period of relative stagnation. Although it boasted several key businesses, notably the Packard and Company Iron Works, Warren had not profited to the extent of Youngstown from the iron manufacturing that began before the Civil War.[65] It is, therefore, not surprising that the bulk of the immigrant Jewish population that arrived in the region settled in Mahoning County. Those few Jews living in Trumbull County at this time are believed to have been German in origin and, thus, as Irv Ozer and his coauthors noted, "affiliated with the reform congregation in Youngstown, Rodef Sholom Temple."[66]

On the Cusp of Change

As members of Congregation Rodef Sholom once again prepared to upgrade to larger accommodations, the area's growing Orthodox population was beginning to coalesce into a separate, viable congregation. According to an article written by Rabbi Liebman in 1870, the first Orthodox Jews to arrive in the region consisted primarily of "Poles, Russians, and a scattering of nationalities." Rabbi Liebman noted that, unlike their Reform brethren, early Orthodox settlers maintained a fairly loose affiliation, organizing for the chief purposes of "making a Minyan [a prayer quorum required by Orthodox law] and saying Kaddish [a mourner's prayer]."[67] Although the exact date of their arrival is not known, there is evidence that highly religious Jewish residents lived in the area prior to the formal establishment of Rodef Sholom. In Sanderson's history of the Greater Youngstown area, he noted that these individuals were "not in sympathy with the Reform service at the Temple" and "desirous of preserving the traditional ritual and customs of orthodox Judaism."[68]

In an article examining the region's Jewish history, Rabbi Shmuel Singer observed that the limited information available regarding the Orthodox

community's origins may reflect a general lack of interest on the part of non-English-speaking immigrants to publicize their activities.[69] Indeed, it was not until the purchase of burial land in 1875 that documents related to an established Orthodox congregation entered the public sphere.[70]

The arrival of Eastern and Central European immigrants in the Mahoning Valley challenged the status quo of the established Jewish community. As Andrew Cayton noted, "[H]istorians attribute the relative acceptance of German Jews in nineteenth century Ohio to their eagerness to become part of the larger public community."[71] On the other hand, the newcomers' distinct cultural and religious traditions accentuated their differentness and probably raised concerns among older Jewish residents. The arrival of the Eastern and Central Europeans marked the beginning of an unprecedented cultural transformation in the Mahoning Valley that would be felt for generations to come.

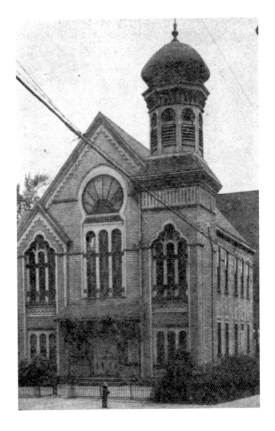

The first edifice of Congregation Rodef Sholom sat at the present-day corner of Lincoln and Fifth Avenues on Youngstown's North Side. The temple was built in an eclectic style known as Moorish Revival. *Courtesy of Mahoning Valley Historical Society.*

Building a Boomtown

As President-elect James Garfield's train eased into a station in Youngstown, Ohio, on February 28, 1881, the veteran lawmaker moved to the rear of the caboose to address a gathered crowd. "I am about to take leave of this old Congressional District," Garfield announced. "I have come the length of it, and I shall say goodbye to it when I say goodbye to you." The president-elect, who boarded the Washington, D.C.–bound train in Mentor, Ohio, had used every stop in his home state to extol the virtues of "the great community of northern Ohio," whose economic and political clout were undeniable.[72] The regional euphoria evoked by the Ohioan's election turned out to be short-lived, however. Less than four months after his inaugural address, President Garfield's program of reform was brutally interrupted when he was wounded by an assassin's bullet on July 2, 1881, and died the following September.

Leading citizens of Youngstown, stunned by the news, launched a fundraising campaign for a proposed Garfield memorial in Cleveland. Yet, for the city's industrial leaders, there were limits to what they deemed appropriate expressions of grief. When employees at Brown, Bonnell & Company, one of the city's largest iron mills, officially requested that work be suspended to mourn the late president, their superintendent, E.H. Williams, offered this response: "If the men desire to attest their sympathy in a substantial way, let them work and donate the amount they earn to the City Hospital or some other charitable institution."[73]

Although Youngstown was a Republican stronghold that had done its share to secure Garfield's election, it was also a fast-paced industrial center,

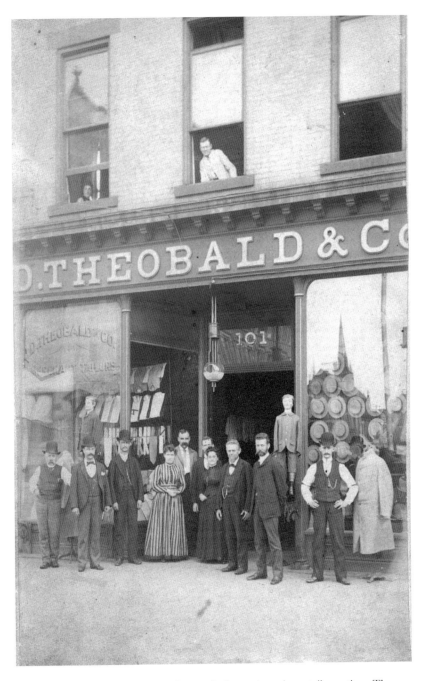

David Theobald & Company was known for its cutting-edge retail practices. The firm introduced a "one-price" policy to a community that was still dependent on bartering, while offering a selection of goods associated with much larger metropolitan areas. *Courtesy of Mahoning Valley Historical Society.*

where any delay in production was treated as a serious matter. In 1863, at the height of the Civil War, the city already boasted "seven iron blast furnaces, three rolling mills, a steelworks, and two machine shops and foundries."[74] Within two decades, dozens of the community's small iron and steel shops had consolidated to form larger operations. Youngstown's importance as a manufacturing center was rivaled by its significance as a transportation hub. Sean Safford noted that around the time of Garfield's election, the city "served [as] the junction of four major trunk lines—the Baltimore and Ohio, the Erie Lackawanna, the New York Central, and the Pennsylvania—and by the turn of the century, more rail cars passed under Youngstown's Center Street Bridge per day than any other location in the country."[75]

The city's growth was reflected in a bustling downtown retail district that featured a number of Jewish-owned businesses, including Guthman Bros. jewelry and furniture store, David Theobald & Company, Strouss-Hirshberg Company and Weil's Combination Store, which sold items ranging from schoolbooks and stationery to wallpaper and window shades.[76] Indeed, Youngstown's transformation into an industrial boomtown had created new opportunities for the city's growing Jewish population.

The Arrival of the Eastern Europeans

By the end of the nineteenth century, however, international and domestic developments contributed to a new set of challenges for the local Jewish community. Few established Jewish residents were prepared for the arrival of large numbers of immigrants from Eastern Europe, whose values differed from those of an acculturated Jewish elite who traced their roots to Western Europe. Fueling this new wave of immigration was the economic malaise that had swept Eastern and Southern Europe, where farming populations struggled to compete with "cheap American and Argentine grain and meat."

In the troubled Russian Empire, these economic difficulties coincided with a wave of political oppression that followed Czar Alexander II's assassination in 1881. After the czar's murder, the imperial government instigated anti-Jewish pogroms "as a technique for diverting revolutionary unrest," presented the incidents as a "spontaneous response to putative Jewish revolutionary activity and economic exploitation" and implemented "emergency regulations" to "protect the native population." The government's "May Laws," enforced between 1882 and 1917, ensured it

would be virtually impossible for Russian Jews to purchase land, build homes or enter the professions of medicine and law. Not surprisingly, two-thirds of the three million Russian immigrants who arrived in the United States between 1880 and 1914 were Jewish.[77] Conditions for Jews in neighboring Eastern European countries were scarcely better. In Habsburg-controlled Galicia, a region on the border of modern-day Poland and Ukraine, "[A]n incipient industrial revolution rapidly eroded the Jewish cottage industry." At the same time, the governments of newly independent countries like Romania often targeted minority groups, especially Jews, who "were threatened with expulsion from small towns and villages."[78]

The arrival of thousands of Eastern European Jewish immigrants in the Mahoning Valley contributed to the diversity of a rapidly expanding community. Between 1870 and 1880, Youngstown's population almost doubled, rising from 8,075 to 15,435.[79] Sherry Lee Linkon and John Russo wrote that, during this period, "One-third of the city's residents were recent immigrants, most of whom lived within easy walking distance of the mills."[80] Like other recent arrivals, Jewish immigrants from Eastern Europe often sought to reorganize their former communities on American soil. As Irving E. Ozer and his coauthors noted, these immigrants "tended to transport with them their *shtetls*, complete with their institutions, including their concepts of worship, their Yiddish accents, their native tongues, their mores, their customs, and even their superstitions and prejudices."[81]

This pattern led Cincinnati's Rabbi Isaac M. Wise to compare the newcomers unfavorably to native-born American Jews, whom he praised as "Israelites of the nineteenth century in a free country," while contending that their Eastern European counterparts "gnaw the bones of past centuries." He added that the new arrivals would likely damage the "good reputation of Judaism" and "without fail lower our social status."[82] Such views were undoubtedly echoed among members of Youngstown's heavily Germanic Jewish elite. Ozer and his coauthors indicated it would have been "surprising" if established local Jews "had not regarded these new Eastern European arrivals, with their *payases* (sideburns), their *tzitzis* (prayer tassles) and their strange clothes and languages, with some degree of concern and apologetic embarrassment mixed with a sense of noblesse oblige."[83]

Yet those Jews included in the larger wave of late nineteenth-century Eastern and Southern European immigrants "were the group most identified with the ways of the modern world." Unlike their non-Jewish counterparts, they "had not been farmers or peasants in Europe, but had practiced trades and professions that eased their transition to the modern urban setting."[84]

Hence, many of these Jewish immigrants opted for self-employment rather than work as industrial laborers, and their integration proved a smoother process than many had predicted.

FORMATION OF CHILDREN OF ISRAEL CONGREGATION

In the absence of a formal congregation, newly arrived Eastern European Orthodox Jews who settled in Greater Youngstown worshipped in private homes—a practice that became increasingly burdensome as the community grew. Thus, in 1883, they formed B'nai Israel Congregation, better known as the "Congregation of Children of Israel." Records indicate that early members of the congregation included Samuel B. Frankle, Moses Kalwrizitsky (Kalver), M. Smith, Abraham Klein, M. Friedman, Leopold Lustig, Solomon Levy, Martin Schwartz, Leopold Newman, Leopold Rosenbaum, M. Goodman, Herman Rice, Isaac Friedman, Simon Fishman, Isadore Myers, Isaac Coch and Emanuel Geiger.[85]

Orthodox Jews, of course, were present in the community well before the organization of a congregation. In an 1870 letter to *American Israelite*, a Jewish periodical, Rabbi Lippman Liebman of Rodef Sholom explained that of the "80 families of Israelites" in Youngstown, a large minority were "Extreme Orthodox...with a Shochet as their Chasan [cantor] and Leader." A comparable group, which he described as "Orthodox, but not as strict as the above," was also composed mainly of Eastern European immigrants. In a reference to the local Reform community, Rabbi Liebman added that a third group "engaged my services and adopted *Minhag* [Jewish custom] America." He then noted, with regret, "that the last two mentioned Congregations can not unite on a liberal basis, and it is hoped that steps looking toward a consolidation will be taken before long."[86] Rabbi Liebman's expressed desire to see his Reform congregation absorb a percentage of the local Orthodox community might have raised eyebrows among that community's leaders. It is possible, however, that Youngstown's Orthodox Jews were preoccupied with their own internal divisions.

About two decades later, in August 1890, a dispute within Children of Israel Congregation found its way on to the front page of the *Youngstown Vindicator*. The newspaper reported that a few members, including "A. Kline [*sic*], A. Frieman, L. Lustig, M. Kalverisky [*sic*], J. Green, Martin

Black and B. Wise," were "thrown out" for "slandering" the congregation's aging spiritual leader, Rabbi A. Freed. One source, described only as "a prominent member," indicated that the expelled congregants "have always been a lot of kickers," adding "we are better off without them." The same unnamed source rushed to the defense of Rabbi Freed, describing him as "a perfect gentleman," and claiming "nobody can truthfully say a word against him." Meanwhile, the dissenting members announced the formation of the "American Orthodox Hebrew Congregation" and discussed plans to secure a rabbi from the Pittsburgh area. "There have been 32 members in the congregation of the Children of Israel and 15 of them joined our congregation yesterday," an unnamed dissenter told a reporter.[87]

Despite the dissenters' threats to establish a rival congregation, Children of Israel survived unscathed, with at least some expelled members returning to the fold. Three years later, in 1893, the congregation erected its first edifice on Summit Avenue, just south of the Smoky Hollow neighborhood on Youngstown's North Side. Ozer and his coauthors indicate the building "was labeled as 'the Summit Avenue Shule' or 'the Ungarishe [Hungarian] Shule.'" The congregation's founders had indeed included many Hungarian immigrants, but Children of Israel also served "for several years [as] the only place of worship for all [Orthodox] Jews in Youngstown, whether they were Russian, Polish, Roumanian [sic] or Austrian."[88]

While members of the Orthodox Jewish community had disagreements, they were united in their distrust of the standards and practices of the more established Reform community. This became apparent soon after Children of Israel's formation, when members of the congregation questioned the competence of the kosher butchers who served Rodef Sholom. Decades later, founding member Moses Kalver recalled in an interview that "during the early months of the new congregation, the members became dissatisfied with their sources of 'bosor Kosher,' ritually slaughtered kosher meat," and were "forced to import kosher meat from butchers in Cleveland." The situation worsened when members of the congregation hired a self-described shochet who was exposed as a "charlatan." While a competent shochet was soon located, "virtually the whole [Orthodox] community had to re-kasher or dispose of their dishes and utensils, including fine china and heirlooms, something few of them could afford."

Children of Israel's early officers included men who emerged as prominent local leaders, such as Almon "Max" Frankle, Joseph Lustig, H.D. Feldman, Ignatz Schwartz and Max Shagrin. An especially influential member of this group was Max Frankle, whose financial support of the congregation led

Frankle Bros. cigar shop, established in 1884 by Max and Moses Frankle, was a landmark of downtown Youngstown for about a century. When the business closed in the 1980s, the former shop front became the site of the Pig Iron Press, an alternative publishing company. *Courtesy of Mahoning Valley Historical Society.*

some to describe him as "practically [a] sponsor for" Children of Israel.[89] Born in Hungary in 1867, Frankle settled in Youngstown with his parents in 1881. Five years later, in 1884, he formed a partnership with his brother, Moses, and opened Frankle Bros. Tobacco, a landmark business in downtown Youngstown.[90] A longtime president of Children of Israel, Max Frankle was also involved in mainstream fraternal organizations such as the Masons, the Odd Fellows, the Knights of Pythias and the Elks.[91]

Figures like Max Frankle not only suggest the degree to which many Eastern European Jewish immigrants became integrated into the larger community; they also highlight the importance of Jewish business leaders in late nineteenth-century Youngstown. After all, the downtown area in which Frankle Bros. operated was a hub of Jewish commercial activity, and many of those engaged in business emerged as civic leaders.

THE JEWISH PRESENCE IN THE PUBLIC SPHERE

As the nineteenth century came to an end, Youngstown continued to grow. Between 1890 and 1900, the population increased by more than 35 percent, rising from 33,220 to 44,885.[92] Within a few decades, the city had evolved from a dusty village into "a sprawling, somewhat dirty, steel mill town," with "skies shaded from the sun during the day by clouds of smoke from the factory chimneys and lighted at night by the red glow of the molten steel furnaces."[93] Indeed, the 1890s had witnessed a dramatic shift from iron to steel production, following the local introduction of the Bessemer process, a relatively inexpensive procedure involving the removal of impurities from iron through oxidation. In 1899, a group of local investors, including Myron C. and George D. Wick, consolidated three of the region's former iron mills and established the Republic Iron and Steel Company, which "grew quickly by consolidating twenty other iron mills scattered throughout the South and Midwest."[94]

While a few Jewish entrepreneurs were directly involved in the city's industrial expansion, the Jewish community's clearest contribution to the city's development was downtown's glistening retail district, which offered residents products, services and trends associated with larger metropolitan areas. Downtown's premier men's clothing establishment was David Theobald & Company, which continued to operate under Ferdinand Ritter, the firm's senior partner since Theobald's death in 1886.[95] As late as 1893, the *Vindicator* stated that omitting David Theobald & Company from any overview of the local business sector "would be like writing of Italy and failing to mention the Alps."[96] Arguably, though, the city's most innovative retail establishment was the Strouss-Hirshberg Company, which, in 1887, moved to the Wick Building, an elegant structure located a block west of Youngstown's Central Square. By 1893, the department store occupied three floors of the building, which was outfitted with a hydraulic elevator described as the "best between New York and Chicago."[97] Other well-known businesses included Guthman Bros. jewelry and furniture store, initially operated by Elias and Emanuel Guthman;[98] Jonas jewelry shop, founded by German-born William Jonas in the 1860s;[99] and Pollock-Dougherty Company, a tobacco shop established, in part, by Cleveland-born Monroe Pollock.[100] Meanwhile, veteran retailer Samuel Weil had formed a partnership with one-time clerk James Hiney. Thus, the former Weil's Combination Store, at the southeast corner of Hazel and West Federal Streets, became known as Weil & Hiney.[101]

Newcomers to the local business sector included Michael U. Guggenheim, a Tennessee native who acquired a partnership in the clothing establishment

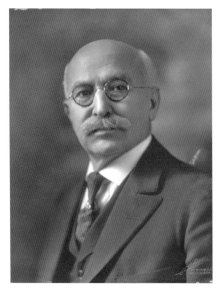 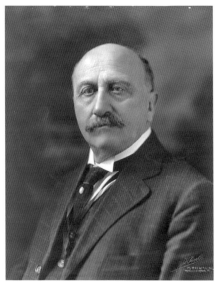

Left: German-born Isaac Strouss arrived in the Mahoning Valley as a teenager. Under the guidance of his cousin David Theobald, Strouss developed the skills that made him the driving force behind the Strouss-Hirshberg Company, one of the area's biggest retail firms. *Courtesy of Mahoning Valley Historical Society.*

Right: Born to a successful German retailer, Bernard Hirshberg brought outstanding accounting skills and an expert knowledge of furs to the partnership of Strouss-Hirshberg Company. *Courtesy of Mahoning Valley Historical Society.*

of Hartzell Bros. Company.[102] After little more than a decade, however, Guggenheim moved on to become a prominent figure in the fields of insurance and real estate.[103] He was soon joined by English-born brothers Michael J. and Meyer Samuels, who migrated from Cleveland and opened Samuels jewelry store, a downtown fixture well into the next century.[104] In 1895, Russian-born brothers Nathan, Louis and Emanuel Ozersky established Ozersky Bros. Bakery, a thriving downtown business that they eventually used to sponsor scores of Russian Jewish immigrants.[105] About four years later, in 1899, Morris and Miles Moyer migrated from eastern Pennsylvania and established Moyer Bros. trousers manufacturing company on West Federal Street, subsequently relocating to a larger facility on Commerce Street as the business developed. Joseph Butler noted that, by 1920, the firm's output was an astonishing "2,500 pairs of trousers weekly."[106]

For Youngstown's Jewish entrepreneurs, involvement in business often served as an entrée into politics and other forms of public service. This pattern is exemplified by the career of Michael Wolff, a successful merchant

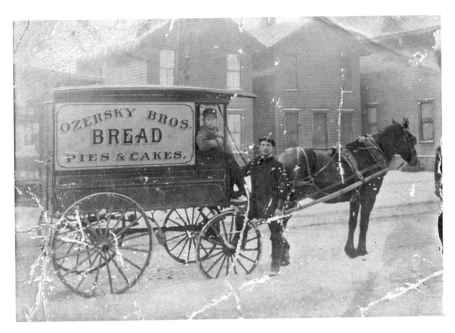

Trained as a baker in Imperial Russia, Louis A. Ozersky founded the Ozersky Bros. Bakery with his brothers Nathan and Emanuel. The bakery provided a foothold to hundreds of Russian Jewish immigrants as they struggled to adapt to their new home. *Courtesy of Mahoning Valley Historical Society.*

who, in 1893, was appointed "tax inquisitor" by Mahoning County treasurer Joseph Schnurrenberger.[107] Wolff was hardly alone. In 1893, after Grover Cleveland's second election as president, Emanuel Guthman, a staunch Democrat and longtime business manager, became deputy county treasurer under the aforementioned Mr. Schnurrenberger.[108] Other business leaders sat on prestigious boards and committees. Retailer Bernard Hirshberg, for example, was a long-standing trustee for Youngstown's Reuben McMillan Library, acted as treasurer of the Mahoning County Tuberculosis Society and served as director of the Youngstown Chamber of Commerce.[109] In some respects, Hirshberg followed in the footsteps of his former employer David Theobald, who, in 1881, served as an incorporator of the Youngstown Hospital Association, a precursor of what eventually became known as the Western Reserve Care System. Notably, the association's sixty-six charter members included Jewish business leaders such as Hirshberg, David T. Jonas, Isaac Strouss and Samuel Weil.[110]

Few of the city's Jewish residents, however, balanced the responsibilities of business, politics and public service as effectively as Emanuel Guthman's younger

brother, Leo. One of the city's most prominent attorneys, Leo Guthman earned a law degree at the University of Virginia in 1883 after gaining experience in Youngstown's business sector. Three years later, in 1886, he suspended his law practice "to take charge of the Theobald interests, upon the death of Mr. Theobald."[111] (This was apparently a temporary situation, as Ferdinand Ritter ultimately took over the retail firm.) Overall, Leo Guthman was best known for his work as a philanthropist and civic leader. A longtime president of the Youngstown Playground Association, Guthman donated the property that became the city's South Side Park, located on a tract of land just east of the main thoroughfare of South Avenue.[112]

In the male-dominated era of the late nineteenth century, women were often relegated to subordinate roles. Societal norms, however, did not prevent some women in the Jewish community from taking an active part in community affairs. Lillie (Mache) Guggenheim, for instance, served as president of the Woman's Board of City Hospital, Youngstown's first public hospital, which opened on the South Side in 1883. She also served on the membership committee of the city's Visiting Nurses Association, while acting as a board member for the Fresh Air Camp, a recreational ground for underprivileged children.[113] Likewise, Betty (Hoechstadter) Weil was a charter member of the Visiting Nurses Association and also dedicated herself to the education of immigrants and the poor. Mrs. Weil "regularly" taught a class at Youngstown's Free Night School for foreigners and served on the board of the city's Lucretia Baldwin Free Kindergarten.[114] These women, along with many of their peers, were involved in the network of specifically Jewish organizations that arose in the late nineteenth century. In many ways, these organizations helped Jewish women—and men—develop the leadership skills that enabled them to make significant contributions to the larger community.

The Rise of Local Jewish Organizations

The growth of secular Jewish organizations in the first few decades of the nineteenth century reflected the Germanic elite's desire to achieve a degree of Jewish unity, despite the weakness of many congregations. As Howard M. Sachar observed, "[T]he number of synagogues had reached one hundred sixty, but the spiritual leadership and educational programs of these congregations were feeble." Furthermore, in communities across the nation, "the sheer range of Jewish philanthropic and fraternal activities outstripped

congregational resources." Perhaps the most popular of the early fraternal societies was B'nai B'rith ("Children of the Covenant"), established in New York City in 1843 by a group of German Jewish retailers who "came up with the notion of an organized Jewish fellowship." Influenced by the Masonic lodges, B'nai B'rith's founders adopted "a florid assortment of Masonic-style regalia, rituals, catechisms, grips, and passwords," while their officers bore "exalted Hebrew titles—Grand Nasi (president), Grand Aleph (vice-president), Grand Sopher (secretary)." As Sachar noted, the organization "evidently struck a responsive chord," and by 1861, "B'nai B'rith lodges were operating in every major Jewish community in America," where they were rapidly "becoming an instrument of acculturation."[115]

This trend toward secularization became more pronounced in the late nineteenth century, belying the fact that "over three hundred Reform temples were operative in thirty-seven of the thirty-eight states of the Union." By the 1880s, the appearance of groups like the Young Men's Hebrew Association (YMHA) reflected a collective impulse to "reinforce Jewish cultural values in secular terms." Drawing upon the example of the Young Men's Christian Association, the YMHA demonstrated the degree to which "Jewish laymen sensed the value of a Christian model for their own young people," while also reflecting the Germanic elite's desire to bring the community into the U.S. mainstream.[116] The final decade of the century witnessed the creation of the National Council of Jewish Women, which "represented a transition from the older Hebrew Ladies Aid Societies, with their emphasis on sewing bees and the collection of clothing for the Jewish needy." Founded in Chicago in 1893, the organization moved "away from social congenialities to such tangible projects as sponsoring settlement houses, educating professional social workers to deal with tenement conditions and delinquent Jewish children, and lobbying…for the establishment of juvenile courts in New York and Chicago."[117]

The first major Jewish secular organization represented in Youngstown was B'nai B'rith, a chapter of which was founded around 1870. While the oldest surviving minutes of a meeting of Mahoning Lodge No. 339 of the Independent Order of B'nai B'rith trace back to May 7, 1902, there is evidence that a local branch was established earlier. Ozer and his coauthors indicated that, as early as 1891, the Youngstown lodge met regularly on the first and third Sundays of each month at Congregation Rodef Sholom.[118] Furthermore, Rabbi Lippman Liebman, in his 1870 letter to *American Israelite*, confirmed the presence of "a good working Lodge of the B.B. numbering between 50 and 60 members.[119] Almost four decades later, General Thomas W. Sanderson noted that Lodge No. 339 was the product of an "amalgamation"

of two local previous chapters, Youngstown Lodge and Herman Rice Lodge. He added that a portion of the organization's membership dues went "to the support of the Hebrew Orphan Asylum in Cleveland, and for the National Home for Consumptives in Denver, Colorado."[120]

The late 1890s witnessed the establishment of yet another popular fraternal organization, the Progress Club. While the organization was largely social, it also sponsored speakers on a wide range of topics. As was the case with the local lodge of B'nai B'rith, the organization's leadership included members of Youngstown's elite, such as Emanuel Hartzell, Max Frankle, Emanuel Mittler and Adolph Louer.[121]

That same year, in April 1896, a local section of the National Council of Jewish Women (NCJW) was organized at the home of Mrs. Betty Weil, the wife of Samuel Weil. Twenty-three women gathered at the home to listen to Mrs. Hugo Rosenberg, president of the Pittsburgh section of the NCJW, as she stressed the need to organize councils in cities around the country to meet the needs of Jewish immigrants from Eastern Europe. About seven months later, in November 1896, two representatives of the Youngstown section, Mrs. Caroline Theobald and Mrs. Betty Weil, attended the NCJW's National Triennial Convention in New York City. Within a few years, the organization would be actively involved in national fundraising campaigns, including an effort to assist U.S. soldiers wounded in the Spanish-American War.[122] At this point, however, the local section of the NCJW gave little indication of the influence it would eventually exert on civic affairs.[123]

Challenges and Opportunities of a New Century

During this period, the Jewish communities of the Greater Youngstown area were more populous and diverse than ever before. Youngstown itself claimed two vibrant congregations, Rodef Sholom and Children of Israel. If the older of the two, Rodef Sholom, experienced challenges in the area of leadership after the 1886 resignation of Rabbi Lippman Liebman, it also boasted an impressive new edifice, which towered above a major intersection on the city's North Side. While the nearby city of Warren lacked a congregation, it benefited from the emergence of Jewish leaders who would lay the groundwork for a largely autonomous community. Indeed, Eastern European Jewish immigrants who arrived in Warren "immediately took steps to establish a common forum

for worship." Ozer and his coauthors observed that the first of these *minyans* took place at the home of Russian-born scrap dealer Jacob Knofsky, "during the High Holidays in the fall of the year." In addition, *yahrzeit minyans* were "held at a given time at someone's home or store to help a member of the community commemorate the passing of a loved one," with services that included the recitation of the *Kaddish* prayer (mourner's prayer).[124]

Across the border, in western Pennsylvania, the city of Sharon also hosted a growing Jewish community. In the late 1860s and early 1870s, a small group of Hungarian Jews from the Cleveland area, led by Jacob Traxler, settled in Sharon and established a number of small businesses. Charles Daus ran a downtown barbershop, Morris Alexander operated a tavern and Nathan Rosenblum became senior partner in a family-owned grocery store. Around this time, another immigrant, Aaron Cohen, opened a downtown boardinghouse "that served as a way station for the young men arriving from across the sea." Cohen not only helped these immigrants get started as peddlers, but he also presided over religious services that were held at a private home on Shenango Street. In the late 1880s, many of those immigrants who settled in Sharon volunteered their time and energy to remodel the house, which became the first edifice of Congregation Beth Israel on August 18, 1888. While the new congregation became a center of Sharon's growing Jewish community, it did not attract everyone. Many established members of the community, including representatives of the Traxler and Printz families, continued to attend Youngstown's Congregation Rodef Sholom, located about fifteen miles away.

By the late 1890s, a small Orthodox community was developing in the newly established town of South Sharon (later renamed Farrell), which had been "laid out alongside the new Buhl Steel Mill on former cow pastures." In the early 1900s, the Eastern European immigrants who settled in the town established Congregation B'nai Zion.[125] Significantly, both of these Pennsylvania communities were oriented toward Youngstown, unlike New Castle, which was more aligned with the Jewish community of neighboring Pittsburgh.

Overall, Jewish communities in the region that eventually became the "Steel Valley" were vibrant. At the same time, as the uneasy relationship between Reform and Orthodox congregations suggests, these communities were in a state of transition. Across the country, the influx of Eastern European immigrants, combined with disturbing events at home and abroad, prompted many to question old assumptions about the nature of Jewish identity.

The Reform movement's emphasis on Judaism as a religion, as opposed to a nationality, was reflected in the discourse of prominent leaders like Cincinnati's Rabbi Isaac Wise, although even he was attached to a concept of Jewishness that

In August 1888, under the leadership of innkeeper Aaron Cohen, a small group of Eastern European immigrants established the first synagogue in Sharon, Pennsylvania, which was located on the second floor of a private home. *Courtesy of Mercer County Historical Society.*

transcended denominational commitments.[126] Other Reform leaders proved more consistent on the subject, linking the persistence of anti-Semitism, in part, to a collective sense of Jewish nationhood that was supposedly becoming redundant. In 1891, eminent attorney A. Leo Weil, of Pittsburgh, in a speech

delivered at Congregation Rodef Sholom, predicted, "With social equality, civil equality and political equality once attained, the Jewish race, as a race, will be run." He went on to forecast that "[n]o trace of Jewish nationality will be left but its history."[127] Such views would not stand the test of time, however. The vicious pogroms in Russia and other parts of Eastern Europe had shaken the confidence of assimilated Jews around the world.

Meanwhile, developments in Western Europe raised questions in the minds of even acculturated Jews. A notable case was that of Theodor Herzl, an Austro-Hungarian journalist who, according to some accounts, was inspired to establish the modern Zionist movement after witnessing the anti-Semitic furor unleashed by France's Dreyfus affair in the 1890s. At the center of the controversy was a French Jewish officer, Alfred Dreyfus, who had been falsely accused of providing secret documents to the Imperial German army. As Peter Kanez observed, "[W]hen attempts were made to demonstrate Dreyfus's innocence, mobs gathered in the streets and angry voices were heard shouting, 'Death to the Jews!'" In the wake of these public outbursts, it was "sobering for Jews to recognize the depth of antisemitic feelings in a large segment of the population."[128] A secular Jew, Herzl nevertheless became convinced of the need for a Jewish state. Moreover, his ideas dovetailed with those of a cultural Zionism already prevalent in much of Eastern Europe. As Howard M. Sachar observed, "It was the influence of Theodor Herzl at the turn of the century, with his dynamic and uncompromising vision of Jewish political sovereignty that re-energized American Jewry's incipient Zionist movement."[129]

Jews on both sides of the Atlantic found it increasingly difficult to ignore the spread of a racialized anti-Semitism inspired by popular interpretations of Darwin's theory of evolution. This strain of anti-Semitism, "with the new scientific racist rationale superimposed on the old religious bigotry, became a significant political force in Germany, Austria and France."[130] In the United States, the rising tide of Jewish immigration from Eastern Europe spurred questions about the Jewish community's "place in the American racial order." The arrival of these immigrants coincided with the migration of tens of thousands of rural dwellers into urban settings, where many of them encountered Jewish populations for the first time. Hence, Jews would become "linked in the popular imagination with many of the disturbing changes Americans were confronting."[131] This combination of trends gradually undermined the assimilationist model of Jewishness promoted by America's Reform leadership. In Youngstown's Jewish community, the spread of Zionist ideas would inspire passionate debate, bitter disagreement and an explosion of institution building.

3

"Strangers in the Land"

On September 6, 1901, the American public was stunned by news that President William McKinley had been gravely wounded by a gunman at the Pan-American Exhibition in Buffalo, New York. News reports indicated a young anarchist approached the president as he greeted the crowd and fired two shots directly into his chest. Buoyed by reports of his imminent recovery, the public was devastated when the president took a turn for the worse and died eight days later, on September 14. Since President McKinley was a native of the Mahoning Valley and maintained long-standing friendships in the community, his death struck area residents especially hard. When news spread that the president had been shot, representatives of local religious organizations gathered to pray for his recovery, and members of Rodef Sholom expressed the congregation's "sympathy to the suffering chief executive and his sorrowing wife."[132]

The tragic death of President McKinley was one of many disconcerting events that occurred within the first few years of the twentieth century. The century was barely three months old when the U.S. Jewish community lost a remarkable leader. On March 26, 1900, eighty-year-old Rabbi Isaac Mayer Wise died of a stroke he had suffered two days earlier while delivering a lecture at Cincinnati's Hebrew Union College.[133] During his long career, Rabbi Wise served as founding president of Hebrew Union College, publisher of the Jewish periodicals *American Israelite* and *Die Deborah* and chief architect of Reform Judaism in the Americas. Given the overwhelming response to Rabbi Wise's death, his family permitted his body to lie in state

at Cincinnati's Plum Street Temple, where at least ten thousand mourners passed the funeral bier.[134] In Youngstown, older members of Congregation Rodef Sholom almost certainly recalled Rabbi Wise's invitation to send delegates to the historic 1873 conference that led to the establishment of the Union of American Hebrew Congregations.

On the heels of these developments, Jews across the country were dismayed to learn of more violence in Imperial Russia, where anti-Semitic policies continued to inspire bloodshed. In April 1903, Kishinev, the capital of the czarist province of Bessarabia (in the modern-day Republic of Moldova), was home to over 125,000 residents, almost half of them Jewish. Riots that began on Easter Sunday claimed the lives of 49 Jews, while 500 were wounded. Ultimately, 1,300 homes and businesses were looted and destroyed, and 2,000 families were left homeless.

The Kishinev pogrom and its aftermath had far-reaching consequences. In the United States, the violence led Jewish leaders to discuss the formation of an organization to protect "the rights of their brethren in other countries." Three years later, in 1906, a group called the American Jewish Committee was established by such prominent figures as Oscar Straus, Jacob Schiff, Cyrus Sulzberger, Louis Marshall and Cyrus Adler, to name a few.[135] Meanwhile, news of the riots galvanized U.S. Jewish leaders' support for the rising number of Eastern European immigrants. Anxiety aroused by the Kishinev pogrom deepened on July 3, 1904, with the reported death of Theodor Herzl, founder and guiding light of modern Zionism. Herzl's sudden demise at the age of forty-four was devastating to world Judaism on a number of levels. Apart from Herzl's role as an inspirational figure, he also provided the kind of steady leadership that prevented the global Zionist movement from fragmenting along ethnic and religious lines.

Signs of Progress in an Era of Uncertainty

While the new century had opened with a series of unsettling events, Jewish residents of the Mahoning Valley nevertheless had reasons to be optimistic. Over the past three decades, the combined populations of Mahoning, Trumbull and Mercer Counties had increased by a staggering 45 percent, rising from 119,637 in 1870 to 174,112 in 1900. The engine of the region's growth was the city of Youngstown, whose population alone jumped from 8,075 in 1870 to an astonishing 44,885 in 1900. The *Encyclopedia Americana*

William Wilkoff and brother Samuel established one of the region's largest scrap operations in Youngstown in the late 1880s. This undated photograph shows one of the company's billboards against the backdrop of Youngstown Sheet and Tube Company—a firm that William Wilkoff helped to organize in 1900. *Courtesy of Mahoning Valley Historical Society.*

noted that, by 1900, 27 percent of the city's population was foreign-born, while 41 percent was "of foreign parentage."[136] Many new arrivals were drawn by the area's burgeoning iron and steel industry. The organization of Republic Iron and Steel Company in 1899 was followed in 1900 by the creation of Youngstown Iron Sheet and Tube Company (later known as Youngstown Sheet and Tube Company), which soon emerged as the fifth-largest steel producer in the nation.[137] Two of the new firm's incorporators were native-born businessmen Henry Wick and James Campbell, who had been involved in Republic Iron and Steel Company. However, a third, and crucial, player in Youngstown Sheet and Tube's organization was Lithuanian-born scrap dealer William Wilkoff, whose personal history echoed the pattern of the era's popular "rags-to-riches" stories.

Born in 1864, in modern-day Vilna (Vilnius), Lithuania, then part of Imperial Russia, William Wilkoff had immigrated to the United States at

the age of seventeen. After taking a job with a railroad crew, Wilkoff saved a portion of his wages to purchase "a small stock of merchandise," which enabled him to work as a peddler in the Pittsburgh area. Wilkoff went on to work as an independent junk dealer in nearby Beaver Falls, Pennsylvania, expanding "his equipment to a single horse and wagon." Then, in 1888, he formed a partnership with his brother, Samuel, and the pair emerged as successful wholesale junk dealers in Akron, Ohio. The Wilkoffs, aware of opportunities related to the steel industry in nearby Youngstown, established a new business on a spot located just west of the city's downtown.[138] Since steel production depended heavily on the availability of scrap metal, their enterprise flourished.[139] In 1900, William Wilkoff caught the attention of Wick and Campbell, who were concerned about the dominating presence of the newly established U.S. Steel Corporation; the three men agreed "to form a corporation to manufacture steel pipe and sheets"—hence the name, Youngstown Sheet and Tube Company.[140]

The Wilkoff brothers were not the only Jewish immigrants to contribute to Youngstown's industrial development during this period. In 1903, German-born brothers Julius, Gustave and Albert Kahn organized the Trussed Concrete Steel Company "in a small shed…with a dozen employees." Popularly—and, later, officially—known as Truscon Steel, the company became an industrial landmark of the city's East Side. The educated sons of a rabbi, the Kahn brothers followed a different path than that of the Wilkoff brothers. After the Kahn family's immigration from Bad Munstereifel, Germany, in the late nineteenth century, they eventually settled in Detroit. Julius Kahn secured work as an engineer, and the concept of reinforced concrete occurred to him in the early 1900s while he was supervising the construction of the National War College, in Washington, D.C. After discussing the idea of reinforced concrete with his brothers, Gustave and Albert, it was agreed that the Kahns would manufacture their new product in Detroit. Their subsequent decision to move to Youngstown was based on the availability of high-quality steel there, as well as the fact that the fledgling company "would save freight rates on raw material." Truscon Steel remained one of the area's top manufacturing firms until its merger with Republic Steel decades later.[141] Meanwhile, Albert Kahn established a national reputation as an architect, designing Detroit landmarks such as the Ford Motor Company's Highland Park Plant and the Fisher Building. Two of the buildings he designed in Youngstown—the Stambaugh Building and Mahoning National Bank Building (now Huntington)—remain downtown landmarks.

This 1906 Lustig Bros. Shoes advertisement was published six years after the firm's establishment by Joseph and Max Lustig. In 1900, after pursuing other retail ventures, the Lustig brothers purchased the former Turner-Cornelius shoe store in downtown Youngstown. When Max died, Joseph Lustig bought his interest in the business for his son, Bertram. *Courtesy of Mahoning Valley Historical Society.*

While relatively few of Youngstown's Jewish residents were directly involved in the steel industry, all recognized that their fortunes were tied to the city's prosperity. As the century progressed, downtown's retail district continued to expand, and Jewish immigrants created more than a few businesses that emerged as local icons. In 1900, for instance, Austro-Hungarian immigrants Joseph and Max Lustig purchased an old storefront on West Federal Street and opened Lustig Bros. Shoe Store. Under the energetic leadership of Joseph Lustig, the business grew into one of the most popular of its kind in the area.[142] Then, in 1915, former grocer Charles Livingston established a partnership with sons George and Lester and opened Livingston's, a women's ready-to-wear shop that

soon became known as "the place which had all of the latest styles."[143] Other Jewish businessmen, such as Clarence Strouss, son of retailer Isaac Strouss, emerged as prominent civic leaders.[144]

Institution Building in the New Century

Meanwhile, the pattern of organizational development that began at the turn of the century continued into the next decade. In March 1907, the Mahoning Valley's Federated Jewish Charities was formed as an umbrella organization whose constituent members included the Council of Jewish Women, the Men's Hebrew Charity of B'nai B'rith, the Ladies' Hebrew Benevolent Society of Congregation Rodef Sholom and the Ladies' Aid Society of Children of Israel Congregation. Spearheaded by Mrs. Morris Moyer, president of the Council of Jewish Women, the new organization followed the federation model, in which each society had three representatives who elected their own officers to conduct organizational business. This collective system reduced duplication of efforts and conserved resources. One of the organization's major concerns was the provision of food, shelter and employment to the "deserving poor."[145] That same year, local students benefited from the formation of the Youngstown Education League, an organization that maintained a fund to provide interest-free loans to young Jewish scholars of limited means. As Dora Brown noted, "[T]here were no hard and fast rules" concerning the repayment of loans, "though the applicant usually begins to make return soon after he is in a position to do so."[146]

By the early 1900s, the pervasive influence of Theodor Herzl was reflected in the establishment of a local network of Zionist organizations. As early as May 1894, more than a dozen men gathered at the home of Louis Ozersky to discuss the movement. Afterward, plans were presented to Myer Altshuler to organize a Zion Society, and the attendants agreed to call the group Degel Zion, Hebrew for "Banner of Zion." Over the next few years, Degel Zion attracted well-known speakers from around the country, including Cyrus Sulzberger and Jacob De Haas, who served, respectively, as vice president and secretary of the Federation of American Zionists. Other visiting luminaries included Rabbi Saul Silber of Columbus, L.H. Miller and L. Hollander of Buffalo, Rabbi A.M. Ashinsky of Pittsburgh and Rabbi Samuel Margolies of Cleveland. Since the membership of Degel Zion was restricted to men, a movement began among wives of members to organize

a women's group. In November 1906, a meeting to establish the Ladies Zion Society was held at the Zion Institute, an organization that occupied three floors of a building in the city's downtown. Within a few years, the Ladies Zion Society had a membership of over forty and secured affiliation with the Federation of American Zionists.

Degel Zion proved to be the first of many Zionist organizations established in the area. Less than a decade later, on May 24, 1908, the opening of the Youngstown Hebrew Institute (YHI) was marked with a ceremony at Children of Israel Congregation. The new institute opened its doors on East Rayen Avenue, not far from the Orthodox synagogue, on land purchased by businessman Max Frankle. Drawing financial support from donations and members' monthly contributions, the institute recruited eighty-five pupils ranging in age from six to fourteen, who attended classes five days a week.[147] It was overseen by a board of education composed of civic and business leaders and benefited from the support of the Ladies Auxiliary of the YHI, which helped to provide students with school supplies.[148] Notably, the institute's building served as

Youngstown-area delegates to a Zionist convention in Pittsburgh, Pennsylvania, pose outside of the main office of the H.J. Heinz Company in July 1910. Earlier, the group toured the company's manufacturing plant. *Courtesy of Mahoning Valley Historical Society.*

the de facto headquarters for almost a dozen organizations, ranging from literary clubs to social-service groups.[149]

Surprisingly, it took several years before a significant number of young Jewish men and women in the Mahoning Valley became involved in the Zionist movement. On October 13, 1907, a meeting held at the Zion Institute led to the formation of Sons and Daughters of Zion. The new group held weekly classes for foreign-born young people; created a reading room with English, Hebrew and Yiddish books; and contributed money to Zionist causes abroad.[150] Almost five years later, on July 21, 1912, another youth-oriented organization, the Young Men's Hebrew Association, opened its headquarters to the public. Organized months earlier, the social club boasted 150 members, and its building on West Federal Street included a library, a reading room, a swimming pool, a billiard room and a gymnasium with lockers and showers. YMHA representatives announced that their association was well equipped to provide opportunities for education, social interaction, social service and athletic activity.[151]

DEVELOPMENT OF RELIGIOUS INSTITUTIONS

The rise of secular and Zionist organizations in the early twentieth century was paralleled by the growth of religious institutions. Some congregations developed smoothly, while others experienced conflict related to leadership and other issues. Evidence of such tension arose in the spring of 1912, when a schism developed in a heavily Lithuanian Orthodox community on Youngstown's East Side. Since the 1890s, the district had hosted a congregation known as Shaarei Torah that served about 150 families.[152] Later headed by local Jewish leader Tevila Cohen, Shaarei Torah had functioned informally for at least a decade, holding services at private homes. As the community grew, however, a house on South Hine Street was turned into a makeshift synagogue, while land in nearby Cornersburg was purchased for a cemetery. By 1912, a splinter group led by Samuel Levy and Harry Friedman had established its own congregation, which they called Shaarei Torah Anshe Chessid Shel Emes.[153] After purchasing the former site of Second United Presbyterian Church on Himrod Avenue, the dissenters remodeled the structure to function as a synagogue. Drawing large numbers of Orthodox Lithuanians and Hungarians, the new congregation became popularly known as Big Shaarei Torah, while the original congregation,

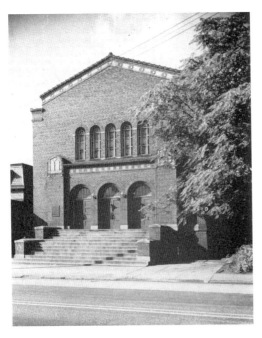

The first edifice of Temple Emanu-El, dedicated in 1912, was noted for its elegant brick and limestone façade and stained-glass windows. Located on East Rayen Avenue, the building later served as the site of St. Andrew's AME Church. *Courtesy of Mahoning Valley Historical Society.*

Little Shaarei Torah, slowly disintegrated. The old congregation's failure, as one East Side resident stated, resulted from "membership loss...poor management and internal bickering." Just over a decade later, Little Shaarei Torah effectively disappeared.

In May 1912, around the time Little Shaarei Torah was battling for survival, the congregation of Emanu-El ("God Be with Us") dedicated its first edifice on East Rayen Avenue. Organized in 1906 under the leadership of Nathan Ozersky,[154] the congregation was described as "a lofty spirit seeking its proper establishment."[155] For the Eastern European immigrants who organized Emanu-El, a major priority was the religious education of their children. Five years earlier, in 1907, its congregants played a key role in the development of the Youngstown Hebrew Institute.[156] Moreover, the congregation's spiritual leader, former Columbus resident Rabbi Saul Silber, acted as dean of the institution. (Rabbi Silber went on to serve as founding president of Chicago's Hebrew Theological College.) The dedication ceremony for Emanu-El's new brick temple featured speeches by Conservative leader Rabbi Louis Wolsey, Cleveland's Rabbi Samuel Margolies and Youngstown mayor Fred A. Hartenstein.[157]

That same month, Congregation Rodef Sholom, under Rabbi Louis Grossman, purchased 2.5 acres of land in Tod Memorial Cemetery, on Youngstown's North Side. The land comprised about 275 lots, most of which were large enough to accommodate eight to ten graves.[158] At that time, Rabbi Grossman arranged for the transfer of remains from the congregation's former cemetery in Brier Hill. The burial ground's dedication on January 26, 1913, drew more than one hundred congregants. The well-publicized ceremony was

officiated by Rabbi Grossman, who was assisted by Akron-based Rabbi Isadore E. Philo.[159] Interestingly, nine months later, on September 28, 1913, Rabbi Philo would be installed as the new spiritual leader of Rodef Sholom, a development that coincided with a period of rapid expansion. Tall and imposing, with a deep, sonorous voice, he held a doctorate in philosophy as well as a law degree. Rabbi Philo could speak with authority on a wide range of topics, and one regional newspaper described him as "an orator of rare ability," whose audiences routinely "burst forth in spirited applause."[160]

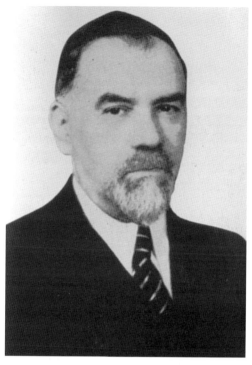

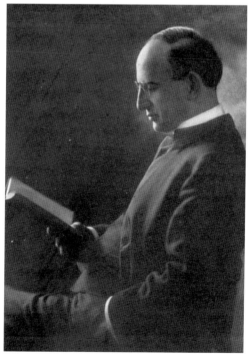

Top: The first spiritual leader of Emanu-El congregation, Rabbi Saul Silber, also served as dean of the Youngstown Hebrew Institute, which the congregation had established. A renowned scholar, he became founding president of Chicago's Hebrew Theological College in 1922. *Courtesy of Mahoning Valley Historical Society.*

Right: Welsh-born Rabbi Isadore E. Philo, longtime spiritual leader of Rodef Sholom, enjoyed a national reputation as a speaker and writer. In May 1928, he debated activist lawyer Clarence Darrow at Youngstown's Stambaugh Auditorium. Initially opposed to Zionism, Rabbi Philo reevaluated his position after learning of Nazi atrocities against European Jews. *Courtesy of Mahoning Valley Historical Society.*

Shortly after Rabbi Philo's arrival, the congregation's officers approached him about the need for a larger building, indicating that even the auditorium and vestry room failed to hold the membership.[161] In January 1913, the congregation took its first step toward this goal by organizing a fundraising dinner at the Progress Club, which raised $25,000 for the project. The congregation's president, Max E. Brunswick, then appointed a five-member committee to select a site for the new temple. The committee suggested a lot on the corner of Elm Street and Woodbine Avenue, in a semi-suburban area of the city's North Side. After the recommendation's approval and the land's purchase, Brunswick appointed a building committee that included some of the congregation's most prominent members. On the morning of April 17, 1914, members of Congregation Rodef Sholom, led by Rabbi Philo, broke ground on the site of their new synagogue. Several months later, on August 2, 1914, another ceremony marked the laying of the cornerstone, an event that drew Jewish leaders from around the state.

Less than a year later, on June 11, 1915, the congregation hosted a four-day dedication event that drew state and national Jewish leaders, including Rodef Sholom's former spiritual leader, Rabbi Louis Grossman, then serving as president of the Ohio Rabbinical Association. The most prominent guest at the event was New York's Rabbi Stephen Wise, a

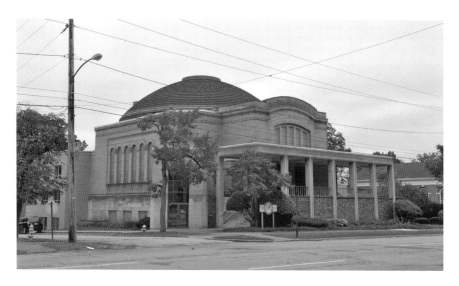

Upon its completion in June 1915, the second edifice of Congregation Rodef Sholom featured the largest dome in the state of Ohio. Regarded as one of the most beautiful temples in the country, the building remains a landmark of Youngstown's North Side. *Courtesy of Mahoning Valley Historical Society.*

national Reform leader, who delivered the keynote speech at a reception to launch the event.[162] Designed by the local architectural firm of Stanley and Scheibel, the building had been envisioned as a community center, as well as a house of worship. The complex stretched 68 feet along Elm Street and measured 121 feet in depth. Its main structure, composed of gray Darlington brick, sat on a gleaming base of Indiana limestone, complemented by the limestone steps of the main entrance. The new temple's most striking feature was a dome spanning 65 feet, covered with red, semi-glazed German tile and topped with a copper crown. The *Vindicator* indicated no dome within the city was comparable, as it was regarded as the largest in the state of Ohio.[163] Congregation president Max Brunswick congratulated a building committee that had included such notable figures as Michael Guggenheim, Emanuel Hartzell, Philip Karjan, Otto Kaufman, Charles Levy, Michael Livingstone, Louis L. Rice, Michael J. Samuels and Clarence J. Strouss.

THE PROSPECT OF WAR

As the congregants of Rodef Sholom anticipated the completion of their new synagogue, reports of an imminent European conflict dominated local headlines. Given the community's ethnic diversity, scores of local residents had family members who were caught up in the war that broke out in August 1914. Indeed, some area residents found themselves trapped in Europe during routine visits with relatives. On August 24, 1914, local residents learned of the narrow escape of businessman Abe Sauber, who was visiting relatives in Hungary when the war began. Anxious to return home, Sauber tried to board a train in Budapest, only to learn that railway transportation was reserved for the mobilization of troops. "With characteristic aplomb," Sauber put aside his passports and "informed the guards he was a soldier." He maintained this pose until the train reached Germany, where "he found it useful to produce his passports."[164] While Sauber returned safely to Youngstown, another local businessman, Jacob Eigner, was less fortunate. The twenty-five-year-old Austrian native had been visiting his mother in Europe when Austria-Hungary declared war against Serbia. The *Youngstown Telegram* reported that Eigner "was called upon for military service, against which he protested because of his being an American citizen." Forced into the army, Eigner refused to "bear arms," at which point he was court-martialed and executed.[165]

As the war continued into the fall and winter, members of the local Jewish community became increasingly concerned about conditions for European Jews. In December 1914, a mass meeting was called for "a direct appeal for aid to the starving people of the fatherlands." Spearheaded by Rabbi Philo and congregants of Rodef Sholom, the initiative drew support from regional Jewish leaders, including Rabbi L. Davidson of Children of Israel and Rabbi Samuel Margolies of Cleveland. Then, in January 1916, the regional Jewish community received disturbing news from the American Jewish Committee, a group dedicated to protecting overseas Jewish populations. Referring to documents from various sources, the committee concluded that the seven million Jews in the eastern war zone had been targeted by troops on both sides of the conflict. In an eerie foreshadowing of events that occurred less than two decades later, the committee noted that "hundreds of thousands were…being packed…in sealed freight cars, shuttled from town to town, side tracked for days without food or help of any kind."[166]

In response to such reports, President Woodrow Wilson proclaimed January 27, 1916, as National Jewish Relief Day. Soon after, religious and civic leaders across the Mahoning Valley urged the public to support the cause. Youngstown mayor Carroll Thornton, joined by local religious leaders, participated in a rally that included appeals for financial assistance. To help meet the national goal of $10 million, the local Jewish community pledged to raise $10,000, while local leader Otto Kaufman accepted the role of campaign chairman.

By this time, the United States' tortured neutrality was unraveling. Less than three months later, on April 2, 1917, President Wilson went before a joint session of the U.S. Congress to request a declaration of war against Germany. The president's reasons included Germany's violation of its pledge to suspend unrestricted submarine warfare in the North Atlantic and the Mediterranean, as well as its attempts to form an alliance with Mexico against the United States. On April 4, 1917, the U.S. Senate voted to support the measure, and the U.S. House concurred two days later. These developments led some critics of U.S. involvement to reevaluate their positions. Several months later, in June 1917, Rabbi Isadore Philo served as guest speaker at an annual Flag Day event at an Elks lodge in Mansfield, Ohio. A long-standing pacifist, Rabbi Philo described the evolution of his attitude toward the war. Acknowledging that he once dismissed it as another "old world feud," Rabbi Philo added that a series of events led him to reinterpret it "not as a world war, but a war for the world."[167]

WARTIME DEVELOPMENTS IN WARREN

In September 1918, about two months before the end of hostilities in Europe, the Orthodox Jewish community of nearby Warren dedicated the first edifice of Temple Beth Israel, which stood on First Street, on a plot donated by Mr. and Mrs. Jacob Knofsky. Led by spiritual leader Rabbi S. Greenstein, the congregation "quietly dedicated its synagogue amid news flashes of Allies gaining on all fronts, pleas for purchase of Liberty Loan Bonds, and the lament of the toll taken by influenza."[168] Until then, Temple Beth Israel's twenty-five families had worshipped in private homes or in a rented hall above Warren's Union Savings & Trust Company.

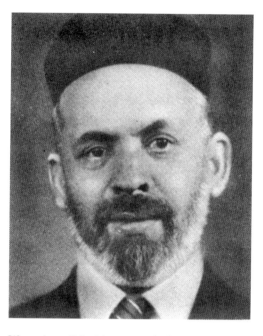

Warren's small Jewish community benefited from the spiritual leadership of Rabbi S. Greenstein. In September 1918, Rabbi Greenstein presided over the dedication of Beth Israel congregation's first edifice. *Courtesy of Mahoning Valley Historical Society.*

Led by the congregation's first president, Max E. White, a fundraising committee including Herman Wolkoff and Jack Kaskar raised money for the building.[169] They received considerable help from Mr. and Mrs. Knofsky, who, apart from donating land for the project, offered $2,500 toward the synagogue's construction.

Beth Israel was the centerpiece of a growing Orthodox community that was largely made up of immigrants from Russia, Poland, Lithuania, Romania and Hungary. The new temple was strategically located near the shop of Lithuanian immigrant Solomon Shultz, a kosher butcher who also served as the community's *shochet*. Shultz was among the congregation's fifteen charter members along with Jacob Knofsky, Max White, Gary Fierer, Harry Frank, Herman Wolkoff, Louis Taub, Sam Union and Abraham Goodman. By the time of Beth Israel's dedication, some members of the congregation had risen to prominence in the Warren area. Local Jewish business leaders included Russian-born Jacob

Given Solomon Shultz's role as a schochet, the Shultz family played a vital part in the organization of Warren's Jewish community. This 1927 photograph shows Louis B. Shultz, Max Shultz and Samuel "Tony" Shultz (*left to right, standing*), as well as Sophia Bellin Shultz, Hannah Weiner Shultz and Solomon Shultz (*left to right, seated*). *Courtesy of Mahoning Valley Historical Society.*

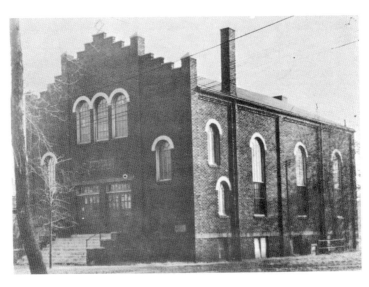

The construction of the city's first synagogue in 1918 was a milestone for Warren's Jewish community. Previously, religious services were conducted in private homes. The congregation of Beth Israel was officially incorporated in 1919. *Courtesy of Mahoning Valley Historical Society.*

Knofsky, who began his professional career as a "ragman," buying and selling rags door to door, and rose to become one of the city's major scrap-iron dealers. Another notable member of Beth Israel was President Max White, who worked as an agent for one of the city's major car dealerships.[170] While Warren's Jewish community had developed more slowly than that of Youngstown, it quickly assumed a distinct identity.

THE CHILDREN OF ISRAEL-ANSHE EMETH SPLIT

With the war's conclusion in November 1918, local disagreements within the Jewish community that had been overshadowed by the conflict came to the forefront. In Youngstown, a long-standing rift in the Orthodox congregation of Children of Israel culminated in a public rupture that threatened the community's integrity. A major area of disagreement among congregants was the direction of Children of Israel's religious education program. While after-school classes for about fifty students were previously held at the North Side's Elm Street Elementary School, some congregational leaders encouraged members to enroll their children at the Youngstown Hebrew Institute, a move that led others to question whether the congregation could afford to maintain a separate school.

Education was not the only issue that divided congregants, however. Many also disagreed over certain religious practices, especially *mechitza*, the physical separation of male and female worshippers during services. Some members argued the practice was an ethnic tradition with no foundation in religious texts and called for its abolishment. Others treated it as a fundamental aspect of religious observance and resented any talk of its elimination. By this time, the Conservative Movement had gained a following among U.S. Jews who sought an alternative to the strict traditionalism of Orthodox Judaism and the assimilationist tendencies of the Reform Movement. The U.S. religious movement had been inspired by the nineteenth-century European Historical school of Judaism, which arose in response to the wave of assimilation that swept Western European Jewry after the Enlightenment. Like the Conservative Movement, the Historical school of Judaism had "sought to stem that tide by applying new, historical methods to the study of the Jewish tradition within the contexts of traditional Jewish practices and a commitment to Jewish nationhood."[171]

Disagreements over education and religious practice among congregants of Children of Israel were exacerbated by debates regarding the synagogue's location. Many congregants had migrated to the city's upper North Side, with its elegant homes and spacious parks, even as the neighborhood around the Summit Street Temple deteriorated. Hence, disagreements over Children of Israel's location pitted upwardly mobile congregants against those who remained in the "old neighborhood." On October 1, 1919, a group of former Children of Israel congregants announced they would form a new congregation "orthodox in ritual, but conservative in nature." Leaders of this group included Mr. and Mrs. Max Fish, Mr. and Mrs. Max Frankle, Mr. and Mrs. J. Schwartz, Mr. and Mrs. David Rand, Alex Friedman, J.D. Feldman, Joseph Shagrin and Philip Isenberg. Five days later, on October 6, an application for a charter was submitted, and on October 12, the members agreed upon the name Anshe Emeth ("Men of Truth"). After consulting Rabbi Solomon Goldman of Cleveland, a major force in the national Conservative Movement, the leaders of Anshe Emeth applied for a state charter. Several months later, an option was taken on a lot at the intersection of Elm Street and Park Avenue, and it was purchased for $15,750.[172] Soon after, Max Fish, leader of the splinter group, was elected as the first president of Anshe Emeth congregation.

POSTWAR ANGST AND RISING INTOLERANCE

The aftermath of World War I produced new challenges, at home and abroad. While President Wilson framed the conflict as a war that would "make the world safe for democracy," his idealism was no match for the political realities of the era. The president's perceived refusal to compromise with Republican leaders guaranteed that he would fail in his bid to secure the U.S. Senate's approval for the terms of the Treaty of Versailles, along with American involvement in the League of Nations, a body intended to discourage prewar nationalism in favor of a new focus on collective security. Meanwhile, the inconsistency President Wilson showed in his support for the self-determination of subject peoples earned him the antagonism of influential ethnic groups within the United States.

If the war facilitated the destruction of long-standing empires in Central and Eastern Europe, as well as the Near East, it was also true

that the U.S. government now "confronted a hostile Bolshevik regime, a Japanese government determined to assert power in East Asia, and the growing resentment of Latin America toward the United States."[173] Moreover, in the wake of Kaiser Wilhelm's abdication and exile, the Allies' decision to exclude Germany's Weimar government from negotiations at Versailles only exacerbated German resentment over the terms of the treaty. Meanwhile, postwar Europe's economic recovery was stalled by the U.S. government's rigid refusal to forgive debts and its maintenance of high tariffs on European imports.

At home, the U.S. public was divided on constitutional amendments providing for women's suffrage and the prohibition of alcoholic beverages. Adding to this discord was intense labor strife and public paranoia concerning Russia's Bolshevik regime, which was encouraged by a government-led "Red Scare" that culminated in the deportation of thousands. The fault lines that emerged in the wake of the war deepened as a result of the short depression that swept the economy in the early 1920s. By this time, the Republicans had regained power, with President Warren G. Harding entering the White House on a platform promising "normalcy." Yet, as David G. Goldberg observed, "Only with the return of prosperity and the election of Calvin Coolidge did American politics return to the 'normalcy' promised by Warren Harding in 1920."[174]

During this tumultuous era, public perceptions of the U.S. Jewish community continued to evolve in disturbing ways. While prewar discourse on American Jews expressed optimism that they would be fully integrated into mainstream society, "[W]hite Americans in the interwar period were increasingly concerned that Jews represented a distinct 'problem' in American life."[175] All of these trends would inform the development of the Youngstown area's Jewish community in the years leading up to the Second World War.

4
Between the Wars

On a balmy evening in June 1921, Dr. Chaim Weizmann, president of the World Zionist Association, surveyed the capacity crowd at downtown Youngstown's Hippodrome Theater. "Zionism is no mere dream of home-loving Jews," he announced from the stage. "Zionism is already a reality." Dr. Weizmann continued in a quiet, almost professorial style, describing plans to build a Jewish homeland in Palestine as "natural and simple." Dr. Weizmann's optimism was echoed in a keynote speech by Dr. Schmaryn Levin, a resident of Palestine who had previously served as one of a handful of Jewish deputies in the Duma, Imperial Russia's short-lived parliament. Dr. Levin's speech, delivered in Yiddish, generated so much emotion that "women in the audience threw their jewelry on the stage." Among the items strewn before the speaker was a small gold watch belonging to a sixteen-year-old girl who had died during the Spanish flu epidemic. The deceased girl's father explained that she had "worked unceasingly for the Zionist movement," and the watch was "her last contribution."[176]

Zionist leaders like Dr. Weizmann had reason to be confident. Less than a year earlier, in April 1920, the Allied Powers participated in a conference at San Remo, Italy, where England, France, Italy and Japan (with the United States present as an observer) agreed on a resolution that divided the former Ottoman Empire into three territories: Iraq, Syria and Palestine. The resolution determined that Syria would fall under France's control, while Great Britain would oversee Iraq and Palestine. A key element of the resolution was the 1917 Balfour Declaration, which called for "the

establishment in Palestine of a national home for the Jewish people." The declaration's implications were so dramatic that one British diplomat, Lord Curzon, called it Israel's "Magna Carta."[177]

When news of the resolution reached the Mahoning Valley, Jewish leaders hailed it as a triumph for Zionism and laid plans to mark the event. The largest celebration occurred on June 3, 1920, when almost two thousand Jewish residents of the region attended a meeting at Youngstown's Park Theater, after participating in a parade through the city's downtown. Speakers at the event included local rabbis and civic leaders, such as Youngstown mayor Fred Warnock, who pledged his support to the Jewish cause, stating, "My sympathy, my hopes, and prayers are with you in your desire to return to the land of your fathers."[178] Two years later, in July 1922, the British Mandate of Palestine was formally ratified by the League of Nations. Zionist leaders from across the Mahoning Valley celebrated, hailing the reclamation of Jewish Palestine as "the greatest event in two thousand years of Jewish history."[179]

Rising Anti-Semitism in the Postwar Era

The euphoria many American Jews experienced upon hearing of developments in Palestine was mixed with a new sense of urgency, as they became increasingly aware of the hostility of some of their neighbors. The supportive words uttered by Youngstown's Mayor Warnock in 1920, on the event of the Balfour Declaration, may have struck some of his Jewish listeners as exceptionally tolerant, given that a rising number of public figures expressed less friendly sentiments. Indeed, anti-Semitism in the United States would reach its peak in the 1920s and 1930s. Youngstown native Helen Shagrin recalled that, in the 1920s, local Jews often avoided commenting on issues like religion and nationality when they applied for employment. "One of my very good friends even had to deny her Judaism to get a job," said Shagrin. "She had to absolutely never refer to anything Jewish where she worked."[180]

Anti-Jewish paranoia was among factors that contributed to the U.S. Congress's passage of the Immigration Act of 1924, which severely limited immigration from Eastern European nations with sizable Jewish populations. The Bolshevik Revolution and subsequent anti-communist "Red Scare" had deepened anti-Semitic attitudes, since many Americans associated Jews with the emergence of communism.[181] While nativist sentiment in the North

fueled the regional expansion of the Ku Klux Klan, readers throughout the country were exposed to anti-Semitic tracts such as the nineteenth-century forgery *The Protocols of the Elders of Zion* and Henry Ford's four-volume publication, *The International Jew*, released between 1920 and 1922.

For local Jewish residents, Ford's book was especially disturbing, because it specifically referenced the Mahoning Valley. In December 1919, a proposal was made to Youngstown's Board of Education to remove Shakespeare's *The Merchant of Venice* from the standard curriculum due to the play's negative portrayal of a Jewish character, Shylock. Agreeing with the proposal, the school board subsequently passed the measure. Though seemingly innocuous at the time, the decision was picked up by regional, then national, news outlets. Eventually, the story landed on the desk of Henry Ford in Detroit. When *The International Jew* was published, Ford cited the Youngstown school board's decision as evidence of a Jewish conspiracy to undermine the U.S. educational system.[182] Outraged, local Jewish leaders gathered at Rodef Sholom to protest Ford's anti-Semitic attacks in January 1921. Accusing the industrialist of spreading malicious propaganda, Rabbi Philo blasted Ford for being "a tool of the remaining reactionaries of Europe" and warned Christians that "[t]o remain silent at this time is to lend aid and comfort to the enemies of religion…to continue silently is to consent to this murderous plan to crucify a whole people."[183]

Growing Relief Efforts for European Jewry

Anti-Semitism was even more prevalent across the Atlantic, where the disruptions of the war and the rise of a communist regime in Russia had sharpened long-standing ethnic, religious and ideological divisions. Amid reports of worsening conditions for European Jews, the local Jewish community channeled more of its resources into programs to assist beleaguered overseas populations. A strong emphasis was placed on the Kingdom of Hungary, one of the successor states to Austro-Hungary, then embroiled in a series of social, political and economic crises.

Over a period of several decades, Jews of Hungarian descent had emerged as a sizable and influential group in the Mahoning Valley, and they were deeply aware of the plight of their former compatriots. In January 1922, eighty-five prominent citizens, mostly Jews of Hungarian descent, assembled in the Youngstown offices of Frankle Bros. cigar shop to organize a

campaign to support Jewish culture and charitable institutions in Hungary. The meeting marked the birth of the American Hungarian Jewish Relief Committee. The newly formed organization, led by committee chairman Joseph Friedman, forged an alliance with a similar organization in New York City that was overseen by leaders such as Dr. Elijah Adler, chief rabbi of Hungary; Dr. Francis Szekely, president of the Budapest Jewish community; and William Grosshandler, the brother of Youngstown businessman Nathan Grosshandler.[184]

The organization of the American Hungarian Jewish Relief Committee was not the only reflection of the local Jewish community's growing sensitivity to developments in Europe. In April 1926, the Mahoning Valley's Jewish community participated in what would be the largest philanthropic event in Jewish American history. To meet a national goal of $15 million, Jews from every local temple, society and organization committed to raise $75,000 for the United Jewish Campaign for European Relief.[185] The campaign was endorsed by every local congregation, while each Reform and Orthodox rabbi urged his congregants to support the cause. After a rousing speech by Rabbi Philo, a volunteer team of over one hundred members was assembled. Women were especially interested in the campaign and constituted a large percentage of volunteers.[186] Largely due to their efforts, the $75,000 commitment was reached in just a few weeks.

THE RISE AND EXPANSION OF CONGREGATIONS

Fundraising campaigns for local projects were also enormously successful, and the 1920s witnessed the rise of new religious institutions, as well as the expansion of others. In September 1922, the region's newest congregation, Anshe Emeth, celebrated the opening of its new synagogue, which was located at the corner of Elm Street and Park Avenue. Built at a cost of more than $200,000, Anshe Emeth was designed to accommodate a Jewish center, which reflected the priorities of spiritual leader Rabbi B.H. Birnbaum, who promoted the education of the congregation's children. Under the leadership of the temple's president, Ignace (Ignatz) Schwartz, Anshe Emeth's membership swelled to 225 members, while its religious school attracted more than 300 students.[187] The temple's dedication, on January 7, 1923, was part of a four-day celebration that closed with a banquet that

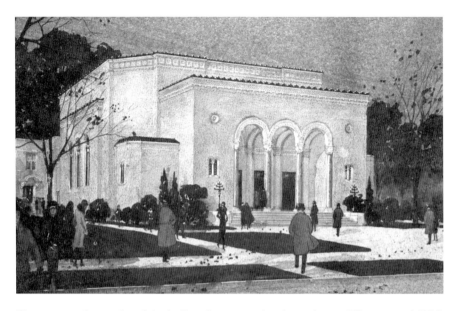

The new temple complex of Anshe Emeth congregation, located east of Youngstown's Wick Park, was dedicated in March 1928. Designed by architect Morris Scheibel, the Moorish Revival landmark was built under the supervision of contractor Emanuel Katzman. *Courtesy of Mahoning Valley Historical Society.*

drew 500 guests. Meanwhile, Jewish leaders from across the nation sent congratulatory messages.[188]

Three years later, another congregation dedicated its new edifice on the city's South Side, a development that undoubtedly surprised some older Jewish observers. Throughout most of the nineteenth century, the majority of Youngstown's Jewish community had lived, worked or worshipped on the city's North Side. However, within the first two decades of the twentieth century, due to factors such as immigration and social mobility, the demographic makeup and location of Youngstown's Jewish population began to shift. By the end of the First World War, almost 40 percent of the city's Jewish residents were of Russian, Polish or Slavic origin, and most of them resided on the South Side. Naturally, they wanted a congregation that would reflect the traditions and practices of their community.

In the spring of 1920, a few South Side Jews began to gather informally. By 1922, that group had grown to the extent that formal incorporation seemed the next logical step. Naming their new congregation Ohev Tzedek ("Lovers of Justice"), the members began to hold meetings and religious services in private homes or rented rooms. Within several years, mainly due to the fundraising efforts of the congregation's women's auxiliary, Ohev

Tzedek had secured enough money to purchase a lot on East Myrtle Avenue as the site of its future temple. The cornerstone for Ohev Tzedek synagogue was laid on August 23, 1925. Built at an estimated cost of $25,000, the structure was formally dedicated on March 20, 1926.[189]

Youngstown was not the only community in the region to experience rapid growth in the 1920s. A year and a half earlier, on September 2, 1923, congregants of Beth Israel, in Sharon, Pennsylvania, rededicated their refurbished synagogue on Shenango Street. A substantial brick addition, built at a cost of $30,000, increased the synagogue's length by forty-five feet, bringing it to forty-five feet by ninety feet. The building's original section was remodeled for use as a Sunday school, while the synagogue's basement was remodeled to include a banquet hall and industrial kitchen. Faced with a growing congregation, Beth Israel's officers, led by their president, A.M. Rosenblum, discussed the need to secure a full-time rabbi. Yet, like many smaller Jewish congregations, Beth Israel found it challenging to keep a spiritual leader, once hired. Lifelong resident Marlene Epstein recalled, "There were periods when we didn't have a rabbi, and some of us were confirmed in Youngstown."[190]

During this period, Warren's Temple Beth Israel continued to grow under the steady leadership of Rabbi Greenstein. In 1928, the congregation purchased a stretch of land between Tod Avenue and Palmyra Road for use as a cemetery. After Rabbi Greenstein's death, in 1931, he was succeeded by Rabbi Leon Stitskin, who built on his predecessor's accomplishments, while also taking a more active role in community affairs. The youthful rabbi emerged as a leader in the Warren Ministerial Association and organized a civic-oriented group known as the Community Forum. Significantly, in the late 1930s, Rabbi Stitskin's visibility would position him to lead a campaign against anti-Semitic activity in the Warren area.[191]

THE GROWTH OF EDUCATIONAL, RECREATIONAL AND YOUTH-ORIENTED ORGANIZATIONS

The growth of Jewish institutions during this period was hardly limited to congregations. By the mid-1920s, there was growing support for the establishment of a community center. Several groups in the region worked on the issue, each developing a plan that differed in terms of complexity and scope; however, "a true community-wide effort never evolved."[192]

Cooperation on the project was hindered, in part, by conflicting visions over the center's primary role. The Young Men's Hebrew Association wanted the center to function as a central facility to foster social activities and athletic events. Temple Emanu-El envisioned the center as a community educational facility, similar to the Youngstown Hebrew Institute. Temple Emanu-El eventually assumed a dominant role in the project's development due to the YMHA's limited funds and lack of consistent leadership.

In 1925, Louis Regenstriech, then president of Emanu-El, appointed a building committee headed by Max Myerovich to find a suitable building for the new Youngstown Hebrew Institute. One year later, in 1926, the former Henry Tod Mansion on the corner of Lincoln Avenue and Holmes Street (now Fifth Avenue) in Youngstown was purchased for $75,000 and remodeled as a school building and meeting place. Due to its convenient location and continual usage, the YHI building soon became known as the area's "Jewish Center."[193] By 1927, an ad hoc administration was established, complete with functioning officers, trustees and an executive board, and the building served as home to "more than 35 social and religious groups…involving over 1,500 individuals."[194] In January 1928, a constitution and bylaws were approved, and a state charter was granted.

As local Jewish leaders discussed plans to establish a Jewish center in 1926, they also laid the foundations for the development of the Jewish Federation. Among those pictured are (*seated, left to right*) Clarence Strouss Sr., Harry Levinson, Bert Printz, Nathan Grosshandler and Louis Regenstreich; (*standing, left to right*) Leo Netzrog, Roy Hartzell, Max Meyerovich, Rabbi Irving Miller and G.L. Evzovitch. *Courtesy of Mahoning Valley Historical Society.*

The nearby Jewish community of Warren experienced similar developments with the establishment of the Warren Hebrew Institute in 1925. Organized under the leadership of Joseph E. Lavine, the institute was envisioned as a means to provide instruction in the areas of prayer, rituals and Jewish history. Within a few years, Sunday school classes were placed under the direction of Dr. Harold Bender and Julius White. By 1928, the institute had merged with Beth Israel congregation. At that point, the activities of both organizations were overseen by a ten-member board of directors that included Roy Knofsky, Joseph Lavine, Israel Jurow, I. Knell, M.S. Rosenberg, P. Avner, Solomon Shultz, H. Wolfkoff, M.I. Brown and Gus Whitman.[195]

By the late 1930s, steps had been taken to establish a Jewish federation in the Warren area. In 1941, the newly established Warren Jewish Federation, under the leadership of Jack W. Heller, set out to acquire property for a Jewish center. In June of that year, the board voted to purchase the former Wilkinson Mansion, located on the city's Mahoning Avenue. Within a short period, the structure had been remodeled to meet safety regulations and accommodate several classrooms. While Warren's Jewish Community Center served as a venue for organizational activity and social events, it also housed a religious school that operated under the supervision of Beth Israel's spiritual leader, Rabbi Lewis Satlow. Therefore, in certain respects, the city's Jewish Community Center functioned as a successor to the old Warren Hebrew Institute.

It would be inaccurate to assume, however, that all educational programs were geared toward religious purposes. A significant minority of the area's Jewish residents was affiliated with secular socialist organizations like the *Farband*, the *Bund* and the *Arbeiter Ring* ("Workmen's Circle"), which were inspired by the General Jewish Labor Bund that had been established in Imperial Russia in the late 1890s. As Ozer and his coauthors observed, these Jewish residents did not want their children "to receive a religiously-oriented Hebrew education, but chose instead to expose them to a more socialistic, secular, Yiddish-oriented education." Classes to provide this kind of education were held at the Wood Street Elementary School on Youngstown's North Side throughout the 1920s and '30s. Founders of the program were loosely affiliated with the American *Yiddishist* Movement, which promoted socialist reform and the promulgation of a Yiddish culture that would "cement Diaspora Jewry together."[196]

Meanwhile, a new emphasis on secular youth organizations was reflected in a November 1927 meeting of Youngstown's B'nai B'rith Lodge No. 339,

Above: Purchased by the Warren Jewish Federation in 1941, this spacious home on Mahoning Avenue was the site of social events and religious education. Sunday school and Hebrew classes were conducted under the supervision of Rabbi Lewis Satlow. *Courtesy of Mahoning Valley Historical Society.*

Left: This Jewish-owned business in Youngstown's Brier Hill District was one of many that catered to the community's large Yiddish-speaking population. *Courtesy of Mahoning Valley Historical Society.*

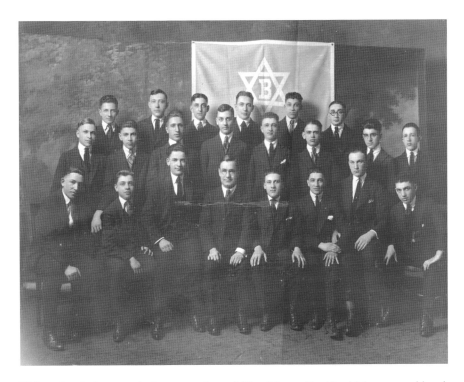

This undated photograph shows members of Blue Mogen David, which was considered the oldest Jewish high school fraternity in the state of Ohio. The group coexisted with scores of other youth-oriented organizations such as Aleph Zadik Aleph, a fraternal organization connected to B'nai B'rith; and the Rodans, a high school fraternity for boys affiliated with either Rodef Sholom or Anshe Emeth congregations. *Courtesy of Mahoning Valley Historical Society.*

where members discussed the possibility of organizing a local chapter of Aleph Zadik Aleph (AZA), a fraternal organization connected to B'nai B'rith. Founded in Omaha, Nebraska, in 1924, the fraternity's founding was a response to the fact that Jewish students were routinely denied entry into Greek organizations. Indeed, the characters Aleph Zadik Aleph were the Hebrew counterparts of Alpha Zeta Alpha, a fraternity that banned Jewish students at that time. Intended for male students between the ages of fifteen and seventeen, AZA had a female counterpart, B'nai B'rith Girls (BBG), which soon established a local chapter as well. As Ozer and his coauthors noted, both organizations initially "functioned independently of any other organization except their parent, the B'nai B'rith, in effect competing with other teen-age fraternal organizations for members and activities." When Youngstown's first Jewish Community Center was established on Bryson

Street in 1937, local chapters of AZA and BBG were the only youth organizations that did not participate in its programs—a situation that did not change until the current center was built in the 1950s.[197]

For teenaged boys who were not members of AZA, a number of alternatives existed, including the Rodans, a high school fraternity for boys affiliated with either Rodef Sholom (*"Rod"*) or Anshe Emeth (*"An"*) congregations; the Center Boys' Association, a youth organization associated with the Jewish Community Center; and the Blue Mogen David Club (BMD), a local fraternity that, since its establishment in 1917, was recognized as the oldest Jewish high school fraternity in Ohio.[198] Additionally, a variety of high school sororities actively participated in the Jewish Community Center's youth-oriented programs.[199]

A major step toward the development of new social and recreational opportunities for local Jewish residents was the establishment of Squaw Creek Country Club on July 26, 1926. Located on a verdant swath of land just south of Vienna, Ohio, Squaw Creek was established, in part, because many local country clubs did not accept Jews as members. Ozer and his

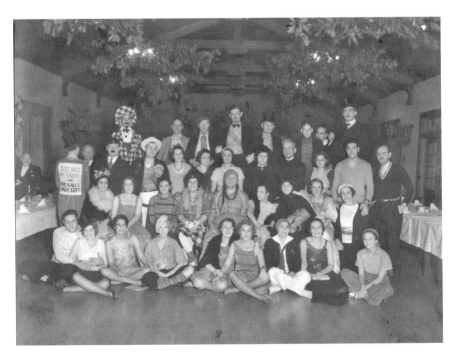

Envisioned as an alternative to the area's "restricted" country clubs, Squaw Creek became a center of local Jewish social life. This 1930s photograph was taken during a costume party at the country club. *Courtesy of Mahoning Valley Historical Society.*

coauthors noted that the "driving force" behind the new club was local jeweler Michael J. Samuels, who resented "the exclusionary policies of the existing country clubs in the area" and treated Squaw Creek as "his personal challenge" to the status quo. Affectionately referred to as "Daddy" by many of the club's members, Samuels served as Squaw Creek's first president, while his son, John Hartzell Samuels, designed the original clubhouse, built at a cost of $85,000.[200] One of the building's impressive features was a spacious lounge with "oriental rugs, white stone fireplace, bric-a-brac, tables and large comfortable tapestry chairs." On the opposite side of the lobby from the lounge was a well-furnished veranda that looked out on the club's golf course, reputed to be "one of the best in this part of the state."[201]

DEVELOPMENTS IN THE BUSINESS SECTOR

The region's vitality was reflected in downtown Youngstown's bustling retail and entertainment district, which hosted a startling range of Jewish businesses. On November 1926, one of the community's landmark businesses, the Strouss-Hirshberg Company, opened the doors of its new six-story, 230,000-square-foot building. Representing an investment of over $4 million in construction and stock, the building featured 150 phones, fifty-five pneumatic delivery tubes and a refrigerated vault that could hold more than $1 million in fur. With elegant accents such as Italian travertine floors and American walnut door frames, the building also boasted a state-of-the-art ventilation system and seven elevators. The store offered a dizzying array of items, including men's and women's clothing, radios, Victrola phonographs, furniture, carpets and rugs, interior décor and kitchen merchandise. The festive nature of the grand reopening was underscored when a commercial pilot circled the new building and dropped a silk parachute carrying a large wreath. Youngstown mayor Charles F. Scheible then presented the wreath to Clarence Strouss, president and general manager of the department store.[202]

Less than two years later, in the summer of 1928, the Los Angeles–based Warner Brothers Studio announced plans to build a world-class theater in the brothers' adopted hometown of Youngstown, Ohio.[203] Although they had long since moved away from the Mahoning Valley, their relatives still lived in the area. The Warner brothers reportedly took steps to ensure that the theater would be a "monument to their organization," as well as

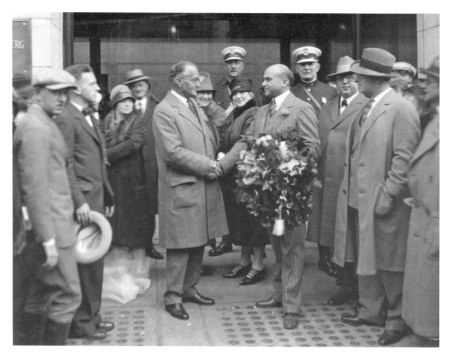

Clarence Strouss Sr. (*right*) accepts a wreath from Youngstown mayor Charles F. Scheible (*left*) to mark Strouss-Hirshberg Department Store's grand reopening on November 2, 1926. The floral wreath was dropped by parachute from an airplane that circled the building three times. *Courtesy of Mahoning Valley Historical Society.*

Tickets to the May 1931 opening of Youngstown's Warner Theatre featured images of Harry, Albert and Jack Warner. The Warners reportedly built the world-class theater as a memorial to their late brother, Sam, who drove the studio's investment in "talkies." *Courtesy of Mahoning Valley Historical Society.*

a memorial to their late sibling, Sam Warner.[204] Reportedly modeled after the Warner Theatre in Los Angeles, the Youngstown building boasted a capacity of four thousand, with an estimated construction cost of more than $1 million.[205] The theater's grand opening took place on May 14, 1931, with the premiere of the film *The Millionaire*. With thousands of people crowding the streets and hundreds of cars blocking traffic, men and women in formal attire streamed into the theater as studio executives greeted them, while a WKBN radio announcer described the festivities to the outside world. While the "Warner boys" were unable to attend the opening, they sent a studio representative to convey their best wishes, and hundreds of congratulatory telegrams were sent by screen stars and movie producers.[206]

In addition to the Warner Theatre, there were dozens of Jewish-owned businesses located in the elegant section of downtown that stretched west from Central Square to Fifth Avenue. Discriminating customers patronized stores such as Friedman's Confectionery, Levinson's, Klivans's jewelry and Greenblatt's furrier shop. Women kept up on the latest clothing trends at Livingston's, while fashionable men shopped at Hartzell's and the Printz Company. Others ordered custom-made suits from Harr Tailoring, Hodes's tailor shop, Meyerovich Bros., Scher "Your" Tailor and Bud the Tailor, owned by David Schneider. The district's tonier shoe stores included Lustig's and the Cinderella Shop, whose co-owners, Joseph Knable and Sam Kornspan, catered to women. Another district landmark was Fish's dry-cleaning shop, whose clients included downtown's luxurious Hotel Pick-Ohio.

Downtown Youngstown was also home to the area's most trusted tobacconists, such as Frankle Bros., Shagrin-Roseman and the Anchor Cigar Company, owned by Jacob Fendrich. Local technology buffs swore by Ross Radio Company, which occupied the former flagship location of Burt's Confectionery, originator of the Good Humor line of ice cream novelties.[207] Popular downtown eateries included Joseph's and the Ringside (owned by Nick Joseph and Ben Harris, respectively), while children gravitated to the Bloch Candy Company. Meanwhile, the "West End" featured several major packing and manufacturing firms, including Altshuler's Albro Packing Company, Sniderman's City Fruit Company and the Moyer Manufacturing Company, which produced men's pants. By 1936, the district also hosted the Tamarkin Company, a wholesale grocery firm located west of Fifth Avenue, where Commerce Street ended.[208]

The eastern section of downtown Youngstown, though less glamorous, reflected the community's diversity. The "East End" featured Greek-owned coffee houses, Italian-owned produce markets, Eastern European

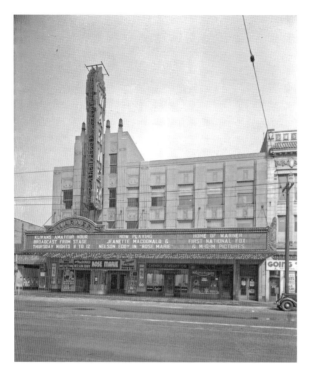

Left: Youngstown's Warner Theatre was modeled after the Warner Theatre in Los Angeles. Built at a cost of more than $1 million, the theater had a seating capacity of four thousand people. *Courtesy of Mahoning Valley Historical Society*.

Below: This 1930 photograph of downtown Youngstown captures the vitality of Central Square, which was ringed with theaters, restaurants, hotels, banks and other businesses. *Courtesy of Mahoning Valley Historical Society*.

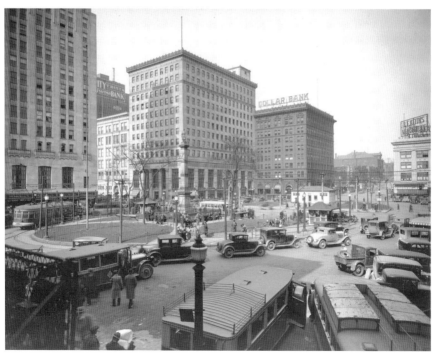

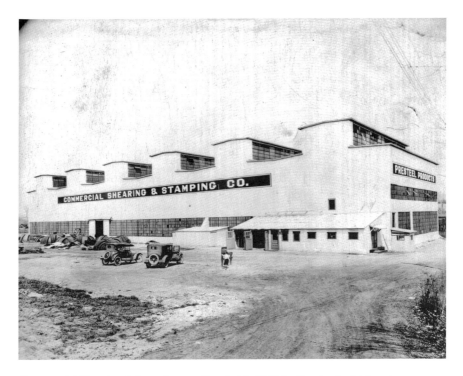

Commercial Shearing & Stamping was founded in 1920 by Russian Jewish immigrants Robert, Jacob and Henry Carnick, who later sold it for $125,000. The company thrived for decades under new ownership. *Courtesy of Mahoning Valley Historical Society.*

restaurants, black-owned taverns and jazz clubs, boxing gymnasiums, pawnshops, working-class eateries and low-end theaters. Jewish-owned businesses in the district included delicatessens Evie Eisenstat's, Ozersky's, Udell's and the Ostash; kosher butchers Hoffman's, Miller & Rosenberg's, Ocker's, Roth's and Smulovitz's; shoe stores Brody's, Levine & Sackerman's and S.&A. Rosenbaum's; jewelry shops Ditts's and Klivans's; discount clothing outlet M.J. Rosenbaum's; furniture stores Bolotin-Drapkin's and Hume's; loan companies Sandel's and Kessler's Star Loan Company; and discount meat and produce shops Cohn's East Federal Cut Rate Market, Grossman's East End Cut Rate Market and Simon and Singer's Public Market. Other well-known Jewish-owned businesses in the eastern section of downtown were Giber Leather Company, Glicksteen's pet supply shop, Levinson's Tire Company, Peskin Bros. Sign Company, Pianin's wallpaper firm, Schwartz's M&E Army Store, Regent Billiards, the Triangle Raincoat Company and Rome's Youngstown Feed and Grain.[209]

Elsewhere in the city, a wide variety of Jewish-owned businesses flourished, even during the hard times that followed the 1929 Wall Street crash. On the North Side, the Commercial Shearing & Stamping Company, founded in 1920 by siblings Robert, Jacob and Henry Carnick, continued to expand under new ownership. In 1922, just two years after organizing the steel plate–stamping business, the brothers sold it to the David Joseph Company for $125,000.[210] Likewise, the Youngstown Towel Supply & Laundry Company, headed by Harry Spero, grew rapidly. Later known as Penn-Ohio Coat, Apron, and Towel Supply Company, the firm operated numerous subsidiaries, including United Paper Service.[211] Another North Side firm, the Frank Sherman Company, moved its scrap operation from a small lot on Watt Street, just north of downtown, to a spacious site on West Rayen Avenue.

At the same time, the United Printing Company, led by senior partner Nathan Grosshandler, distributed the popular, twice-weekly *Shopping News* from its plant near Spring Commons, west of the downtown area. Several blocks away, on the near South Side, stood Nathan Darsky's Golden Age Beverage Company, the foundation for the American Beverage Corporation, which eventually maintained five subsidiaries, including Pepsi-Cola Bottlers of Miami and the Golden Age Beverage companies of Youngstown, Akron, Dayton and Houston.[212] Elsewhere on the South Side sat the offices of Roth Bros., Inc., a roofing, heating and sheet metal business established by Polish immigrants David and Abraham Roth. "My father worked all the time," recalled Sam A. Roth, son of Abraham Roth. "He would go out at five in the morning and come home at seven or eight at night, every day."[213] Years later, the business expanded to include an air-conditioning division.[214] Some businesses, like Century Food Market, a modern supermarket, began modestly and gained momentum. When Edward and Jules Aron opened their first store on the city's Glenwood Avenue in 1940, few anticipated that the business would emerge as one of the region's first successful supermarket chains.

On the East Side, the Schwebel Baking Company—led by Dora Schwebel after the 1928 death of her husband, Joseph—was equipped to spend $100,000 on a new bakery by 1936.[215] "She was just a dynamo," recalled her grandson Paul Schwebel, president of Schwebel Baking Company. "She would work all day and go home and have dinner with her kids, and then…she would be out there loading trucks in the evening."[216] Two years later, in 1938, East Side businessman Marvin Itts (Itkovitz) entered the local aluminum industry with his new firm, Modern Trimedge, later known as Trimedge Industries.[217]

Dora and Joseph Schwebel started to bake bread in their Campbell, Ohio home in 1906. After working out agreements with local grocery stores, the couple distributed their baked goods around the metropolitan area and eventually purchased their first fleet of trucks. After Joseph's death in 1928, Dora continued to develop the company with her son Irving. *Courtesy of Mahoning Valley Historical Society.*

The 20th Century's Art Deco design was inspired by the owners' frequent visits to tourist-friendly restaurants in Miami, Florida. Its eclectic menu offered everything from snacks to full-course meals. *Courtesy of Mahoning Valley Historical Society.*

Many local restaurants relied on the services of Hollander's Meats. In the 1950s, Louis Hollander purchased the former Petrakos Grill, which he reopened as Hollander's Grill. Faced with mounting evidence of downtown's deterioration, he closed the restaurant in the 1960s. *Courtesy of Mahoning Valley Historical Society.*

During the 1930s and early 1940s, the area also saw a blossoming of Jewish-owned restaurants and eateries, some of which became landmarks. Several were established by the innovative team of Harry and Faye Malkoff, who opened a string of local eateries toward the end of the Great Depression. Their son, Kurt, explained that his parents were inspired to enter the restaurant business in 1937, after observing the success of "hamburger joints" during a brief visit to California. Their first restaurant, the Griddle, was opened in a former bicycle shop on Midlothian Boulevard, on the city's South Side. "They didn't have a whole lot of money to do anything other than make food, so there was no marketing money or advertising," Kurt Malkoff recalled.[218] While the Malkoffs went on to establish several popular eateries such as the Gob Shop, Dixie Kitchen and the El Morocco, their most enduring restaurant was the 20th Century, which opened on the North Side in 1942. In 1939, two years after the opening of the Griddle, Rose and Herb Kravitz established the Elm Street Delicatessen on the city's North Side—a business that continues to thrive as Kravitz Deli. Years later, meat purveyor Louis Hollander would try his own hand at the restaurant business as the owner of Hollander's Grill and as a partner, with Milt Simon, in the elegant Mural Room, both located in downtown Youngstown.

RABBIS IN THE PUBLIC EYE

While business leaders garnered considerable attention in the 1930s, they weren't the only representatives of the Jewish community in the spotlight. In the late 1920s, noted criminal attorney Clarence Darrow, a Mahoning Valley native, took to the national lecture circuit to debate his belief that evolution and religion were incompatible. An outspoken atheist, Darrow had been the lead attorney in the 1925 "Scopes Monkey Trial," defending Tennessee schoolteacher John Scopes for illegally teaching the theory of evolution. Starting in 1927, Darrow entered into a series of friendly debates with religious leaders throughout the Midwest, and he eagerly accepted a challenge from Youngstown's Rabbi Isadore Philo, a lawyer and noted orator. On May 13, 1928, the two men agreed to meet in the city's Stambaugh Auditorium to debate the question, "Is Man a Mere Machine?" Before a packed house of 500 people, the two men sparred verbally over whether man was "a chip of God" or a collection of chemicals "[that] can be bought at the corner drug store for 95 cents."[219] After the debate, which had been broadcast over the radio, an informal exit poll was taken of 130 people, and Rabbi Philo was declared the victor by a slim margin.

Almost two years later, on January 5, 1930, the local media commented on the arrival of twenty-three-year-old Rabbi Kalmon "Karl" Manello, who assumed leadership of Temple Emanu-El on the North Side. The charismatic Rabbi Manello replaced Rabbi Irving Miller, installed just four years earlier. Greeted by almost six hundred congregants, the new rabbi held impressive credentials. He was a recent graduate of the

A dinner to mark the installation of Rabbi Irving Miller at Youngstown's Temple Emanu-El drew hundreds of guests. Just four years later, Rabbi Irving would be succeeded by the charismatic Rabbi Kalmon Manello. *Courtesy of Mahoning Valley Historical Society.*

Jewish Theological Seminary in Chicago and one of the youngest rabbis in the country. During a lavish banquet after the installation ceremony, representatives of the congregation read aloud almost one hundred congratulatory telegrams. The banquet was the culmination of a three-day celebration, and it drew about 250 Jewish leaders from across the Mahoning Valley.[220] An energetic and proactive leader, Rabbi Manello promptly scheduled a meeting with leaders of regional congregations to discuss the state of Jewish education, as well as the supervision of *kashrut* (kosher food). Largely through his efforts, an agreement was reached with every congregation to form an organization that consisted of three delegates per temple. The new federation set out to place the area's individual Hebrew schools under a single system, which, in retrospect, was an early step toward the regionalization of the area's Jewish community.[221]

THE IMPACT OF EUROPEAN NAZISM

The flurry of institution-building and organizational development that characterized the late 1920s and early 1930s occurred against a backdrop of ominous events. Alarmed by the escalating violence directed at European Jewry, Jewish residents of the Mahoning Valley organized a mass meeting in August 1933 at the Idora Park theater to discuss a boycott of German products. Addressing a crowd of more than one thousand Jewish residents, prominent New York attorney Samuel Untermeyer condemned the German government for its persecution of Jews and denounced the Hitler regime. Speaking to WKBN radio, which was hooked up to a national broadcast, Untermeyer encouraged Jews of all nations to unite against Germany and went on to criticize Rabbi Stephen Wise and the American Jewish Committee for opposing a boycott.[222] Untermeyer insisted that, if a total economic boycott were enacted, the Hitler regime would fall within six to twelve months.[223] On August 1, 1934, nearly one year after Untermeyer's Idora Park speech and twenty years to the day of Germany's declaration of war in 1914, President Paul von Hindenburg died, and Adolf Hitler seized complete political power over Germany.

As tensions in Europe escalated, a congressional inquiry was held to discover whether a link existed between the Silver Shirts, an American organization, and Hitler's Nazi Party. In Warren, the group's anti-Semitic leanings were evident to Beth Israel's Rabbi Leon Stitskin, who led a

public campaign against the Silver Shirts. Mobilizing groups such as the American Legion and Warren Ministerial Association, the rabbi brought about "the virtual death of the organization in Warren."[224] Local Jewish leader Aaron Grossman recalled that Youngstown-based opponents of the vigilante organization took a decidedly direct approach. Led by local barber Paul Fox, members of various Jewish youth organizations, including AZA, the Rodans and BMD, converged on the Silver Shirts' meeting place in the city's Central Auditorium, expressing their displeasure with blackjacks and lead pipes. "For some reason all the policemen appeared to be off sick that night and we walked in on the Silver Shirt meeting without interference," Grossman explained. "They never again met in downtown Youngstown after that night."[225]

Toward the end of 1934, local Jewish leaders called for all congregations to demonstrate their collective solidarity. Speaking to a crowd of more than six hundred people at Anshe Emeth Temple, Rabbi Kollin, along with Rodef Sholom's Rabbi Philo and Emanu-El's Rabbi Manello, emphasized the need to work together as a community, rather than as separate congregations. The

During a visit to Youngstown in the 1930s, First Lady Eleanor Roosevelt met with female professionals, including attorney Fanyerose Gancfried (*seated, far left*). One of the first local women to gain prominence in the legal profession, Gancfried campaigned for a judgeship in 1936. *Courtesy of Mahoning Valley Historical Society.*

rabbis also stressed the need for an organization that was positioned to speak authoritatively for the Jewish people of the Mahoning Valley. "[W]e ask the nations to unite when we ourselves are not united," Rabbi Philo stated. "In spite of our learning and our suffering and our experience, we have not developed the spirit of working together."[226]

Following the rabbis' plea for unity, Mahoning Valley Jewry found itself at a crossroads. With the effects of the economic depression still apparent, the need for local welfare campaigns and economic assistance programs was greater than ever. Wealthy and middle-class citizens, their incomes tapped by state and federal taxing agencies, were no longer able to shoulder the burden of providing assistance to local and overseas Jewish communities. In a move that reflected national trends, the Mahoning Valley's Jewish community began to explore the concept of a single organization to oversee the area's vast network of social welfare programs, while avoiding the duplication of charitable efforts. In August 1935, a group of individuals met to discuss the formation of a Jewish federation in the Mahoning Valley. Impressed with the idea, Clarence Strouss, president of Strouss-Hirshberg Company, penned an open letter to the Jewish community proposing the creation of an agency to oversee, evaluate and direct charitable initiatives. On October 31, the Jewish Federation of Youngstown was formally created, and bylaws were adopted.[227] A week later, on November 7, a meeting was held and Strouss elected as the organization's first president, while the organization's provisional headquarters were established at Anshe Emeth Temple.[228]

Just over a year later, in January 1937, eminent rabbi Stephen Wise, one of American Jewry's leading voices, came to Youngstown to deliver a solemn message to the local Jewish community. Speaking to a capacity crowd of six hundred at Congregation Rodef Sholom, Rabbi Wise advised that the situation in Europe was worsening by the day. Romania, Czechoslovakia and Poland were deteriorating at an alarming rate—economically, politically and religiously. Meanwhile, hundreds of thousands of Jews had found refuge in Palestine, with room for about two million more. Rabbi Wise cautioned the congregation that Hitler's drive was not just anti-Semitic but also targeted Protestants and Roman Catholics, among other groups. At the end of his speech, the rabbi issued an ominous warning: "If you have anyone in Germany whom you can possibly take out of the country, do so at once."[229]

On November 9, 1938, the Nazi government orchestrated a massive pogrom throughout Germany and Austria that became known as *Kristallnacht* ("Night of Broken Glass"). The action, led by Nazi paramilitary troops and supported by scores of civilians, resulted in the destruction of

seven thousand Jewish-owned businesses and the burning of one thousand synagogues. Meanwhile, thirty thousand Jews were interned in concentration camps. This alarming news intensified local support for the Zionist Movement, while energizing efforts to facilitate the resettlement of German Jewish refugees within the Youngstown area. As early as March 1938, the Youngstown Jewish Federation had allocated funds to an organization called the German-Jewish Children's Aid, "with the result that several children were later placed with Youngstown Jewish families." In September of that year, the federation and local chapter of B'nai B'rith joined forces to secure volunteers to sign affidavits of support for European refugees seeking to immigrate to the United States. As Ozer and his coauthors noted, 1940 commenced "with more than forty families of German refugees resettled in Youngstown." With the intensification of Nazi Germany's anti-Semitic policies, the pace of the operation soon accelerated to five families per month.

To cope with the influx of refugee families as well as individual children, the federation took steps to ensure that a division known as the Family Welfare Department (a forerunner of Jewish Family and Children's Services) received licensure from the Ohio Department of Public Welfare "to place dependent and neglected children and to perform adoption services."[230] Sadly, however, efforts to rescue endangered European Jews were hampered by the U.S. government's highly restrictive policies on Jewish immigration, which were largely influenced by Assistant Secretary of State Breckinridge Long, an outspoken anti-Semite. Finally, in October 1941, the issue of Jewish immigration from Nazi-controlled regions of Europe "became moot," when "Berlin issued orders to deny all further exit visas to Jews."[231]

Around this time, members of the regional Jewish community began to lose contact with relatives in Europe. In western Pennsylvania, Edith (Katz) Peskin, then a student at Farrell High School, often considered visiting relatives in her native Czechoslovakia, and she wrote regularly to her grandmother. After graduating from high school, she went on to secretarial school, got a job and postponed any plans to visit Europe. "I'd still write to them, but I didn't go," she recalled. "That happened in '41, so they were already having problems then." At some point, she noted, letters from Europe stopped arriving, and her parents' struggled to learn all they could about their relatives' fate. When asked what ultimately became of her grandmother, aunt, uncles and cousins in Czechoslovakia, Mrs. Peskin responded, with a tone of resignation, "Oh, they were killed. All of them."[232]

5

"The Good War"

In the early morning hours of December 7, 1941, hundreds of Japanese fighter planes appeared in the skies over Pearl Harbor, the U.S. naval base located near Honolulu, Hawaii, and attacked without warning. For almost two hours, pilots of the Imperial Japanese navy assaulted the base, dropping bombs and crashing their planes into docked vessels. When the attack was over, almost twenty American naval vessels, including eight battleships and more than three hundred airplanes, were badly damaged or destroyed.[233] Over two thousand Americans soldiers and sailors were killed, while about one thousand were wounded.

One day after the assault, on December 8, U.S. president Franklin D. Roosevelt asked Congress to declare war on the Empire of Japan. Three days after congressional approval was obtained, Germany and Italy declared war on the United States. The U.S. Congress swiftly reciprocated by declaring war on Germany and Italy. Hence, almost two years into the conflict, America was now a full participant in World War II. Within hours of the attack, news of the terrible events at Pearl Harbor struck the mainland. Not surprisingly, U.S. Army, Navy and Marine recruitment centers across the Mahoning Valley were flooded with eager volunteers, some as young as fifteen years old. Prior to the attack, most offices had received an average of twenty-five applications per month. In its aftermath, one recruiter reported receiving over a dozen applications within two hours of opening his office.[234] In order to handle the overwhelming local response, several recruitment centers announced they would remain open twenty-four hours a day and seven days a week.

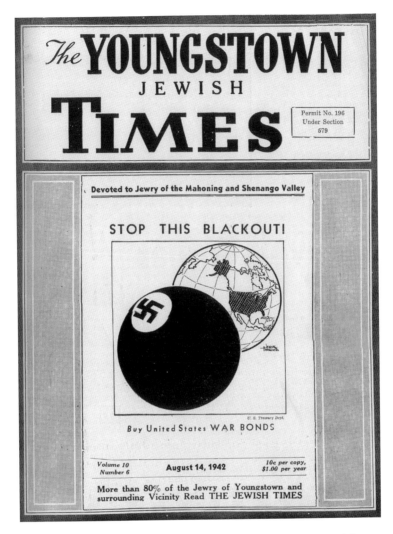

The August 1942 cover of the *Youngstown Jewish Times* reflects the special meaning World War II had for the local Jewish community. *Courtesy of Mahoning Valley Historical Society.*

During this time, the regional Jewish community committed vast numbers of servicemen to the war effort. While figures for neighboring communities are unavailable, records show that, at the time of America's entrance into the war, Jews constituted 3.2 percent of the total population of Youngstown. Furthermore, Jews in the "draft reservoir" totaled 3.1 percent, and Jews in service totaled 3.9 percent. Although total service membership for Youngstown comprised 47.1 percent of the total

reservoir, Jews in service represented 59.3 percent of the Jewish draft reservoir. By the end of the war, almost 920 Jewish men and women served in the military, including 2 Jewish chaplains, representing more than 15 percent of the city's total Jewish population.[235]

A notable figure was Anshe Emeth's Rabbi Morris Gordon, who secured his military commission early in the conflict and found himself embedded within the legendary "Flying Tigers," under the command of Claire Chennault in northern China. During his years in Asia, Rabbi Gordon earned the American Bronze Star and Chinese Medal of Honor for his involvement in the campaign to capture the Burma Road.[236] As one of the only Jewish clergymen stationed in Asia, Gordon oversaw twenty-two towns within a vast region that stretched for thousands of miles. Under these circumstances, he often served as a cultural and religious ambassador for Judaism. At times, Rabbi Gordon found himself explaining Jewish beliefs to children at Buddhist schools. On other occasions, he officiated funerals

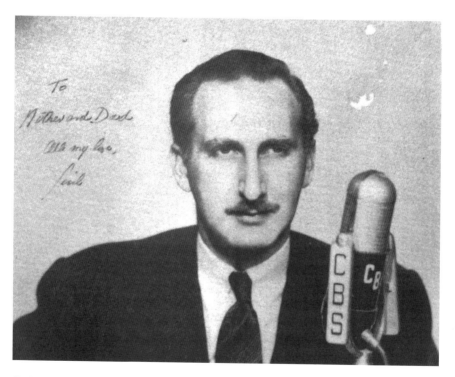

Cecil Brown, a former Warren resident and one-time editor of the *Youngstown Jewish Journal*, thrilled radio audiences during World War II. A correspondent with the Columbia Broadcasting Company, Brown was recruited by veteran journalist Edward R. Murrow. *Courtesy of Mahoning Valley Historical Society.*

for local village elders. In one case, he even performed religious services that were attended by the likes of U.S. general Albert C. Wedemeyer and Chinese general Chiang Kai-shek.[237]

Others contributed to the war effort as civilians. Even before America's direct involvement in the conflict, former Warren resident Cecil B. Brown, one-time editor of the *Youngstown Jewish Journal*, had been recruited by veteran journalist Edward R. Murrow as a war correspondent for the Columbia Broadcasting Company. Like other journalists covering World War II, Brown found himself in harm's way. In 1941, he was among surviving passengers of the British cruiser *Repulse*, which was sunk by the Japanese navy in the China Sea. That same year, Brown narrowly escaped British-held Singapore before it fell to Japanese forces. In 1942, the war correspondent's experiences were the basis of the bestseller *Suez to Singapore*, which took a critical view of British actions in Singapore. During the war, Brown's "broadcast commentaries were followed by millions of listeners."[238]

PROTESTING INTOLERANCE AT HOME AND ABROAD

By the time the United States entered World War II, the American Jewish community's long-standing concerns about Nazi brutality were supplemented by new fears regarding the situation in Palestine, where thousands of Jewish refugees were being turned away. The tightening of restrictions on Jewish immigration to British Mandate Palestine reflected Britain's awareness of the fact that the Middle East would serve as a theater of conflict in any war. In May 1939, as war became inevitable, the British government initiated a feverish campaign to secure the goodwill of several Middle Eastern countries whose lands were viewed as crucial staging grounds in a potential conflict with the Axis Powers. As part of this campaign, Britain issued a controversial White Paper declaring that "the framers of the Mandate in which the Balfour Declaration was embodied could not have intended that Palestine should be converted into a Jewish state against the will of the Arab population of the country."[239] This policy shift was a devastating blow to secular and religious Jewish leaders, as well as those Zionists who sought a Jewish state, regardless of Arab consent. The new declaration envisioned a single Palestinian state that would provide a "Jewish National Home," while placing severe limits on Jewish immigration.

The policy allowed for the arrival of just 15,000 immigrants a year for five years, until 1944, and Arab consent would be required thereafter. This change troubled Jewish leaders, who noted that Jews constituted more than 30 percent of the Palestinian population (at 467,000), while more than two-thirds had immigrated to the region by the 1930s.[240] During the last decade, the Jewish population had almost tripled, rising by 180 percent. For many Jewish leaders, the new immigration policy appeared to be designed to arrest that trend.

Recognizing that the door to Jewish Palestinian immigration was rapidly closing, Jewish leaders in the Mahoning Valley objected to the British action and submitted a formal protest in November 1943. The region's Rabbinical Council issued a statement asking "that the doors of Palestine be opened to large scale Jewish immigration so as to provide a refuge for the homeless wanderers who seek its shelter." The rabbis observed that the Balfour Declaration had been endorsed by "52 governments, including the United States," and that the new proposal was a complete reversal of the British covenant. "In the face of the disasters that have befallen the Jews of Europe under Hitler, it is unconscionable that they should be deprived of the hope of eventually finding peace and freedom in the future Jewish Commonwealth," the statement declared.[241]

This was not the first time that the local Jewish community showed solidarity with European Jews who suffered under the Nazis. On December 2, 1942, the chief rabbinate of Palestine and the Union of Orthodox Rabbis of America called on Jews across the world to participate in a day of fasting and prayer. In response, the Mahoning Valley Jewish leaders issued a proclamation that requested full observance of the day. Apart from participating in organized prayer, local congregations listened to a variety of national radio programs broadcast throughout the day. Meanwhile, a special joint memorial service was held by four of Youngstown's Jewish congregations: Emanu-El, Children of Israel, Ohev Tzedek and Shaarei Torah.[242]

Less than two months later, on February 24, the growing alarm of U.S. Jewish leaders was reflected in a telegram that New York City's Rabbi Stephen Wise addressed to businessman Oscar Altshuler, president of Youngstown's Albro Packing Company. The message called upon Jewish communities around the nation to "demand action" by the U.S. government "to save Jews from Hitlers [sic] extermination program." Rabbi Wise indicated that two million European Jews had already been killed by the Nazis, while a similar fate "awaits those who remain." He explained that the Free World Association, an antifascist Popular Front

In June 1944, young congregants of Ohev Tzedek gathered for their confirmation in a ceremony officiated by Rabbi Samuel Hopfer, the congregation's first spiritual leader. *Courtesy of Mahoning Valley Historical Society.*

group, had joined forces with other "leading organizations" to secure the "exit of Jews from Axis Europe and creation of havens for them under united nations guarantee in allied and neutral countries as well as Palestine." The telegram referred to an upcoming demonstration to preserve European Jewry scheduled to take place on March 1 at New

York City's Madison Square Garden, an event that ultimately drew seventy thousand people.[243]

It was no accident that Rabbi Wise contacted Oscar Altshuler, whose participation in the Zionist Movement traced back decades. On October 13, 1909, the Polish-born Altshuler chaired the first meeting of Youngstown's chapter of the Sons and Daughters of Zion, and he served as the chapter's first president.[244] In the spring of 1928, he was instrumental in bringing Zionist leader Louis Lipsky to Youngstown for a talk sponsored by the local chapter of Hadassah, a women's Zionist organization.[245] Four years later, on April 18, 1933, Altshuler attended a banquet hosted by the Palestine Friends of the Hebrew University to mark the eighth anniversary of the university's establishment, an event held at Jerusalem's King David Hotel.[246]

Altshuler was not the only prominent local Zionist who lobbied for the rescue of European Jews while promoting the creation of a Jewish state in Palestine. He worked closely with Youngstown businessman James Ross, who served on the executive committee of the Zionist Organization of America. A well-known philanthropist, Ross contributed generously to scientific research institutes in Palestine and, later, Israel, a reflection of his rarified background. Born in Odessa, Russia, Ross had earned a doctorate in international law at Moscow's International Institute of Law before immigrating with his wife, Edith, in 1920.[247] Both men cooperated with Slovak-born attorney Joseph Friedman, whose command of languages positioned him to work with resettled refugees while serving as "legal representative for many former Youngstown residents who returned to their homelands."[248] Other key participants in Zionist organizations were attorney Murray Nadler; furniture retailer Jacob Bolotin; tailor David Schneider; dry-cleaning proprietor David Fish, whose wife, Theresa, carried on his activities after his death in 1941; insurance salesman Joseph Hill; Raymond Fine; Ben Lazar; and Harry Starn.[249]

While the oppression of Jewish communities overseas remained a priority for local Jewish leaders, a growing number of them recognized that racial prejudice was a serious problem on the homefront, as well. In February 1944, representatives from the regional Jewish community attended an ecumenical meeting hosted by the Youngstown Interracial Committee, a group that promoted cooperation between whites and African Americans. Attended by more than two hundred ministers, judges and civic leaders of all races and creeds across the region, the meeting featured five speakers, including Bishop Lorenzo King of the regional Methodist church and Leonard Seliger of the Youngstown Jewish Center. In his address, Bishop King noted that, despite

their contributions to American society (including support of the war effort), African Americans continued to face overwhelming discrimination. He went on to call for greater cooperation among minorities. Echoing King's sentiments, Seliger declared that the "modus operandi" of the postwar world should be designed in a way that the "hurts and indignities to minorities can be erased." Referring to his own community, Seliger added that "Jews of Youngstown make up 10 percent of those serving in the armed forces from the city."[250]

DEVELOPMENTS AT HOME

In the midst of World War II, the local Jewish community continued to mark significant milestones. Beginning on May 8, 1942, Congregation Rodef Sholom engaged in a three-day celebration to mark its seventy-fifth anniversary, along with the thirtieth anniversary (and imminent retirement) of Rabbi Philo. Led by congregational president Ralph Wilkoff, the anniversary program featured addresses by civic and Jewish leaders from across the region, including Rabbi Samuel Goldenson of New York and the eminent Rabbi Joshua Liebman of Boston. (As the grandson of Rabbi Lippman Liebman, the first official spiritual leader of Rodef Sholom, Rabbi Joshua Liebman was a frequent visitor to the Youngstown area.) Participants enjoyed a banquet, festival and dance, along with a climactic "burning of the mortgage" ceremony.[251]

Despite the festive atmosphere, congregants undoubtedly regretted the loss of Rabbi Philo, whose retirement would become effective five months later. Significantly, Rabbi Philo proved to be one of three local rabbis who would leave their posts in less than two years, as Anshe Emeth's Rabbi Kollin resigned in November 1941, and Emanu-El's Rabbi Manello eventually stepped down in June 1943.[252] These losses must have posed a challenge to the community, given that the rabbis, apart from serving as spiritual leaders of their respective congregations, were integral players in a variety of Jewish organizations and participants within the larger community. In time, however, the area benefited from the arrival of a new crop of energetic clergymen.

On Friday, November 6, 1942, Rabbi Philo's successor, Rabbi Abraham H. Feinberg, was installed in an evening ceremony at Congregation Rodef Sholom. As a local newspaper article observed, Rabbi Feinberg was youthful, idealistic and well educated. Rabbi Feinberg held degrees in philosophy

from the University of Cincinnati and Hebrew Union College, "where he was a Phi Beta Kappa man and student instructor in philosophy, editor of various college publications" and "found time for a little basketball."[253] Appropriately, the ceremony was officiated by Dr. Julius Morgenstern, president of Hebrew Union College.[254]

Less than two years later, on September 18, 1944, Jewish families across the region crowded into their synagogues to observe the first day of the religious new year, Rosh Hashanah. At Rodef Sholom, Rabbi Feinberg expressed cautious optimism about the future, while warning his congregation against the dangers of moral apathy and indifference. "We are fighting Hitlerism and yet we are carrying on practically the same sort of thing in America against the Negroes," Rabbi Feinberg observed. Challenging his congregants to combat prejudice and discrimination at home, the rabbi asked, pointedly, "Will we give less to the peace machine whose goal is construction than we did to the war machine whose goal is destruction?"[255]

Meanwhile, across the border, in Sharon, Pennsylvania, the congregation of Beth Israel was in the course of reinventing itself. This gradual process began in the 1930s, when the congregation's spiritual leader, Rabbi Maurice Moskovitz, introduced a series of changes in what had been a traditional Orthodox congregation. These reforms included the introduction of sermons, late Friday evening services and English-language prayers. In addition, men and women sat together during services for the first time. By this time, the shul had become known as "the Congregation of the House of Israel." Interestingly, efforts to ease the congregation in the direction of Reform Judaism coincided with steps toward the construction of a new edifice. As early as 1943, Nathan Routman, eventual head of the congregation's finance committee, promoted the idea of a new temple complex. At that point, members of the Rosenblum and Epstein families drew up a trust agreement for the project in which they made a charitable bequest of $25,000, on the condition that construction of the new temple would begin within five years. Members of the two families that signed the agreement included Lillian Rosenblum, H.D. Rosenblum, Carol Rosenblum, Oscar Ben Rosenblum, Myrtle Rosenblum, Sam Epstein and Bess Epstein.

From there, the project moved forward quickly. The congregation's building committee raised an additional $50,000, selected a site, secured an architect and placed bids for the project. Given that the war was in progress, however, civilian construction was prohibited, and the funds were placed in war bonds until they could be used. Meanwhile, the congregation underwent a series of more dramatic reforms. Notably, women were permitted to sit on

The construction of Sharon's Beth Israel in August 1903 was a major step forward for the city's Jewish community. The brick edifice had a seating capacity of one hundred people. *Courtesy of Mercer County Historical Society.*

the congregation's board, and the organization was asked to appoint five women to sit on the building committee. In May 1945, the congregation decided to adopt a program of "progressive Judaism," and Samuel Epstein, a member of the congregation's board since the 1920s, was selected to facilitate the temple's transition from Orthodox to Reform Judaism. "He had a view based on his experiences as a member of the Pennsylvania Council of Reform Judaism," recalled Marlene Epstein, his daughter-in-law. "He went to meetings in Philadelphia, and he broadened our understanding of Reform Judaism through his involvement there."[256]

In his search for a new spiritual leader, Epstein consulted Rabbi Stephen Wise, head of the Jewish Institute of Religion. The process culminated with the appointment of Rabbi M. Robert Syme, who carried out changes such as the introduction of a "mixed" choir (featuring men and women), the installation of an organ and the use of Reform Judaism's *Union Prayer Book* during Friday evening services. While Rabbi Syme was admired among

proponents of Reform Judaism, his policies met with resistance from other congregants, and he eventually resigned. Hence, the congregation's postwar development, including the construction of a new edifice, would take place under the leadership of Rabbi Meyer M. Abromowitz, who struggled to smooth over disagreements within the congregation and suggested that the board rename the congregation Temple Beth Israel.[257]

Milestones of the Postwar Era

On August 15, 1945, tens of thousands of Youngstown-area residents awaited the announcement that the war was over. By early evening, thirty thousand people had crammed into Youngstown's Central Square, while hundreds of others gathered at local churches and synagogues.[258] For leaders of the region's Jewish community, however, the war's conclusion was not simply a time of jubilation; it was also an occasion to reflect on the future. Within five months, Rodef Sholom's Rabbi Feinberg addressed the moral and spiritual implications of the atomic bomb that brought an end to hostilities in the Pacific. On January 25, 1946, Rabbi Feinberg delivered a talk titled "The Chosen People in the Atomic Age," which posed several questions: "What do we mean by chosen people; are we set aside? And if so for what? Greater responsibilities or privileges?"[259]

Less than one month later, as if to underscore the uncertainties of the postwar era, the local Jewish community learned that thirty-nine-year-old Rabbi Feinberg had died on the early morning of February 25, 1946.[260] Known for his warmth and openness, Feinberg was praised by community leaders as an individual who was committed to building relationships among people of all religions, races and nationalities. Rabbi Feinberg was also prescient. In one of his last holiday sermons, he predicted the immigration crisis that would face European Jews. Warning that "a mighty caravan of all nations" was already "marching resolutely toward the land of promise," the rabbi told his congregation to be ready and that they must "mobilize for peace just as they [were] mobilized for war."[261]

The following spring, the community learned of the death of a longtime Jewish leader who was widely respected for his contributions to the Mahoning Valley. On the evening of March 7, 1947, Clarence J. Strouss, president of the Strouss-Hirshberg Company, suffered a fatal cerebral hemorrhage, just a week after collapsing in his downtown department

store. In a full-page tribute, the *Vindicator* described Strouss as an individual who was "in the forefront of every worthwhile activity in Youngstown, regardless of race, color, or creed" and having "the respect of all groups and all classes."[262] Arguably the city's most prominent Jewish businessman, Strouss was identified in his obituary as a "civic leader," which reflected the extraordinary number of memberships, trusteeships and benefactor roles he held throughout the region. In a unique tribute, Strouss's funeral was officiated by four of the area's leading clergymen: Rabbi Sidney M. Berkowitz of Rodef Sholom, retired rabbi Isadore Philo, Reverend Roland Luhman of the First Reformed Church and Dr. Russell Humbert, pastor of Trinity Methodist Church.[263] Several months after Strouss's death, it was announced that the Strouss-Hirshberg Company would merge with the May Department Store Company, a proposal negotiated for more than a year.[264] Strouss's death struck the Jewish community especially hard. Within a month of the retailer's funeral, Harold Klivans, president of Congregation Rodef Sholom, announced that the temple's remodeled social hall would be known as the Clarence J. Strouss Memorial Hall.[265]

While the postwar era was characterized by tragic losses for the local Jewish community, it also witnessed events that pointed toward a more hopeful future. Less than six months after the death of Rodef Sholom's Rabbi Feinberg, he was succeeded by the aforementioned Rabbi Sidney Berkowitz, who, like his predecessor, graduated from Cincinnati's Hebrew Union College. In addition, Rabbi Berkowitz offered a uniquely international perspective. In 1937, he had been awarded the Mrs. Henry Morgenthau Fellowship to study in Europe, and for the next two years, he pursued his doctoral studies in philosophy at Oxford and Cambridge Universities, in England, and the Sorbonne, in Paris. Rabbi Berkowitz ultimately earned a degree in semiotics from Cambridge University in August 1939, shortly before the outbreak of the war. After volunteering in the

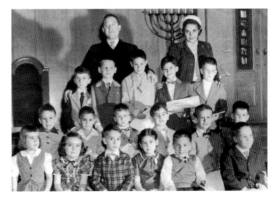

Rabbi Sidney Berkowitz and Sophie Slavin pose with members of a consecration class at Rodef Sholom in 1952. Rabbi Berkowitz, who arrived in Youngstown in 1944, would serve the congregation for thirty-six years. *Courtesy of Mahoning Valley Historical Society.*

chaplain's corps in 1942, the rabbi "served in Hawaii, Saipan and Okinawa and flew to dozens of islands where the air force had bases or contingents of men."[266] Rabbi Berkowitz was formally installed as the spiritual leader of Rodef Sholom on August 20, 1946. Building on the tradition of civic engagement established by his predecessors, he emerged as one of the community's most visible religious leaders.

A little more than a year later, in October 1947, Temple Emanu-El formally announced a campaign to build a new edifice during the installation ceremony of the congregation's new spiritual leader, Rabbi Harry Bolensky.[267] Recognized by many as a regional center of traditional Torah teachings, Emanu-El's new edifice would be located at the corner of Fifth and Fairgreen Avenues and designed to offer "the best in modern facilities for progressive Hebrew education, including club rooms, lecture and social halls, and nursery and playrooms," so that parents could attend services and other temple functions.[268]

Jewish War Veterans, Palestine and the Plight of Jewish Refugees

Several months after the untimely death of Rabbi Feinberg, his prediction of a postwar Jewish immigration crisis began to unfold. In Austria, Jewish refugees were streaming into Vienna at a rate of hundreds per day. Some reports estimated that nearly ten thousand people per month were being smuggled into the American German zone, in an organized movement reminiscent of the American Underground Railroad. Nearly twenty-four thousand people were reported to have entered Italy, with Palestine as their anticipated destination.[269]

In response to the looming crisis, five thousand Jewish war veterans descended upon Washington, D.C., in July 1946 to lodge formal protests with the national government. Leading the delegation of Jewish chaplains was Rabbi Morris Gordon of Youngstown's Anshe Emeth. Traveling to the office of Ohio senator Robert Taft with a group of Jewish veterans from Youngstown, Akron and Cleveland, Rabbi Gordon declared his opposition to the British ban on immigration to Palestine, as well as British imprisonment of Jewish leaders and recent attacks on the Jewish Agency. Senator Taft assured Gordon and his delegation that he stood for "the immediate admission of 100,000 homeless Jews into Palestine" and that he planned "to make his

A historical plaque marks the former site of Ross Radio. After World War II, businessman James Ross, a committed Zionist, played a role in the clandestine shipment of guns and ammunition to Palestine. The building is now occupied by the Tyler Mahoning Valley History Center, a campus of the Mahoning Valley Historical Society. *Courtesy of Nea Bristol.*

feelings regarding the Jewish situation in Palestine known from the floor of the Senate very soon."[270]

In the years that followed World War II, Jewish Agency chairman David Ben-Gurion believed that Jewish Palestine's residents, known collectively as the *Yishuv*, would undoubtedly have to defend themselves against Palestinian Arabs and hostile Arab states. As a precaution, plans for a large-scale, covert arms acquisition campaign in the West were established and coordinated by the semi-clandestine military arm of the Yishuv, the *Hagana*.[271] Irv Ozer and his coauthors explained that residents of the Mahoning Valley not only supported this plan but actively participated in shipping arms to Jewish Palestine.

Starting in 1947, members of the local Jewish community voiced their concern over reports that the British were stripping Jewish settlers of their guns in an effort to ease unrest. Motivated by their belief that the settlers were being left defenseless in a hostile environment, small groups of local Jews began soliciting weapons and ammunition from veterans across the region, including Youngstown, Warren and Sharon. During evening hours, small groups of Jewish residents brought collected weapons and ammunition

to the Ross Radio Company on West Federal Street, where crews packed them into crates marked "radio parts" that were shipped to a warehouse in New York City. From there, the weapons and ammunition were "sorted, matched, cannibalized, repaired, etc., and repacked in crates marked 'farm equipment' and shipped clandestinely to somewhere in Palestine."[272]

The Road to the Creation of a Jewish Homeland

On January 22, 1948, hundreds of well-wishers gathered at Anshe Emeth Social Hall for a "Bon Voyage and Testimonial Dinner" to honor Marvin Itts (Itskovitz), general chairman of the Youngstown Jewish Federation's 1948 fundraising campaign. A youthful industrialist from the city's East Side, Itts was a proven fundraiser who had gained recognition, a few years earlier, for his work as cochair of the annual campaign's general trades division. Five days after the dinner, on January 27, Itts was among twenty-six U.S. Jewish leaders who met at New York's LaGuardia Field to board a Trans-World Airline plane bound for Paris, which would be the starting point of a four-week visit to Europe and Palestine.

As delegates of the United Jewish Appeal, the leaders were expected "to report to their communities on rehabilitation needs" in postwar Europe, as well as Palestine. Fourteen additional delegates were scheduled to travel by ship to meet the remainder of the group in Europe.[273] An early destination in the group's itinerary was the site of Dachau concentration camp, the first internment facility established by the Nazi regime and a place where hundreds of thousands had been tortured and starved to death. Itts himself was photographed as he perused a vandalized sign intended to commemorate the victims of the Nazis.[274] The group's fact-finding mission concluded in strife-torn Palestine, where Itts was among eleven delegates fired upon by snipers as they were driven to Jerusalem in armored cars.[275]

Upon their return in late February 1948, the forty delegates set out to discuss the needs of Palestine and help raise funds for a $250 million national drive. On the evening of May 13, Itts joined in this effort when he took part in a panel discussion titled "Behind the Headlines…in Europe… in Palestine." The event was held at Congregation Rodef Sholom and moderated by Maurice Bernon, national chair of the American Jewish Joint Distribution Committee, a humanitarian organization established to assist

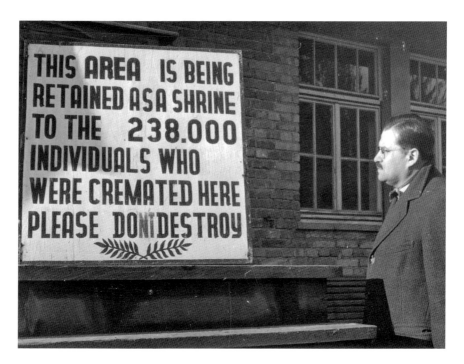

As a delegate of the United Jewish Appeal, business leader Marvin Itts visited the site of Nazi Germany's notorious Dachau concentration camp in 1948. A photographer captured Itts as he examined a marker vandalized by someone attempting to remove part of the word "don't." *Courtesy of Mahoning Valley Historical Society.*

beleaguered Jewish populations worldwide. The panel discussion featured two other recent visitors to Palestine: Pittsburgh attorney Louis Little and Butler, Pennsylvania resident Arthur Jaffe, a former U.S. Army captain who had spent two years in the strife-torn region.[276] Over the next few months, Itts would speak at numerous venues on his experiences in Europe and Palestine. Looking back, his daughter, Marilyn Itts Oyer, recalled this period as "a harrowing time," noting that she spent days and weeks "wondering when [my father] was coming back." Itts's various trips overseas were taken "in the littlest planes," Mrs. Oyer noted. "It was very hard on my mother and us…but we were very proud of him."[277]

On May 14, 1948, in Tel Aviv, Jewish Agency chairman David Ben-Gurion proclaimed the State of Israel, establishing the first Jewish state in two thousand years. Within hours of the announcement of the independence of Israel, the Arab-Israeli War commenced. Five Arab nations—Lebanon, Syria, Egypt, Saudi Arabia and Iraq—invaded lands formerly held within the Jewish Palestinian Mandate. The Israelis, though less equipped in

terms of weapons, managed to fight off the Arabs and seize key territories, including Galilee, the Palestinian coast and a strip of territory connecting the coastal region to the western section of Jerusalem. In 1949, a series of UN-brokered cease-fires left the State of Israel in permanent control of this conquered territory. The newly established borders resembled approximately 75 percent of previous British Mandate Palestine. The remaining 25 percent was divided between Egypt, which agreed to administer the Gaza Strip, and Jordan, which was allowed to annex the area around East Jerusalem and the area currently known as the West Bank.[278]

During this critical period, the local Jewish community organized a series of fundraising events to benefit the fledgling Jewish state. In September 1948, for instance, the Youngstown campaign for the United Jewish Appeal, led by Marvin Itts, organized a $500-a-plate "Destiny Dinner," held at the Squaw Creek Country Club.[279] The event's keynote speaker was film and stage star Eddie Cantor, a vocal Zionist who once played to vaudeville audiences in downtown Youngstown.[280] When Cantor addressed the crowd of more than one hundred people, he dispensed with his usual comedy routine to discuss his recent European tour, emphasizing the material needs of overseas Jewish populations. Stopping at individual tables, "bickering and bartering and bargaining" for hours with patrons, Cantor managed to elicit a staggering $200,000, an average of $2,000 per couple.[281]

Several years later, after Israeli prime minister Ben-Gurion proposed the issuance of bonds to help the country establish a solid economic foundation, Cantor returned to the area to speak on the importance of purchasing so-called Israel bonds. In a 2002 interview, local Zionist leader Joseph Hill recalled that Cantor was challenged by a guest at the event. "After his talk, one of the citizens got up and said the bonds were non-deductible, and you would never get your money back," Hill explained. "And do you know what Eddie Cantor said to that guy? He said, 'Yes, it's not deductible, but neither is a blood transfusion.'"[282]

6
Optimism and Activism

On July 17, 1948, two months after the establishment of the State of Israel, residents of the Mahoning Valley learned of the death of Rodef Sholom's rabbi emeritus, Isadore E. Philo, who succumbed to a heart ailment at the age of seventy-four. Known for the "ringing tones" of his public oratory, Rabbi Philo had served for decades as the unofficial "voice" of the regional Jewish community.[283] For three decades, before health problems intervened, he spoke on issues ranging from the role of religion in a post-Darwinian society to the dangers of anti-Semitism. In more recent years, Rabbi Philo had lent moral authority to local efforts to address the problem of racial discrimination, prompting the Youngstown Interracial Committee, a group with ties to local African American leaders, to praise the late rabbi for his "left-minded sense of duty to his position as a spiritual leader."[284]

While the loss of Rabbi Philo was a blow to the local Jewish community, the region continued to attract exceptional leaders, a trend highlighted in January 1951, when Rabbi J. Leonard Azneer became the spiritual leader of Anshe Emeth. Rabbi Azneer, who earned a doctorate in philosophy from the Jewish Theological Seminary of America, was the former national board director of the National Synagogues of America and served on the National Advisory Committee of the United Jewish Appeal. Moreover, in February 1951, Rabbi Azneer was appointed to the national board of the United Synagogues of America, one of five rabbis in the country selected. The organization, which comprised all of the nation's Conservative

This undated photograph shows members of Youngstown's B'nai B'rith Bowling League, one of scores of recreational organizations that flourished during the 1950s. *Courtesy of Mahoning Valley Historical Society.*

congregations, determined policies for the laity, while setting standards for the theological seminaries that trained rabbis.[285]

Overall, the years that followed World War II were informed by a spirit of optimism. The fact that the United States—alone among the Allies—was unscathed by the wholesale bombing that destroyed industry and infrastructure elsewhere contributed to a collective attitude of invincibility. "The US had the only significant economy and military left standing after the war, largely because our land had not been bombed," a later newspaper article observed. "This put us in a position of special and unequalled power. Our military could not be challenged, and our economy had open global markets with no competition."[286]

Such confidence was prevalent in regions like the Mahoning Valley, whose steel industry had contributed so much to the war effort. Yet, in the face of widespread optimism, trends in the nation's industrial sector were working against places like Youngstown, Warren, Sharon and Farrell. America's once formidable industries were overwhelmed by numerous factors, including "the transformation of industrial technology, the acceleration of regional

and international competition, and the expansion of industry in low-wage regions, especially the South." A regional shift in industry was evident as early as the 1930s, when the government "channeled a disproportionate amount of resources to the South." This trend was accelerated by developments in transportation. Federally subsidized highway construction "made central industrial location less necessary by facilitating the distribution of goods over larger distances."[287] In time, this change would render the area's massive urban steel-production plants (all located along major rail lines) artifacts of the past.

Most residents of the area were blissfully unaware of these developments. The decline of the area's steel industry was gradual, and the postwar "baby boom" temporarily masked a steady decrease in urban populations. Since regional schools and congregations were compelled to build additions (or new physical plants) to accommodate the postwar generation, most observers anticipated a pattern of continued growth, if anything. Meanwhile, the Cold War politics of the era "prompted American leaders to depict the American nation as strong, unified, and steadfast in its devotion to timeless ideals," a trend that distracted large segments of the public from contentious domestic issues, such as racial discrimination and widespread poverty.[288]

THE POSTWAR "CHURCH BOOM"

The baby boom was not the only contributing factor to the expansion of Jewish institutions in the postwar era. The vitality of the region's Jewish community must be understood in the context of a religious revival that swept the United States during the late 1940s and early 1950s. As the nation emerged from the horrors of World War II, a renewed commitment to spirituality was reflected in the rise of celebrity theologians like the Reverend Norman Vincent Peale, the Reverend Billy Graham, Bishop Fulton Sheen and Rabbi Joshua Liebman, author of the bestselling *Peace of Mind*, a meditation on the relationship between spirituality and psychology. Less than a decade after the war's conclusion, almost 60 percent of Americans belonged to a religious congregation—an all-time high. Hence, new houses of worship "sprouted like mushrooms on the suburban landscape."[289]

By the summer of 1948, the local media reported the spike in construction, and the *Vindicator* noted that the area was "experiencing a church building boom."[290] In the Jewish community, this trend was reflected, at first, in modest construction projects. In March 1948, for instance, Rodef Sholom

showcased Clarence J. Strouss Memorial Hall, which had been initiated by Rabbi Berkowitz two years earlier, shortly after the congregation's eightieth anniversary. In June of that year, the remodeling project was carried out under the direction of local architect Morris W. Scheibel and building chairman Harry Spero.[291]

A year and a half later, in October 1950, the congregation of Anshe Emeth gathered to dedicate their new Leon J. Knight memorial chapel, funded through a family bequest to honor the memory of the late attorney Leon J. Knight, who died in 1942. During the chapel's dedication, speeches were delivered by the congregation's prospective spiritual leader Rabbi J. Leonard Azneer, Anshe Emeth's Cantor Ernest Gottesman and Rabbi Morris Gordon, who led the congregation from 1942 to 1947.

More ambitious construction projects were on the horizon, all of which involved Morris Scheibel, a prominent local architect noted for his 1929 design of Central Tower, a landmark of downtown Youngstown. Among the largest of these projects was the proposed new edifice of Temple Emanu-El, predicted to cost about $500,000. Congregation president Max Myerovich explained that the building itself would require $200,000, with the remainder of the funds covering furnishings and equipment. On September 14, 1951, after seven years of planning and fundraising, the 345 families of the congregation gathered to dedicate their new synagogue in a three-day celebration, presided over by Emanu-El's Rabbi Harry Bolensky and Cantor Ichak Gross. The congregation's two-story limestone and brick building, designed by Scheibel, stretched 105 feet by 95 feet across a manicured lawn facing Fifth Avenue, still dotted with the Tudor-style homes of the city's erstwhile industrialists.[292]

By this time, congregants of Sharon's Temple Beth Israel, located just east of the Ohio-Pennsylvania border, had dedicated their new $100,000 temple complex at the corner of Highland Road and Euclid Avenue. On September 10, 1950, the congregation held services for the last time in their old synagogue on Shenango Street.[293] The dedication ceremony came just five years after the congregation's momentous shift from Orthodox to Reform Judaism, and Morris Scheibel's design for the new temple reflected this development. In line with tradition, Temple Beth Israel's buff brick edifice faced east on Euclid Avenue, nestled on a fifteen-foot grade. At the same time, Scheibel took steps to ensure that the structure's design would not draw "inspiration from strange and unfriendly antiquities." Among the structure's distinctive features was the sanctuary, with its high ceilings and towering ark of polished quarter-sawn oak. Flanked by bronze menorahs,

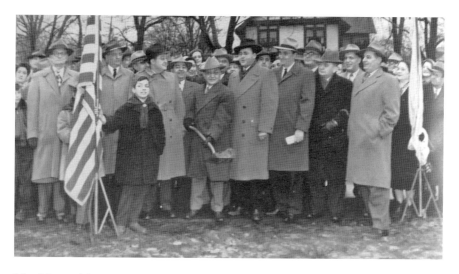

Max Meyerovich, president of Temple Emanu-El, breaks ground during a 1950 ceremony to initiate the construction of the congregation's second edifice on Youngstown's Fifth Avenue. *Courtesy of Mahoning Valley Historical Society.*

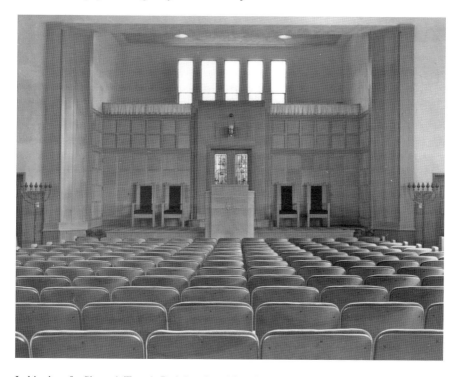

In his plans for Sharon's Temple Beth Israel, architect Morris Scheibel eschewed the eclectic styles often employed in the past. His spare, straightforward design reflected his expressed desire to capture the true essence of Judaism. *Courtesy of Mercer County Historical Society.*

the ark stood below a carved Hebrew inscription that translated as, "Know thou before Whom thou standeth." Designed to serve as the community's social and educational center, the new complex featured classrooms, a social hall and an industrial kitchen.[294]

A few months later, on March 18, 1951, the congregation of Warren's Temple Beth Israel broke ground for the construction of its new building on East Market Street. Among those who turned the first shovelfuls of dirt at the ground-breaking ceremony were Beth Israel's spiritual leader Rabbi Salamon Faber, Cantor Joseph Rakusin and Max Reisman, chair of the congregation's building fund committee. The proposed complex, designed by Morris Scheibel and Wilbert H. Shaffer, reflected the congregation's anticipation of future growth. The *Tribune* reported that the $250,000 building would "be so constructed so that it will be possible to make additions to it at a future date." While the sanctuary could hold four hundred people,

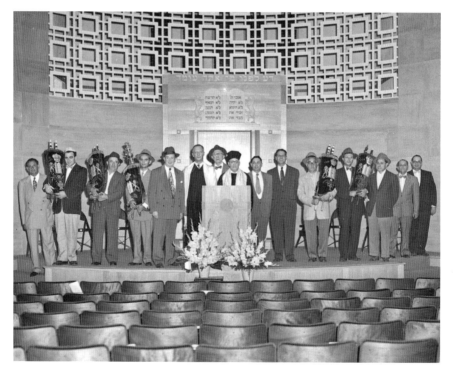

Participants in the 1952 installation of the Torahs at Warren's Beth Israel Temple Center included (*left to right*) Abe Knofsky, Morton Solomon, Morris Narotsky, David Sieman, Max Reisman, Rabbi Salamon Faber, Joseph E. Lavine, Cantor Joseph Rakusin, Harry Klivan, Milton Gordon, Burt Saddle, Leonard Lavine, Eugene Kay, Sam Newman and Louis B. Shultz. *Courtesy of Louise Shultz.*

it was designed so that seating could "almost be doubled by rolling back modern folding doors between the sanctuary and social hall."[295]

The new Beth Israel Temple Center was consecrated about a year and a half later, on September 11, 1952, when congregation president David Sieman carried the *Sefer* Torahs from the old temple and building fund chairman Max Reisman placed them in the ark of the new building.[296] Tellingly, the structure was "the third of its type in the neighborhood," given the recent completion of new edifices for Central Christian Church and SS Peter and Paul Byzantine Catholic Church.[297] Cleveland native Louise Shultz, who moved to the area several years after her marriage to local dentist Dr. Bernard Shultz, recalled the community as "welcoming" and somewhat diverse, since Jewish residents "had a Christian neighborhood mixed in."[298]

During this time, plans for another major construction project were percolating on Youngstown's South Side. Since the completion of its first synagogue in 1925, the congregation of Ohev Tzedek had been dedicated to growing its membership and building a larger facility. During and after World War II, the congregation continued to grow under the spiritual leadership of Rabbi Chaim Applebaum and, later, Rabbi David Massis. By the end of the 1940s, however, the neighborhood around the synagogue was deteriorating, and some congregants pushed for the synagogue's relocation farther south, near Boardman Township. In March 1950, the congregation formally requested that the federation conduct a survey to determine whether a new synagogue on the South Side was feasible or even necessary. When the federation approved the project, Ohev Tzedek's leadership initiated the building project with a campaign goal of $200,000.[299]

Plans to build a new edifice for Ohev Tzedek coincided with other significant developments. In 1953, Herman Roth, president of Ohev Tzedek, announced that his congregation planned to merge with the "virtually defunct" East Side congregation of Shaarei Torah, which had long struggled to maintain its independence. By the early 1950s, Shaarei Torah's membership had dwindled to the point where it could no longer support a separate facility. Leaders of the merged congregation, known as Ohev Tzedek–Shaarei Torah, announced that future worship services would be conducted at the South Side synagogue. On the surface, Shaarei Torah appeared to benefit disproportionately from the merger. In truth, though, the transaction benefited both congregations. Shaarei Torah secured a larger, better-equipped edifice, as well as a growing membership, while Ohev Tzedek gained access to the smaller congregation's cemetery on Tippecanoe

After the two congregations merged in March 1954, Ohev Tzedek gained access to Shaarei Torah's cemetery in Cornersburg, Ohio. Until then, Ohev Tzedek was the only active congregation without its own burial ground. *Courtesy of Nea Bristol.*

Road, near Cornersburg. For decades, Ohev Tzedek had been the only active congregation in the Youngstown area without its own burial ground, a situation that changed after the merger.[300]

After Ohev Tzedek and Shaarei Torah formally merged in March 1954, plans for a new synagogue began to take shape. In time, sixteen acres were purchased on Glenwood Avenue, just south of Shields Road. This tract of land allowed for parking, as well as space for future expansion projects. In July 1956, the merged congregation welcomed its new spiritual leader, Rabbi Arnold Turetsky, and the next year, in September 1957, the new building was completed.[301] Mrs. Florine Rusnak, a seventeen-year-old Sunday school teacher when the building project was underway, took a group of students to the site to view the structure's unfinished dome. "The only thing up there was the wooden framework, and the cement floors…but those fifteen little kids would stand in that huge room and look up," she recalled.[302] The formal dedication of the temple on Glenwood Avenue took place on May 17, 1958, about eight months after the congregation's Torah scrolls were transferred from the former synagogue on Myrtle Avenue.[303]

Not surprisingly, the construction of the new complex put a strain on the congregation's financial resources, and within a year, the membership

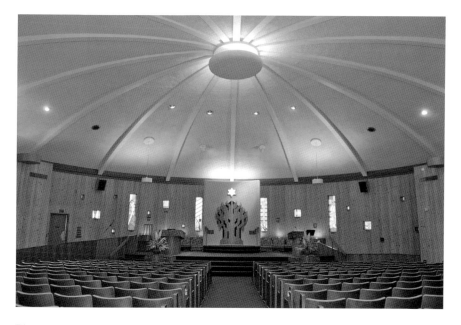

The new edifice of Ohev Tzedek–Shaarei Torah served simultaneously as a house of worship, a meeting place and a house of study. Under Rabbi Arnold S. Turetsky, the congregation became formally affiliated with United Synagogues of America (now the United Synagogue of Conservative Movement), the primary organization of the Conservative Movement in North America. *Courtesy of Nea Bristol.*

of Ohev Tzedek–Shaarei Torah was compelled to focus, once again, on fundraising. A traditional method to raise funds was to produce entertaining shows for the public. In 1959, temple members Shy Lockson and Mrs. Bea Santer launched what became known as "O.T. Productions," a vehicle to produce high-quality musical shows for the temple's benefit. Mrs. Santer, known to be "gifted in the verbal arts," was an ideal partner for Lockson, a versatile musician and bandleader who ran a tailoring business in downtown Youngstown. What set O.T. Productions apart was its capacity to attract people from diverse backgrounds and encourage them to work together in a spirit of friendship and community.

Each year, Lockson and Mrs. Santer produced elaborate shows that drew hundreds of people from an array of backgrounds. During the company's showing of *My Fair Lady* in 1965, almost fifty churches and synagogues were represented on stage or behind the scenes. After producing more than eighteen shows in as many years, O.T. Productions netted the congregation more than $150,000. By the mid-1960s, proceeds from these musical productions had positioned Ohev Tzedek–Shaarei Torah to begin

construction of a $100,000 religious school, to be connected to the temple by a large, paneled foyer. The six-thousand-square-foot building included classrooms, a chapel, a youth lounge, an office complex and parking space for more than one hundred vehicles.[304]

Yet, not all local religious institutions were growing. By the end of the decade, another congregation was planning to vacate its original building, though under different circumstances. After almost sixty years at their synagogue on Summit Avenue, leaders of the congregation of Children of Israel began to explore the possibility of relocating. Apart from the fact that its building was in need of repair, the congregation faced an aging membership, a declining neighborhood and changing demographics. In addition, a devastating fire had left the congregation without a working *mikvah* (ritual bathing pool). Hence, in 1959, the congregation purchased the former Klivans mansion, located on the corner of Fifth and Alameda Avenues, and retrofitted it to serve as a synagogue. The home's living room became the congregation's main sanctuary, with seating for women in the former dining room. Meanwhile, the basement was remodeled to serve as a social hall, and a nearby sunroom was converted into a chapel for daily minyan and special services.[305]

Building a Jewish Infrastructure

During this period of rapid growth, the shrinking of Children of Israel may have struck observers as an anomaly. For many local Jewish residents, the community's postwar vitality was exemplified by the opening of a state-of-the-art Jewish Community Center on Youngstown's North Side. In June 1950, the project moved into high gear under the leadership of Stanley Engel, the newly appointed executive director of the Youngstown Jewish Federation. Passionate and outspoken, Engel was well known in northeastern Ohio. First employed by the federation as a caseworker in 1939, he was named tristate director of the Cleveland-based Jewish Welfare Council in 1943. By 1945, however, Engel was back in the Mahoning Valley, where he served as acting director of the Youngstown Jewish Federation while the organization's official director, Leonard Seliger, completed his military service. He then worked for several years as director of the federation's Jewish Community Relations Council.

Two weeks after Engel became the federation's executive director, local business leader Marvin Itts spearheaded a $200,000 building fund campaign

More than one thousand people were in attendance at the dedication of the Youngstown Jewish Community Center on August 19, 1954. The facility offered the space and range of activities to accommodate a wide variety of people within the local Jewish community. *Courtesy of Mahoning Valley Historical Society.*

for the project. Along with Ralph Lebowitz, chair of the building and planning committee, Itts engaged the architectural firm of Scheibel and Shaffer to develop plans. About four years later, on August 19, 1954, more than one thousand people from across the Mahoning Valley gathered at 505 Gypsy Lane in Youngstown to inspect the new Jewish Community Center. Within a month, the Youngstown Jewish Federation had transferred its operations from the old center on Bryson Street to the Gypsy Lane facility. In 1960, just six years after the completion of the new facility, local Jewish leaders gathered for the dedication of the Jewish Community Center's long-awaited Schwebel Natatorium. The construction of the huge indoor swimming pool was made possible through an initial $40,000 gift from the Schwebel children in honor of their mother, Dora Schwebel, and in memory of their late brother, Dr. Samuel Schwebel.[306]

The completion of the Youngstown Jewish Community Center represented the culmination of a multigenerational dream. For almost a century, the synagogue had functioned as the chief venue for religious and social interaction among local Jews, and engagement with the Jewish community

The dedication of the Jewish Community Center's Olympic-size swimming pool in 1960 drew leaders from around the area. Known as the Schwebel Natatorium, the pool was made possible through an initial $40,000 gift from the Schwebel family. *Courtesy of Mahoning Valley Historical Society.*

often depended on congregational affiliation. The Jewish Community Center provided the space and range of activities to accommodate a much wider variety of people: male and female, young and old, religious and secular. Never before had Jewish residents of the Mahoning Valley benefited from this level of community-wide, interreligious and interethnic mass programming.[307]

During this period, Stanley Engel presided over another project that would prove to be of long-term value to the Jewish community. After his appointment as executive director of the federation, Engel made it clear that he had two priorities: building a modern Jewish Community Center and a nursing home for elderly Jewish residents.[308] The need for the latter institution had become increasingly apparent. For more than a century, the welfare of older Jewish residents had depended on the initiative of relatives and neighbors. While limited assistance was available through charitable agencies like Jewish Family and Children's Services, the Jewish community lacked a standalone institution dedicated to the care of the elderly. Given

that the region's Jewish population included more than six thousand people in the postwar era, a well-defined plan for elder care, including funeral and burial arrangements, was critical.

Stanley Engel's commitment to the project was total. Decades later, his sons, Brian and Alan, indicated their father's passion for the facility owed much to his personal experience with institutions during his formative years. Born to Hungarian immigrants in 1917, Engel had lost his father when he was six years old, and his struggling mother was compelled to send her sons to Cleveland's Bellefaire Orphanage (now Bellefaire Jewish Children's Bureau). "His entire childhood…was spent in the Jewish orphanage," Brian Engel explained. Alan Engel agreed that his father's upbringing in an institution shaped his priorities, adding that, while Stanley Engel was not religious, he was committed to "Jewish values and the concept of *tikkun olam*, which is 'repair the world.'"[309]

The federation's vision for a local elder-care facility may not have been realized without a generous bequest from a member of one of the community's prominent families. In September 1959, Mrs. Helene Strouss Meyer, sister of the late Clarence Strouss, gifted $100,000 to the federation to be used toward the construction of a home for the aged. Envisioned as a challenge to the community, the contribution was made under the condition that the community would raise the remainder necessary to complete the project. The federation immediately authorized the appointment of a planning and development committee under the leadership of Leslie Spero.[310] This committee studied scores of elder-care homes across the country, weighing the strengths and weaknesses of each. One of the most important features of the home's design was to "meet the medical needs of its residents with a centralized nursing station, physical and occupational therapy facilities and treatment rooms."[311]

After Mrs. Meyer's initial bequest, events unfolded swiftly. In May 1960, Phillip Levy was appointed general chairman of the $350,000 fundraising drive. The following year, Dr. Saul Tamarkin accepted the chairmanship of the building committee. In April 1963, ground for the facility was broken on Gypsy Lane, and less than two years later, on March 7, 1965, construction was completed. Under Engel's direction, the building was opened to the public, with Marvin Itts serving as the facility's first president, Meyer Pollack as administrator, Dr. William Loeser as medical director and Mrs. Pauline Moranz, RN, as head nurse. The facility was named Heritage Manor, Jewish Home for the Aged, conspicuously preserving Helene Meyer's initials, after she declined the use of her name. "She did a lot for the community," her granddaughter Marebeth Meyer Lurie recalled, "but she didn't put her name on things."[312]

A plaque at Youngstown's Heritage Manor commemorates Stanley Engel's crucial role in the institution's establishment. As executive director of the Youngstown Jewish Federation, Engel made the development of a well-defined plan for elder care a priority. *Courtesy of Nea Bristol.*

In line with Engel's vision of a "functional federation," the new facility served as a department of the Youngstown Jewish Federation. "The opposing model would be like Cleveland," explained attorney James Pazol, noting that elder-care facilities like Menorah Park and Montefiore Home serve as independent nonprofit organizations. "Here, the executive vice president of Heritage Manor is directly responsible [to] the executive vice president of the Jewish Federation," Pazol observed. While these departments maintain boards and have their own budgets, they must seek the approval of the budget committee or board of the Jewish Federation before engaging in fundraising. "Stanley Engel… kept everything really tight and under control," Pazol added.[313]

BREAKING DOWN BARRIERS

The period of explosive development that followed World War II was informed by a sharp decline in anti-Semitism. American anti-Semitism had peaked in the years leading up to the nation's involvement in the war. However, with the defeat of Nazi Germany "and the increasing awareness of what happened to the Jews during the Holocaust…antisemitism in the United States, while not entirely erased, began a downward spiral."[314] While this trend was encouraging, the apparent marginalization of religious and racial intolerance in the country was no guarantee that discriminatory practices

would end. On the contrary, as Howard M. Sachar observed, "[I]f antisemitism retreated to the fringes of American life, the elements that huddled at those fringes were never uglier or more virulent." The 1950s and '60s witnessed the escalating violence of a resurgent Ku Klux Klan in the South, and in the wake of Jewish leaders' participation in the civil rights movement, "these groups mounted isolated attacks on synagogues and Jewish centers, even occasionally on rabbis and Jewish laymen in their homes."[315]

Politically, the American Jewish community had undergone a transformation since the early twentieth century, when many Jewish leaders were solidly in the Republican camp. A gradual shift to the Democratic Party, which became apparent during the Republicans' xenophobic 1928 campaign against Roman Catholic presidential candidate Al Smith, concluded during the long tenure of Franklin D. Roosevelt. While pockets of Jewish political radicalism persisted into the late 1940s, often in the form of support for the American Progressive Party, "hair-shirt radicalism gradually ceased altogether to be a meaningful factor in Jewish political identification." This trend owed much to the Democratic progressivism of the New Deal,

Local businessman and Zionist leader James Ross poses with former president Harry Truman during his visit to the Youngstown area in the 1950s. *Courtesy of Mahoning Valley Historical Society.*

but Jewish leftists were also disturbed by revelations of Soviet leader Josef Stalin's anti-Semitism, and many were inspired by the creation of a Jewish state, which "tended to displace and refocus the old leftist allegiances."

Jewish voters largely supported the legacy of Roosevelt's New Deal, reflecting a collective belief "that their security depended with almost mathematical exactitude upon a healthy economy and on strong judicial barriers between church and state." During the presidential election of 1952, which ended in a landslide victory for Dwight D. Eisenhower, Democratic candidate Adlai Stevenson secured 74 percent of the Jewish vote, as he would in the subsequent presidential election of 1956. Four years later, in 1960, Jewish voters gave Democratic candidate John F. Kennedy "81 percent of their votes, more than he received from his fellow Catholics." The political acculturation of American Jews, however, coexisted with an awareness of their minority status, as well as sensitivity to all forms of institutional

Rising political star John F. Kennedy meets with civic leaders Dr. Nathan Belinky (*second from left*) and Marvin Itts (*third from right*) during a 1959 reception at Youngstown's Mural Room. Other attendants include contractor William M. Cafaro (*far left*), Congressman Michael J. Kirwan (*second from right*) and political leader Stephen Olenick. *Courtesy of Mahoning Valley Historical Society.*

discrimination. While southern Jews were more circumspect on the issue, nowhere "did Jews identify themselves more forthrightly with the liberal avant-garde than in the civil rights movement of the 1960s."[316]

On a local level, Rabbi Sidney Berkowitz of Rodef Sholom condemned institutional racism while promoting interracial cooperation. Following in the footsteps of his predecessor, Rabbi Isadore E. Philo, Rabbi Berkowitz spoke out against racial bigotry as early as 1949, just five years after his arrival. In the early 1950s, Rabbi Berkowitz received the Arvona Lynch Award, presented each year to a white resident "for being an eager exponent of good human relations." Recipients for the honor were selected by two institutions of the local African American community, the Roberts Deliberating Club and the *Buckeye Review*, a weekly newspaper edited by Nathaniel R. Jones, a future federal judge. In 1958, Rabbi Berkowitz served as a sponsor (along with the local chapter of B'nai B'rith) of a widely distributed pamphlet titled *Challenge…to the People of Youngstown*. In its analysis of the city's housing problems, the pamphlet noted that systematic racial discrimination was among factors contributing to the imminent deterioration of the central business district and the ongoing decline of urban neighborhoods.[317]

While Rabbi Berkowitz was among the most visible Jewish leaders to support the burgeoning civil rights movement, he was not alone. Alice Lev and Abe Harshman, both members of the Youngstown Interracial Committee, emerged as formidable opponents of racial discrimination. Mrs. Lev, a trained nurse and psychiatric social worker, joined the local chapter of the NAACP in the 1950s, not long after she recognized the difficulty of maintaining friendships with African Americans. She was deeply shocked by some of her North Side neighbors' responses to a friendship she established with Frances Osborne, a program director at Youngstown's YWCA. "She came to the house and often stayed overnight with us," she explained, adding that angry neighbors threw rocks at a commercial vehicle owned by her husband, Irv, a local contractor.[318]

Acutely aware of the community's de facto segregation, which rendered certain businesses "off limits" to black customers, Mrs. Lev joined forces with Abe Harshman and African American social worker Ralph Clark to break down such barriers—a product of tradition, as opposed to legislation. Florence Harshman, wife of the late Abe Harshman, recalled that the group's targets included the Jewish-owned 20th Century Restaurant, "where blacks did not go." One evening, the trio entered the North Side establishment, where they encountered a hostess who "didn't know what to do," Harshman explained. When the hostess approached proprietor Harry Malkoff and

asked him how to respond, he calmly advised her to seat the group. "They were seated, and that was the end of it," Mrs. Harshman said. "So…some of it was self-segregation, but there definitely *was* segregation."[319]

The rise of the Youngstown Interracial Committee overlapped with a period of dramatic demographic change in the Mahoning Valley. As migration from the South rose in the postwar era, media references to the community's growing minority population became more frequent. A 1951 newspaper article, for example, quoted a U.S. Census Bureau report that suggested the migration of defense workers was responsible for the growing percentage of "nonwhites" living in the community. The same article noted that "the nonwhite population increased from 14,664 to 21,547 between 1940 and 1950, while the white population dropped [by] almost an equivalent number, from 153,056 to 146,781."[320] The sharp rise in African American migration during this period contributed to chronic overcrowding in the city's traditional black neighborhoods. More established African American residents, seeking relief from congested living conditions, began to migrate to overwhelmingly white neighborhoods, where they often encountered hostility.

Evidence of racial tension was not difficult to find in the mid-1940s. In September 1945, the *Vindicator* published an editorial on a series of disturbances involving white and black youths. The editorial, which praised the municipal government's decision to enforce a curfew to discourage race-related gang violence, acknowledged that the local black community "still has real grievances." However, the editorial contended that "leaders who influence Negroes to demand extremes in social acceptance are only hurting their own people."[321] Such "extremes" apparently included black demands for the integration of local swimming pools. In 1949, another *Vindicator* editorial described a campaign to "force the acceptance of Negroes in all of the city's swimming pools" as the work of left-wing agitators. The editorial claimed that the campaign's supporters included "political factions, the C.I.O., and now the 'Young Progressives,' a Communist front organization."[322] Exposure to such epithets became routine for activists like Alice Lev, who was criticized by local journalist Esther Hamilton, who wrote a popular column. "She alluded to the 'fact' that I had 'communist tendencies,' that this is a communist talking," Mrs. Lev recalled.[323]

Beyond their involvement in the Youngstown Interracial Committee, Alice Lev and Abe Harshman took an active role in municipal politics. Between 1959 and 1961, Harshman, a certified public accountant, was finance director under Youngstown mayor Frank R. Franko, earning a reputation for honesty in an administration that was widely perceived as corrupt. He also served on

This *Vindicator* photograph, taken at an October 28, 1983 awards ceremony, shows (*left to right*) local social activist Ron Pittman, civil rights leader Julian Bond, social activist Alice Lev, local NAACP president Roland Alexander, social activist Doris Perry and social activist and former Youngstown finance director Abe Harshman. Harshman and Lev were among three recipients of the NAACP Community Service Award. *Courtesy of the* Vindicator.

the Youngstown Board of Education, acting as board president in 1969 and 1970—a challenging period marked by a fiscal crisis and tension between African American parents and a largely white teachers' union.

In 1964, Mrs. Lev joined the administration of Mayor Anthony B. Flask as a member of the mayor's Human Relations Commission, which was dedicated to promoting interracial cooperation. Four years later, in 1968, as the commission's executive director, she worked with African American leaders including activists Ron Pittman and Walter Diehl; journalist Andrew Diehl; surgeon Dr. Earnest Perry and his wife, Doris; and obstetrician Dr. Henry Ellison. In 1969, Mrs. Lev and Harshman were instrumental in the creation of the Youngstown Area Development Corporation (YADC), an agency intended to provide technical assistance to minority men and women seeking self-employment in the construction business. Mrs. Lev served as executive director of YADC, while Harshman was active as a board member.

Momentous Developments of a Turbulent Era

The years that followed the assassination of President John F. Kennedy in November 1963 were marked by the optimism of civil rights advocates and the growing horror of those who questioned the nation's deepening military involvement in Vietnam. After the Kennedy assassination, Rodef Sholom's Rabbi Sidney Berkowitz, whose congregation was double its usual size, speculated that people were bewildered and "felt the need for prayers and [an] ability to express their shock."[324] Similarly, Emanu-El's Rabbi Harold Schecter stated that "this Sabbath eve will undoubtedly go down as one of the worst episodes in the annals of American and human history."[325] The American Jewish community's response to the tragedy was reflected in a firmer commitment to liberal political values. During the presidential election of 1964, Jewish voters came out in force for Kennedy's successor, President Lyndon B. Johnson, giving him an astounding 89 percent of their votes, "the highest pro-Democratic percentage of any white religious or ethnic group."[326]

By this time, however, the old verities of postwar consensus liberalism were starting to unravel. Across American campuses, the escalation of U.S. military involvement in Vietnam fueled the rise of the so-called New Left, a youth movement that challenged "the cumbersome mechanism of representational democracy," in the belief that "change would be affected by confrontation and disruption, by mass marches and 'sit-ins' at campus and government buildings." While the movement drew inspiration from "such earlier American crusades as abolitionism and prohibitionism," some of its most visible proponents were Jewish, including Gar Alperovitz, Richard Barnet, Marcus Raskin and Arthur I. Waskow, whose 1971 political testament, *The Bush Is Burning*, chronicled the disenchantment of young Jews with mainstream American values.[327]

Amid the disruptions of the era, members of the region's oldest Jewish congregation gathered to mark its centennial. Faced with the period's jarring changes, many local Jews probably looked to Congregation Rodef Sholom as a symbol of continuity. On Friday, May 13, 1967, more than five hundred people listened as Rabbi Alexander Schindler, national director of education of the Union of American Hebrew Congregations, spoke from the temple's pulpit on the larger significance of the congregation's anniversary. Stressing Rodef Sholom's historical importance, Rabbi Schindler reminded members that the congregation had been one of twenty-three temples involved in the establishment of the Union of American Hebrew Congregations. Less

To promote interfaith and interracial cooperation, Alice Lev and her husband, Irv (*third from left*), hosted a series of discussions at their North Side home. This March 1968 photograph captures a dialogue involving members of the American Jewish Committee and Catholic Interracial Council. *Courtesy of Catholic Exponent.*

than a century later, he observed, the Union consisted of more than seven hundred temples in fifty states, with a membership of over one million. Rabbi Schindler declared that Rodef Sholom's centennial was "a moment of joy not just for the congregation but for all of us."[328]

Within weeks of Rodef Sholom's centennial, the collective attention of the local Jewish community was drawn, once again, to the burning issues of the day. This time, however, the events in question unfolded in the Middle East, and their impact proved galvanizing. Throughout the spring of 1967, the Egyptian government had been amassing forces along the Israeli border in the Sinai Peninsula. In response, the Israelis initiated a series of devastating preemptive strikes against Egyptian airfields. Caught off guard, the Egyptian air force was almost completely destroyed, while the Israelis suffered relatively few losses. At the same time, the Israelis launched a ground offensive into the Gaza Strip and the Sinai Peninsula. The unprepared Egyptians offered little

resistance, and their leader, Gamal Abdel Nasser, was forced to order an evacuation of the Sinai Peninsula. Pursuing the Egyptians westward, the Israelis were able to inflict heavy losses and eventually captured the Sinai. In a desperate attempt to salvage the situation, Nasser convinced the neighboring countries of Jordan and Syria to attack Israel. Fierce counterattacks by the Israelis resulted in the seizure of the West Bank and East Jerusalem from Jordan, as well as the capture and occupation of the Syrian-controlled Golan Heights.

Many local Jewish residents remember exactly where they were when they learned about the outcome of the so-called Six-Day War. In June 1967, David Mirkin was preparing for his bar mitzvah at Temple Emanu-El, and he recalled that his instructor, Cantor Noah Griver, a native of Israel, was "a wreck," seizing every opportunity to listen to news updates on the radio. "That had an impact on me as a kid, but I don't think I…understood the ramifications of what was happening," he added. His brother, Jeffrey Mirkin, indicated he retains a strong impression of the pride he felt in his Jewish heritage. "I think it instilled a sense of patriotism that…you probably didn't really know you had before," he said.[329] Meanwhile, Neil Yutkin, a student at Liberty High School, recalled that the events of 1967 facilitated a subtle change in local perceptions of the Jewish community. "Sixty-seven was the time that Israel was first recognized as a military power, and that made a difference, I think, in the community," he noted.[330]

Few area residents were more deeply affected than Dr. William Lippy, a renowned hearing-restoration surgeon based in Warren. For Dr. Lippy, the Six-Day War was the point "when everything changed." He recalled that he "dabbled in the Jewish community until '67," noting that the war also inspired within him a strong commitment to Israel. On the domestic scene, Dr. Lippy went on to serve on the national board of the United Jewish Appeal, became an active member of the Young Leadership Cabinet of the Jewish Federations of North America and headed the Warren Jewish Federation's annual campaign during a five-year period when the city ranked first in the nation for per capita giving.

Then, starting in 1968, he spent long intervals working and teaching in Israel, serving at one point as a visiting professor at Jerusalem's Hadassah-University Medical Center. In the 1970s, he joined forces with five other international physicians to establish a nonprofit organization known as Israel Tennis Centers, designed to improve the quality of life for Israeli children by enabling them to develop "life skills" through the medium of sports. "We came to Warren and borrowed $2 million from the Second National Bank,

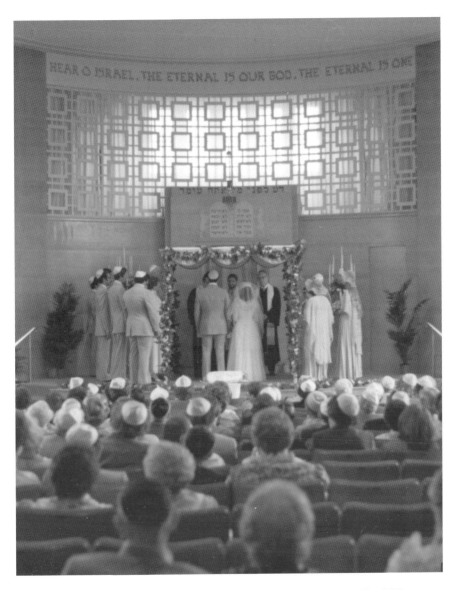

This photograph, taken during the 1978 wedding of Miriam Ellyn Shultz and Daniel Steven Rose at Beth Israel Temple Center, captures the vitality of Warren's Jewish community before the impact of deindustrialization became apparent. *Courtesy of Louise Shultz.*

with the idea to build one tennis center," he explained. The center was intended to serve as a place where the Davis Cup team could practice, while the children played in the next court, "so a standard for kids could be seen," Dr. Lippy added.[331] Since then, the organization has continued to grow, and

it now maintains fourteen tennis centers throughout Israel that serve more than twenty thousand children every year.

Throughout the Mahoning Valley, Jewish leaders responded to developments in the Middle East with similar interest. Many joined in a concerted effort to convince administration and congressional leaders that the United States must support Israel in its time of crisis. Over sixty representatives from Jewish adult and youth organizations met at an emergency meeting of the Jewish Community Relations Council (JCRC) to discuss the latest reports from the national leadership.[332] Within hours, an Israel Emergency Fund drive was authorized by directors of the Youngstown Jewish Federation, which contributed $172,000 to the effort. Furthermore, a delegation was sent to a special conference in Washington to hold a community-wide rally to discuss the latest developments. Among those chosen to represent the Mahoning Valley in Washington was attorney Phillip Millstone, chairman of the JCRC, which was coordinating the work of all Jewish organizations to support Israel's "humanitarian needs during time of war."[333]

Given that Israel was encircled by enemy states, the conflict represented the single greatest threat to the nation's existence since its establishment almost twenty years earlier. Nevertheless, in a decade characterized by assassination, social unrest and crushing disillusionment, the Israeli victory in the Six-Day War offered American Jews a moment of unmitigated pride, accompanied by something resembling hope. As Simon Sebag Montefiore observed, "A decision that had been taken in panic, a conflict that was never planned, a military victory stolen from the edge of catastrophe, changed those who believed, those who believed nothing and those who wanted to believe in something."[334]

7

Boom to Bust

On April 4, 1968, civil rights leader Dr. Martin Luther King Jr. was shot down by an assassin during a visit to Memphis, Tennessee. When news of Dr. King's death reached the Mahoning Valley, civic and religious leaders issued statements expressing shock and sorrow. In Warren, Rabbi Robert Kaufmann, spiritual leader of Beth Israel Temple Center, participated in an interfaith memorial service at the city's First Methodist Church. The following evening, at Youngstown's Congregation Rodef Sholom, Rabbi Sidney Berkowitz told congregants that while many were concerned about the prospect of violence in the wake of Dr. King's murder, thoughtful citizens would treat the incident "not as a justification for equally senseless acts of violence but as a clear call to duty."[335]

About two months later, on June 5, 1968, U.S. senator Robert Kennedy was fatally wounded by a gunman as he walked through Los Angeles's Ambassador Hotel. Senator Kennedy's death occurred minutes after he addressed a crowd of supporters who were celebrating his victories in the California and South Dakota primary elections for the Democratic nomination for president of the United States. Several days after the senator's assassination, the region's Jewish community paid tribute to the political leader with a series of memorial services. Rabbi Berkowitz, in a sermon to almost four hundred congregants at Rodef Sholom, praised Kennedy's fight for social justice, as well as his tireless advocacy for the poor.[336] Many suspected these tragic developments would transform the country beyond recognition.

In the Mahoning Valley, the atmosphere of uncertainty that arose in the wake of the assassinations was soon heightened by a fiscal crisis involving Youngstown's public schools, where racial tension was already widespread. On the evening of February 10, 1969, the community received unwanted national attention, as the cohosts of the popular television show *Laugh-In* awarded the city its satirical "Flying Fickle Finger of Fate Award." When Dick Martin asked about the award's latest recipient, cohost Dan Rowan responded, "The voters of the city of Youngstown, Ohio," who had rejected "an increase in school taxes" for "the sixth time in two years." When Martin replied that many cities had done the same, Rowan responded, "Yes…but in Youngstown, they don't even have enough money to keep the schools open."[337]

The exchange, which angered local civic leaders, referred to a situation that had escalated since the autumn of 1968, when school board president Abe Harshman struggled to convince voters to pass a $12 million tax levy to support Youngstown City Schools. After explaining that it cost about $85,000 per day to educate the city's twenty-seven thousand students, Harshman warned residents that the school system was practically bankrupt.[338] Unmoved, voters repeatedly rejected the measure. With teacher strikes imminent, the schools were shut down for a five-week period, from Thanksgiving until New Year's Day.[339]

At the peak of the crisis, the Jewish community stepped to the forefront of the levy issue, voicing support for the measure. In a joint statement, all five local rabbis endorsed the school tax, referring to education as "the cornerstone of American democracy" and "the safeguard of America's freedom and tranquility."[340] Likewise, federation president Dr. Samuel Goldberg approved a mailer to be sent to every Jewish household in the area reminding residents that "our Jewish community has always given full and complete support to the needs and the perfection of our public school system," while adding that education "has always been an integral part of our Jewish heritage."[341] After months of campaigning with other concerned parties, members of the Jewish community were thrilled when voters passed the levy on the seventh attempt.[342]

A CHANGING METROPOLITAN AREA

Along with other factors, the controversies affecting Youngstown's public schools undermined urban neighborhoods, as more families relocated

to prosperous suburbs with well-funded school districts. Yet, as late as the 1960s and early '70s, the middle-class neighborhoods that dotted the city's North Side seemed relatively stable. Once the heartland of Youngstown's Jewish community, the district retained a substantial Jewish population, recalled Judith Gross, who taught Sunday school at Rodef Sholom. Her son, Michael, thrived in the neighborhood, where he spent hours at the Jewish Community Center, often competing in sports with older members. "We would play racquetball with all those old guys, and…they kind of schooled us, not just on sports, but other aspects of life," Michael Gross recalled.[343] Meanwhile, dietician Ted Powell remembered that, as late as the 1970s, North Side Hospital served so many Jewish patients that its administrators had kosher food brought in from neighboring Heritage Manor.[344]

By that time, however, urban trends had conspired to dampen the vitality of the North Side's once vibrant neighborhoods. Building projects that included the expansion of Youngstown State University cut off major arteries, while the building of an inter-connective highway system sliced through once flourishing neighborhoods. At the same time, the highways encouraged the flow of capital out of the city and into the suburbs.[345] The impact of these developments on neighborhood businesses was instantaneous.

By the late 1960s, the 20th Century Restaurant faced challenges that included a deteriorating neighborhood. Kurt Malkoff, the son of co-owner Harry Malkoff, recalled that his father, who suffered from a heart condition, asked whether he would be interested in taking over the business. "I just saw the hours he worked and everything else, and…I wanted to go to graduate school," Kurt Malkoff explained.[346] Fortunately, in 1970, Harry Malkoff's accountant, Joseph Levy, expressed an interest in purchasing the business and formed a partnership with his brothers, Morris, Marvin and Jacob Levy. Other landmark businesses on the North Side disappeared. Nudel's Delicatessen, located on Elm Street, closed soon after the death of owner Ben Nudel in 1971. "After my father got ill and passed away, we sold the store, because none of us wanted to continue it," recalled his son, Stan Nudell, who later altered the spelling of his family name to ensure that it would be pronounced correctly.[347]

Meanwhile, a growing number of local entrepreneurs pursued the option of relocating to the suburbs. By the end of the decade, Rose and Herb Kravitz questioned the long-term viability of the Elm Street Delicatessen, which had operated on the North Side since 1939. Their ultimate decision to move the business to Liberty Township, on the southern edge of Trumbull County, reflected their awareness of trends that were transforming the North Side.

The Elm Street Delicatessen, founded by Rose and Herbert Kravitz in 1939, became a popular North Side gathering spot after World War II. The business reemerged as Kravitz Deli after its relocation to Liberty Township in 1970. *Courtesy of Solomon "Jack" Kravitz.*

"People were leaving the neighborhood," recalled Donia Kravitz Foster, one of the couple's three children. "My friends left the area. A lot of their parents were getting older, and they moved out to the suburbs."[348] Notably, a similar demographic shift was unfolding on the city's South Side, where the Jewish population migrated to neighboring Boardman Township—a trend reflected in the earlier relocation of Ohev Tzedek–Shaarei Torah.

The effects of suburbanization were especially apparent in downtown Youngstown, the region's traditional retail and entertainment hub. By the early 1960s, major firms, including Youngstown Sheet and Tube Company, had relocated their headquarters from the central city to the suburbs, dampening the business of downtown restaurants and shopping outlets that depended on employees' patronage. At the same time, the district's elegant department stores faced stiff competition from suburban plazas, and they would soon confront the more formidable challenge of shopping malls. Palatial movie theaters began to close with the rise of suburban cinemas, while the opening of government offices around the community practically eliminated the need for residents to travel downtown to do mailing or pay

utility bills. Even banks, which would remain a presence in the downtown area, opened scores of suburban branches, reducing the flow of customers at their central offices.

Nevertheless, the downtown still hosted a number of substantial Jewish-owned businesses. Lustig's Shoes, under the management of Sidney and Howard Kline, maintained its flagship store on West Federal Street, while also operating branches around the Mahoning Valley and western Pennsylvania. Haber's Furniture had two downtown locations: one on the corner of Walnut and East Federal Streets and the other on West Federal Street. Jerold Haber, son of co-owner Frank Haber, recalled that his father and uncle Martin Haber expressed optimism about the prospect of urban

The Mural Room, located near Youngstown's Vindicator Square, set a local standard for dining elegance in the 1950s and '60s. The restaurant closed in 1970, amid the rapid decline of downtown's retail and entertainment district. *Courtesy of Mahoning Valley Historical Society.*

renewal, which they expected to benefit their seventy-seven-thousand-square-foot store on East Federal Street. Like many area residents, they welcomed the modernization of the eastern section of downtown, which was cluttered with declining businesses.[349]

Not everyone was so optimistic. In the mid-1950s, meat purveyor Louis Hollander, co-owner of the elegant Mural Room, opened Hollander's Grill on West Federal Street. Before long, however, he recognized clear signs of urban decay. "Hollander's Grill was closed in the early 1960s…and it really was a sign of the times," recalled Mervyn Hollander, the proprietor's son. "You started to see the development of the suburban strip plazas; and we were located between Hartzell's Men's Wear and Lustig's shoes, so we could see the writing on the wall."[350] Other Jewish landmarks disappeared within a decade, including the Mural Room, Eva's delicatessen, Fish's Dry Cleaning Company, the Giber Leather Company, the Acme Dry Cleaning Company and Manuel and Herman Rome's Youngstown Feed & Grain Company, which was pulled down to make room for the city's new central post office.[351]

Toward the end of the 1960s, local business leaders received a sobering forecast from economic planner Dr. Charles F. Bonser, the keynote speaker at the annual meeting of the Downtown Board of Trade, which was held at the Mural Room. Dr. Bonser, a former Youngstown resident and an associate professor of business administration at Indiana University, had conducted an economic study of Youngstown, in cooperation with the city planning and urban renewal departments. The study concluded that the downtown was experiencing, in economic terms, a "fast slide," and Dr. Bonser urged local civic leaders to develop programs aimed at restoring and preserving the region's central business district. The speaker warned that "a mere continuation of previous economic development activities will simply not be adequate to solve the problem of the Youngstown economy," and he recommended "complete community commitment and involvement" in an effort to make the downtown "the social and entertainment, as well as the governmental, financial, and commercial hub of the city."[352]

While many urban businesses continued to decline, those on the city's periphery tended to thrive. An emblematic event of the period was the launching of the first Arby's restaurant in Boardman on July 23, 1964. The now-famous Arby's brand was developed by Forrest and Leroy Raffel, who previously operated a restaurant-equipment business that had gained recognition for its design work on the Mural Room's "Tiki Lounge," an elegant bar with a Polynesian theme. Yet, trends in the restaurant industry soon led the Raffels to reconsider their options. Given that chains and

franchises rarely patronized local supply houses, they could see no future in their current line of business. Between the fall of 1963 and summer of '64, the brothers developed their concept of a roast beef sandwich shop, and the pilot unit for their franchise opened to local fanfare.

The restaurant was unique in a landscape already dotted with fast-food eateries. "The building looked something like a Conestoga wagon, with a yellow curved roof," Leroy Raffel explained. "It had sandstone walls, ceramic tile floors, recessed lights in a curved ceiling, which was covered in orange and tan striped vinyl. There was a stone patio with colorful umbrella tables." While the Raffels counted on their distinctive building and product to draw customers, they were also determined to provide a new kind of dining environment. "As you entered Arby's you were surrounded by sound and desert colors," Leroy Raffel noted. "The music played. A huge slicer pounded back and forth. A succulent beef roast revolved in a glass enclosed rotisserie on the front counter."[353]

Arby's memorable signage was produced by Youngstown's Peskin Sign Company, whose owner, Marvin Peskin, was sworn to secrecy regarding the sign's appearance. "I remember the day my husband came home with…a sketch under his arm, all rolled up," recalled Edith Peskin. When asked about the mysterious drawing, he agreed to show it to his wife, although he asked her to "keep it under your hat."[354] Given its novelty, the first Arby's was an instant success. "We lit up that big sign with the ten-gallon hat, we turned on the lights, we opened the doors and the place was flooded with people, as though they were hiding in the neighborhood waiting for us," Leroy Raffel recalled. "They came from all over the region—from as far away as Akron and Cleveland, and Beaver County, in Pennsylvania."[355] By 1970, the Raffels had opened 350 units, while 50 more were under construction.

If Arby's success was especially noteworthy, it was hardly the only local Jewish-owned business to flourish in the changing marketplace of the 1960s and early '70s. In the decades since World War II, Steel City Manufacturing Corporation, established by Pittsburgh-born M. Murray Fibus, had emerged as the world's largest manufacturer of mailboxes and newspaper delivery tubes. The firm's success was reflected in Fibus's subsequent role as a business leader who served as a trustee of the National Small Business Association and a member of Ohio governor James Rhodes's Task Force for Small Business.[356]

The same period saw the dramatic growth of Boardman-based Kessler Products, Inc., a plastics firm established by siblings Milton, Morris and Gerald Kessler. Founded as a company that specialized in the production

Youngstown-area entrepreneurs Forrest and Leroy Raffel gained national recognition through the success of their Arby's franchise. The corporation's first restaurant opened in Boardman, Ohio, in 1964. *Courtesy of Mahoning Valley Historical Society.*

of metal tools and car accessories, the firm's focus had shifted to the plastics industry by the late 1940s. Within two decades, Kessler Products Inc. had established a second plant in Dover, Ohio, and its products were shipped around the United States and to eleven other countries.[357] Likewise, the Tamarkin Company, a wholesale grocery business founded by Ben and Jack Tamarkin in 1923, maintained a fleet of trucks and served a fifty-mile radius by the late 1960s.[358] In the early '70s, the company completed a $2 million food distribution unit at Austintown's Western Reserve Industrial Park and handled an estimated $25 million in sales annually.

Other entrepreneurs set out to carve a niche in the suburban construction market. One of the most prominent of the postwar building firms was Custom Built Homes, co-founded in 1947 by Howard Solomon, Abe Post and Myron Agrenovitz. Reinvented as International Homes, Inc., in 1950, the firm went on to produce hundreds of prefabricated dwellings for returning U.S. veterans. Starting in 1963, the company shifted its activities

to the construction of apartment buildings and, eventually, shopping centers. By the early 1970s, the sons of two of the firm's co-founders, Marty Solomon and Ben Post, had joined the business.[359] No less significant was Simco Enterprises, Inc., founded in 1959 by Morris Simon. Like International Homes, Simco focused initially on housing development but eventually concentrated on apartment construction. By the 1960s, Simco had built thirteen apartment complexes comprising almost two thousand units throughout northeastern Ohio and western Pennsylvania. Such businesses anticipated—and benefited from—the growth of suburban areas. Meanwhile, the region's urban core continued to decline, and the erosion of the Mahoning Valley's industrial infrastructure would have dire economic consequences for the entire community.

Traumas of the Early Seventies

As the 1960s came to a close, social and political tensions over America's involvement in Vietnam reached unprecedented levels. On April 30, 1970, President Richard M. Nixon, whose campaign included a pledge to end the war in Vietnam, announced that U.S. combat troops had recently launched the "Cambodian Incursion," a military offensive designed to push back or defeat the People's Army of Vietnam and the National Front for the Liberation of South Vietnam (also known as the Viet Cong). In response, thousands of people across the nation assembled to protest the government's actions.

Among those who organized protests were students at Kent State University, located forty miles west of Youngstown. During several days of campus unrest, the mayor of Kent declared a state of emergency, and Ohio's governor deployed the National Guard to keep the peace. The turmoil at Kent State University reached a climax on May 4, when about 1,500 demonstrators gathered on the University Commons to protest the Vietnam War, while railing against the presence of the National Guard on campus. As the guardsmen moved in, protesters hurled "rocks, chunks of concrete, the troopers' own belching gas grenades and all the standard porcine epithets."[360] Through a haze of smoke, the guardsmen retreated to the top of a nearby hill. Suddenly, they turned and fired in the direction of the protesters. Shrieks and moans filled the air, and when the smoke cleared, four people lay dead at the scene.

While the entire nation was horrified by the Kent State shootings, news of the incident struck the local Jewish community especially hard. One

of the four people killed during the shootings was local Jewish resident Sandy Scheuer, a 1967 graduate of Boardman High School and a member of Ohev Tzedek–Shaarei Torah Congregation. While she had opposed the war, investigators determined that Sandy Scheuer had not been a protester and merely strayed into the line of fire.[361] Her parents' grief was compounded by the fact that, on the day of the shooting, they received a card from Sandy that wished them a happy twenty-seventh anniversary. Two days after the shooting, a special memorial service was held for the slain student. Addressing more than three hundred people, Ohev Tzedek's Rabbi Richard Marcovitz quoted Martin Scheuer, Sandy's father, who told him that he hoped "her death was not in vain" and that "perhaps we will learn the ways of violence and realize we must strive for the way of peace."[362]

As the local Jewish community grappled with complex issues such as the Vietnam War, the conflict in the Middle East continued to escalate, and enemies of the Israeli government took increasingly desperate measures. A little more than three years later, the regional Jewish community was shaken by news that Egyptian and Syrian military troops had engaged in a surprise invasion of Israel on the holiest day in Judaism. When the invasion began, on October 6, 1973, a significant portion of Israel's fighting forces were observing Yom Kippur ("Day of Atonement"). In response to the crisis, federation president Nelson Mendelson called an emergency leadership meeting at the Jewish Community Center, where more than one hundred people gathered to listen to a conference telephone call from the Israeli ambassador to the United States, Simcha Dinitz, which was simultaneously heard in cities across the country. Dinitz urged every community to accelerate their payment of current pledges to the United Jewish Appeal to provide much-needed social services in Israel. Less than three weeks after it began, on October 25, an Egyptian-Israeli ceasefire was secured by the United Nations.

If developments on the local scene were informed by dialogue and outreach, those on the international stage continued to be less reassuring. On November 10, 1975, a global debate was sparked by the United Nations' adoption of a controversial resolution that formally defined "Zionism [as] a form of racism and racial discrimination." Seventy-two countries voted for the resolution, with just thirty-five opposed and thirty-two abstentions. Prior to the vote, the U.S. ambassador to the United Nations, Daniel Patrick Moynihan, warned that the resolution signified a grave misstep on the part of world leaders. "The United Nations is about to make anti-

Semitism international law," Moynihan warned.[363] During a fiery speech against the resolution, the ambassador stated, "The [United States] does not acknowledge, it will not abide by, it will never acquiesce in this infamous act...A great evil has been loosed upon the world."[364]

The day after the resolution's adoption, religious leaders from across the Mahoning Valley expressed their shock and dismay. Dr. Sidney Berkowitz of Rodef Sholom told a *Vindicator* reporter that he wondered how anyone "could honestly confuse the yearning of the Jewish people for a return to their historical homeland from centuries of enforced exile with racism." In a show of solidarity, the region's Christian leaders penned a strongly worded letter to President Gerald R. Ford and members of the American UN delegation to express their deep disdain for the measure.[365] More than a decade later, Youngstown's Bishop James W. Malone, by then president of the National Conference of Catholic Bishops, reaffirmed his opposition to the resolution and urged the United Nations to repeal the "deplorable vote." Bishop Malone also reiterated his concern that the vote would "open the door to harassment and denial of basic rights to Jews throughout the world."[366]

MILESTONES IN THE RELIGIOUS COMMUNITY

The Mahoning Valley's changing economy had greater ramifications than the relocation of Jewish businesses. A decline in population led many Jewish leaders to recommend the consolidation of institutions and services. By the late 1960s, the quality of Jewish education in Youngstown had "deteriorated alarmingly," since the financial burden of maintaining a separate religious school, especially for smaller congregations, was overwhelming. In 1970, a study was commissioned by the local synagogues and the Youngstown Jewish Federation to determine the feasibility of a functional Jewish Day School. A year later, a joint commission on Jewish education was formed, in cooperation with local congregations and the Jewish Federation Board. Then, in 1972, the American Association of Jewish Education (AAJE) advised the local community to adopt an "integrated" approach to Jewish education and combine local programs for greater efficiency.[367]

In response to the AAJE's recommendations, the congregations of Anshe Emeth and Emanu-El merged their religious education programs. At the same time, private conversations took place among temple leaders on the possibility of merging the two congregations. "Everybody saw the reality

of needing to merge, but nobody wanted it," recalled Alan Mirkin, who was then a member of Temple Emanu-El. "You still...had these separate identities."[368] Nevertheless, by the summer of 1973, the two synagogues came to an agreement, and they formally merged on August 1. As a tribute to the congregations' respective identities, the merged entity became known as El Emeth ("G-d is Truth"). While the former edifice of Temple Emanu-El served as the site of the merged congregation, Anshe Emeth's Rabbi Samuel Meyer became its first spiritual leader.[369]

A similar trend was evident in western Pennsylvania, where Farrell's Orthodox congregation of B'nai Zion had struggled for years to maintain its independence. Alan Nathan, a lifetime member of the congregation, recalled Farrell's Jewish community as strikingly self-sufficient. "It's my impression, growing up, that the Jewish people in Farrell had little to do with the Jewish people in Sharon," he said. "I don't think they needed each other as much as we did in our generation, because there were...fewer of us." Yet, in time, as the Orthodox congregation's numbers dwindled, its leadership was forced to collaborate with Sharon's Reform congregation of Beth Israel. By 1967, the two congregations had merged their religious education programs. Four years later, in 1972, B'nai Zion and Beth Israel formally merged, with members of the former congregation holding Orthodox services in Beth Israel's spacious social hall.[370] "There were two parallel services going on at all times," Nathan explained, adding that Orthodox services were eventually held in a small chapel, "as the population of the Orthodox people [had] declined."[371]

Origins of the Jewish-Christian Dialogue

As the Jewish community took steps toward consolidation and renewal, it also made progress in the area of interfaith dialogue. In 1975, Rabbi Samuel Meyer engaged in unprecedented outreach to the area's large Roman Catholic community. Rabbi Meyer had arrived in Youngstown from Lorain, Ohio, in 1971 to serve as spiritual leader of Temple Anshe Emeth, two years before its merger with Temple Emanu-El. Since he was the founding chief executive of the Lorain County Conference on Race and Religion, few were surprised when, in May 1975, the Youngstown Area Clergy Association elected Rabbi Meyer as its next president.[372] Some observers were caught off guard, however, when he initiated a series of six workshops between Temple El Emeth and St. Patrick Parish

In the mid-1970s, Father George Balasko and Rabbi Samuel Meyer initiated a Jewish-Catholic adult enrichment series to highlight the two religions' common traditions. Today, the "Jewish-Christian Dialogue" benefits from the involvement of Father Balasko and Rabbi Joseph Schonberger, the current spiritual leader of Temple El Emeth. *Courtesy of the Catholic Exponent.*

in nearby Hubbard, Ohio, to mark the upcoming tenth anniversary of *Nostra Aetate* ("In Our Time"), the Vatican's Declaration on the Relation of the Church to Non-Christian Religions.

Rabbi Meyer's partner in the development of the workshops was St. Patrick's Father George Balasko, who described their first meeting as a fortuitous accident. "Sister Susan Shurson was running a class [at YSU] on death and dying and burial customs," he recalled. "Rabbi Meyer was on the Jewish side of the ledger; I came in on the Catholic side, and the Protestant minister didn't show." He added, jokingly, "So Rabbi Meyer and I had to sit in for the Protestant minister and make it up."[373] The clergymen quickly bonded and went on to develop a program they described as "grassroots ecumenism" that was designed to "promote mutual understanding among

Bishop James Malone and Rabbi Sidney Berkowitz exchange a "sign of peace" during a February 1976 service at Youngstown's St. Columba Cathedral to mark the tenth anniversary of the Second Vatican Council's declaration on the Catholic Church's relationship with non-Christian religions. *Courtesy of the Catholic Exponent.*

our people and to reflect on the common spiritual bond between us."[374] Yet neither man could have predicted that the workshops would help to lay the foundation for a steadfast partnership between the two religious communities that would extend into the new millennium.

A few months later, on February 1, 1976, Rabbi Sidney Berkowitz and other members of the Jewish community attended a service at Youngstown's St. Columba Cathedral to mark the anniversary of *Nostra Aetate*, a document that transformed relations between the Catholic Church and other religions, especially Judaism. In his homily, Bishop Malone discussed the recent National Catholic Bishops' Statement on Catholic and Jewish Relations, which called for "the reformation of Christian theological expositions of Judaism along more constructive lines," while reaffirming *Nostra Aetate*'s "repudiation of the charge that Jews were and are collectively guilty of the death of Christ."[375] At one point in the service, Rabbi Berkowitz and Bishop Malone shook hands in a "sign of peace," which many interpreted as a symbolic gesture of friendship between the two communities.[376]

The End of an Era

On July 6, 1976, residents of the Mahoning Valley greeted America's bicentennial with an ambivalence that was shared by citizens across the country. After all, the divisive impact of the Vietnam War and subsequent disgrace of President Richard Nixon were fresh memories. In the Youngstown area, such mixed feelings were amplified by growing evidence of the community's decline. Even the implementation of expensive revitalization projects had little effect. Less than two years earlier, on October 5, 1974, the municipal government had announced the opening of the downtown's $1.7 million Federal Street Mall, a pedestrian plaza designed to enhance the community's deteriorating central business district. The grand opening featured festivities that included skydivers, a parade, an antique car show, horse and buggy rides and a local arts and crafts show.[377] In time, however, residents complained that the pedestrian mall impeded the flow of traffic, and downtown businesspeople found it increasingly difficult to compete with the massive shopping malls located to the north and south of the city's core.

The decline of the region's former retail and entertainment center served as a powerful symbol of the community's stagnation, and ambitious young people who went away to college rarely returned. Few segments of the population were more deeply affected by this phenomenon than the Jewish community. By the 1970s, Greater Youngstown's Jewish community, which peaked at about eight thousand in the 1940s, had dwindled to approximately four thousand people.[378] At this point, the most glaring symptoms of the region's decline were still restricted to inner-city neighborhoods, which had been largely abandoned by white, middle-class urban dwellers. In time, however, negative trends within the city's industrial sector would affect the metropolitan area as a whole, including outlying suburban townships. The city's position as an important center of steel manufacturing was about to come to an end.

In January 1969, to the shock of many local observers, New Orleans–based Lykes Corporation, a family-owned business that focused on shipbuilding, completed a hostile takeover of Sheet and Tube.[379] Given the disparity in assets between the two companies, few observers predicted that the merger would benefit Sheet and Tube. A report prepared by the Anti-Trust Division of the Department of Justice predicted that Lykes Corporation would abandon the previous management's long-term strategy to upgrade Sheet and Tube's facilities and plunder the firm's resources. Denied investment, Sheet and Tube managed to lose money even during the brief domestic

steel boom of 1973 and 1974, despite the fact that it was operating at 100 percent capacity. These losses were the result of continual breakdowns that arose from the company's dependence on outmoded equipment. Within eight years of the ill-fated merger with Lykes Corporation, Sheet and Tube began the painful process of closing down its Youngstown-area operations.

Youngstown's most dramatic population losses would occur in the 1980s, following the collapse of its core steel industry. This grim chapter in the community's history opened on September 19, 1977 ("Black Monday"), when representatives of Lykes Corporation announced the closure of the company's huge facility in nearby Campbell, along with smaller plants in neighboring Struthers. The Campbell shutdown itself resulted in the loss of four thousand jobs in the Youngstown area, and it proved to be the first in a series of crippling economic developments.[380] The layoffs in Campbell sent ripples of uncertainty across the community. The shutdown of Youngstown Sheet and Tube's operations in Campbell and Struthers was followed by the staged withdrawal of U.S. Steel in 1979 and 1980, which resulted in the closure of massive steel plants in Youngstown and neighboring McDonald, Ohio.[381]

Another string of closings came with the bankruptcy of Republic Steel in the 1980s. Thus, in the course of several years, the "Steel Valley"—a one-

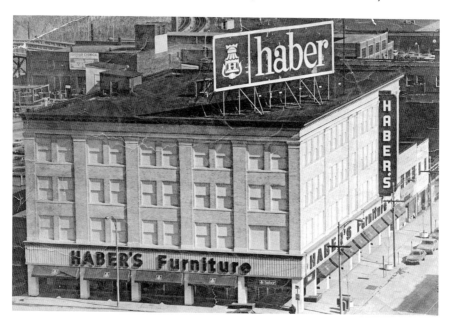

Haber's Furniture, photographed at the peak of the city's urban-renewal program, was one of the last family-owned retail stores to operate in downtown Youngstown. *Courtesy of Jerold Haber.*

time industrial zone comprising Mahoning and Trumbull Counties as well as portions of western Pennsylvania—lost an estimated 400,000 manufacturing jobs, 400 satellite businesses, $414 million in personal income and from 33 to 75 percent of the school tax revenues.[382] The impact of these events on the city's population proved devastating. Indeed, preliminary census figures released in 1980 revealed that Youngstown's population had fallen from 140,509 to 112,146 between 1970 and 1980—a decline of 20.4 percent. Meanwhile, the population of Mahoning County, which includes several large suburban townships, fell by a less dramatic 7.1 percent, slipping from 304,545 in 1970 to 282,813 in 1980.[383]

For some local businesses, the impact of Black Monday was instantaneous. Jerold Haber's family owned and operated Haber's Furniture, one of the few remaining stores in downtown Youngstown. On the morning of September 19, 1977, he recalled, his father and uncle arrived, as usual, to open up the flagship store on East Federal Street. Despite unconfirmed speculation about layoffs in the steel sector, they expected the usual flow of customers. "You saw it coming, because there were rumors," Haber explained. "Once it hit, people cancelled their orders that day, and I can remember my uncle… standing on the mezzanine level…saying, 'What happened to the store? There's nobody here.' I remember him standing there."[384]

"Grace under Pressure"

Those who settled in the Mahoning Valley during the twilight of the region's steel industry found it hard to ignore disturbing economic trends. Yet, many of them were drawn into a Jewish community that was closely knit and energetic. In 1976, Gary Weiss, executive director of Heritage Manor, arrived in Youngstown as a twenty-four-year-old alumnus of the University of North Texas's graduate program in long-term care. While interviewing for the position at Heritage Manor, he was questioned by leaders such as Stanley Engel, Jerome Frankle, Milt Greenberg, Marvin Itts, Frank Klein, Philip Levy, Philip Millstone and Murray Nadler. "You could cut up the room with smoke," Weiss recalled. If his initial experiences were intimidating, Weiss's integration into the community was surprisingly smooth. "When I came to town…every Friday night I was invited to Esther and Irv Marks' *Shabbat* dinner, because she knew I was single," he explained. Within months, he befriended figures like industrial executive and youth leader Aaron Grossman. "He was a sage to me, in some ways," Weiss said. "He taught me a lot about the Jewish community and…how intertwined it is."[385]

Weiss's first impressions overlapped with those of New York–born marketing executive William Benedikt, who arrived in the Mahoning Valley in the late 1970s with his wife, the former Myra Sniderman, a native of the area. "The infrastructure of the town I really didn't pay much attention to," Benedikt acknowledged. "But the Jewish community made an immediate impression on me." Like Weiss, Benedikt was struck by the dedication of community leaders such as Stanley Engel, Buddy Tamarkin and Larry Heselov, whom he

described as "enviably eloquent." He was soon "recruited" by Engel to take a more active role, and over time, Benedikt would become deeply enmeshed in a community he came to love. "Aside from marrying my wife, it's probably the best thing that I ever did, moving to Youngstown," he said.[386]

Despite the economic crisis, the religious community also benefited from dedicated leadership. In May 1980, former Youngstown resident Rabbi Mitchell Kornspan returned to his hometown as spiritual leader of Ohev Tzedek–Shaarei Torah, succeeding Rabbi David Leiter, who had served the congregation since 1978. For members of the congregation who had watched Rabbi Kornspan grow up, his new role required a period of adjustment. As congregant Florine Rusnak noted, however, they were ultimately "very comfortable" with Rabbi Kornspan's long tenure.[387] Less than two years later, in January 1982, Rodef Sholom named Cleveland native David Powers as an associate rabbi, to serve alongside Rabbi Sidney Berkowitz. Rabbi Powers soon emerged as an advocate for the preservation of Jewish identity, defending "the rights of Jews to practice the religious and cultural traditions, which they have maintained for more than 4,000 years."[388] The following year saw the installation of Rabbi Shmuel Singer at Children of Israel, which had been without a rabbi for several years. In February 1983, less than two months after his arrival, Rabbi Singer predicted the growth of Orthodoxy, locally and nationally.[389]

Responses to a Changing Community

As the decade continued, the region's unemployment rate skyrocketed, reaching 20.5 percent in Trumbull County, 15.7 percent in Columbiana County and 13.8 percent in Mahoning County.[390] Despite this trend, the area's Jewish community undertook a number of major expansion projects. In March 1982, about 350 members of Temple El Emeth joined in the ceremonial transportation of Torah scrolls from the former temple at Fifth and Fairgreen Avenues in Youngstown to the new building on Logan Way in Liberty Township. Distance and cold weather prevented them from journeying on foot, so the group took a bus from Fifth Avenue to a shopping plaza at the intersection of Route 304 and Logan Way. From there, temple president Sam D. Roth and Rabbi Samuel Meyer led a procession to the chapel.[391]

The new temple complex, located on 6.1 acres of land donated by Monte Friedkin, was a sleekly designed structure that spanned thirty-five

This view of El Emeth's sanctuary highlights the temple's handsome ark, which was renovated in 1998 to mark the congregation's twenty-fifth anniversary. *Courtesy of Nea Bristol.*

thousand square feet. The complex included a main temple, educational wing, sanctuary, kitchen facilities, offices, small chapel and library. Notably, arrangements were made to provide Children of Israel with the northwest section of the building once the Orthodox congregation had vacated its old venue at Fifth and Alameda Avenues in Youngstown. Those seeking auspicious signs pointed out that the new edifice of El Emeth had been dedicated on practically the same date four thousand years ago on which Moses established the first Jewish sanctuary in the Sinai desert.[392]

Less than a year later, in February 1983, about one thousand people gathered at the Jewish Community Center and Heritage Manor campus to tour the newly renovated facilities. The product of years of planning and a $3.5 million capital campaign, the renovation represented the largest expansion program in the community's history. Visitors to the center received tours led by federation planning and development committee cochairs Leslie W. Spero and Esther Marks, who showed them highlights such as the early childhood, youth, adult, older adult, aquatics and physical fitness departments. Meanwhile, visitors to Heritage Manor were shown around by cochair Leona Cohen, who called attention to the nursing home's new living quarters, arts and crafts department, physical therapy and medical

dispensary, as well as dental and podiatric clinics. Federation president Bert Tamarkin explained to a *Vindicator* reporter that the renovations were "the result of years of planning" and would enable the federation to more adequately address the social, physical, cultural and leisure-time needs of the community.[393]

If the period following the collapse of the steel industry witnessed unexpected signs of growth, it was also characterized by steps toward consolidation. As early as 1979, representatives of the Jewish communities of Youngstown, Warren, Sharon, Farrell and New Castle participated in a "Conference on Regional Communities" at the Youngstown Jewish Community Center. The conference, which was chaired by Youngstown's Adeline Sniderman, featured guest speaker Howard Belkin, a resident of New Britain, Connecticut, who described how his community "had successfully joined with the neighboring large city of Hartford, to secure care for the special needs that people in the smaller city could not handle due to a lack of professional care and finances." Belkin was followed by Leslie Spero, chairman of the Youngstown Federation's Joint Planning and Development Committee, who discussed the local situation.

Within two years, representatives of the four communities reviewed a "Proposal for Amalgamation," after which Warren and Sharon accepted the terms, while New Castle declined.[394] In March 1981, Youngstown Federation president Bert Tamarkin announced the official merger of the Shenango Valley and Warren Jewish communities, calling it "the result of years of informal discussions and an intensive planning process." At a special meeting, the name of the merged entity was officially changed to the Youngstown Area Jewish Federation.[395]

"ON THE SHOULDERS OF GIANTS"

As Jewish residents of the Mahoning Valley struggled to address challenges arising from deindustrialization, they learned of the death of one of their most revered leaders. On the evening of February 6, 1983, one month after his retirement, Rodef Sholom's Rabbi Sidney Berkowitz suffered a fatal heart attack. A civic and religious leader, Rabbi Berkowitz commanded respect throughout the Youngstown area, where he was "looked upon as a spokesman for the Jewish community." His successor, Rabbi David Powers, called the late rabbi "a master of insight and knowledge" who "helped

develop in others enormous respect for the religious feelings of all faiths."[396] Reverend Richard Speicher, executive director of the Mahoning Valley Association of Churches, praised Rabbi Berkowitz as "an exceedingly capable leader" whose compassion "spread far beyond his own deep religious orientation." Likewise, Youngstown bishop James Malone, who delivered Rabbi Berkowitz's eulogy, spoke of his service to the community and his commitment to his faith. "[He] gave able and generous leadership to the improvement of inter-faith relations in our valley," Bishop Malone said. "I shall cherish his memory and I shall miss him as a friend."[397] One congregant, Judith Gross, was struck by the bishop's concluding remarks. "I remember when he finished the eulogy…Bishop Malone said, 'Shalom, Sidney, shalom,'" she recalled. "And oh…I just wept and wept…. I was just so touched by…the friendship that they had."[398]

A little over a year later, on November 20, 1984, Stanley Engel, longtime executive director of the Jewish Federation, succumbed to a long battle with cancer. For some members of the community, it was hard to recall a time when Engel had not been their leader. For forty years, he had been the quintessential community servant, a fundraising workhorse who championed Jewish and Zionist causes. The recipient of every major award offered by the local Jewish community, Engel was also involved in dozens of civic and fraternal organizations and served as an advisor to various state and local boards. Arguably, he was the most influential Jewish leader in the region. Described as a "professional altruist," Engel was nevertheless a man of conflicting personality traits. His protégé and eventual successor, Sam Kooperman, called him a visionary and uncompromising leader. "Stanley was the boss, in no uncertain terms. [He] ran everything with an iron fist," Kooperman recalled. "But he was very compassionate. He really cared."[399] In his last days, Engel was concerned that his work was unfinished. His son, Brian, recalled: "When my father was dying…he said to me, 'If I just had a little more time…' He wasn't so much concerned about living [or] dying, but he wanted more time to get something else done. That always stuck with me."[400]

Memorializing the Holocaust

Weeks before Stanley Engel's death, the regional Jewish community held an event that proved unifying and cathartic: the dedication of the region's first Holocaust memorial. Proposed two decades earlier, the Holocaust Memorial

Unveiled in September 1984, Youngstown's Holocaust Memorial captures the final moments of fourteen victims as they face certain death. The memorial was designed by Columbus-based sculptor Alfred Tibor. *Courtesy of Nea Bristol.*

Committee was formally established in 1981 and funded by organizations such as the Youngstown Area Jewish Federation, the Frances and Lillian Schermer Charitable Trusts, B'nai B'rith Mahoning Lodge 339 and the Zionist Organization of America, Youngstown District. Chaired by Milton Handler, the committee was advised by eminent Holocaust scholar and YSU Jewish studies professor Dr. Saul Friedman.

On the committee's recommendation, the federation chose Columbus-based sculptor Alfred Tibor to commemorate the six million Jewish lives—and twelve million total lives—lost between 1933 and 1945 at the hands of the Nazis. Titled *The Final Embrace*, the sculpture depicts the final moments of fourteen victims, their faces reflecting a mixture of "terror, defiance,

bewilderment and resignation" as they confront certain death.[401] Erected in a parklike setting near the Jewish Community Center, the nine-foot statue was engraved with the anonymous poem "I Believe," which was found scrawled on a cellar wall in Cologne, Germany, where Jews had hidden from the Nazis.[402] Apart from the names of various concentration camps and ghettos, the monument bears the Hebrew word "*Zachor!*" and its English translation, "Remember!" while the granite base is accented with an eternal flame.

The unveiling ceremony, held on September 30, 1984, drew more than five hundred attendants, including fifty Holocaust survivors. Federation president Nathan Monus welcomed the crowd and acknowledged the dedication of those who made the memorial possible. Led in prayer by Rodef Sholom's Rabbi David Powers, the gathering listened to numerous speakers, including survivors Esther Shudmak and Samuel Hollander. In her moving tribute to the courage of Jews and "Righteous Gentiles," Shudmak concluded with a challenge to the young. "To you we dedicate this date of remembrance," Shudmak said. "It is a legacy we pass to you, the youth, from generation to generation. *Zachor*. Remember. Never again."[403]

Milestones of the Eighties

The 1980s witnessed a variety of milestones, including three significant anniversaries in the Jewish community. Early in the decade, the congregation of Ohev-Tzedek-Shaarei Torah gathered to mark the twenty-fifth anniversary of their modern temple complex on Glenwood Avenue. Special events included a talk by NBC News executive Sid Davis, a former congregant. During a Friday evening service on October 15, 1982, Davis discussed his career as chief of the Washington news bureau and White House correspondent for Westinghouse Broadcasting Company. Present during the assassination of President John F. Kennedy, Davis was one of three reporters to witness President Lyndon B. Johnson's swearing in on Air Force One. The next day, on October 16, Rabbi Mitchell Kornspan conducted morning services that were followed by the installation of temple officials and board members. A dance to mark the temple's anniversary and "rededication" took place in the evening.[404]

Three years later, on November 24, 1985, almost three hundred people gathered at the Youngstown Jewish Community Center to celebrate the Jewish Federation's founding fifty years earlier. Master of Ceremonies

A landmark of the Boardman area since 1957, the complex of Ohev Tzedek–Shaarei Torah is noted for the clean simplicity of its Mid-Century Modern design. *Courtesy of Nea Bristol.*

Catholic bishop James Malone (*center*) poses with civic leaders after receiving the B'nai B'rith's Guardian of the Menorah Award in June 1985. Also pictured are (*left to right*) Sam A. Roth, Bill Brennan, Aaron Grossman, James Pazol, Bruce Sherman and Ron Mostov. *Courtesy of Bruce and Carol Sherman.*

Jeanne Fibus presided over a festive evening that featured tributes to several members for service to the community. Honorees included Marvin Peskin, who helped reactivate *Vaad Hakashruth* (kosher supervision); Milton Handler and Dr. Saul Friedman (Marvin and Sara Itts Award), who spearheaded the Holocaust Memorial; and William Benedikt, for his work as president of the Jewish Family and Children's Services. Following an announcement that the federation complex would be renamed after longtime leader Stanley Engel, special recognition was given to Oscar Altshuler and Murray Nadler, the only surviving members of the original federation board, which convened in 1935.[405]

In May 1986, the Mahoning Valley's Jewish community marked yet another milestone when Lillian Kornhauser was elected president of Rodef Sholom congregation, making her the first female lay leader of any congregation in the region. Mrs. Kornhauser "admitted that she never dreamed of becoming president of the temple when she joined thirty-three years ago." While she acknowledged the historic significance of her election, she made no reference to the women's movement. "I've always felt that I've been considered as an equal here," she stated.[406] In an interview held a few months later, Mrs. Kornhauser recalled that even during her childhood, "it was important…for women to get religious training." She added, however, that "it has probably been only about fifteen years since women began to play prominent roles in religious leadership."[407]

Warren's Jewish community gathered in October 1988 to celebrate the seventieth anniversary of Beth Israel, which had been founded in the 1910s by a half dozen Jewish immigrants. About 150 people participated in an anniversary dinner that featured a multimedia slide show compiled by historian Wendell Lauth and an original music program by Ruth Schwartz. The congregation's spiritual leader, Rabbi David Steinhardt, told celebrants that he had been drawn to the community five and a half years earlier because of its caring spirit and solidarity. "We confidently celebrate our past and our future," he said. "Whatever the challenge, we have been able to pursue it as one." During the event, Anita Lavine, the temple's first woman president, shared her impressions of the city's Jewish community upon her arrival years earlier. "I fell in love with Warren when I first came here," she noted.[408]

Near the end of the decade, Youngstown's oldest congregation, Rodef Sholom, saw another change in leadership. In July 1989, the congregation appointed Rabbi Jonathan M. Brown to replace Rabbi David Powers, who had served the temple for seven years. Rabbi Brown knew of Youngstown

through family lore. During the early twentieth century, his paternal grandparents lived on the city's South Side, where his father spent part of his childhood. Of particular interest to Rabbi Brown was the improvement of relations with other ethnic and religious communities. To that end, he worked with groups to promote greater understanding of the burgeoning AIDS crisis and chaired a task force on black-Jewish relations.[409] In an interview with *Vindicator* religion editor Leon Stennis, the rabbi reflected on the ideological gulf that had developed between the Jewish and African American communities since the 1960s. "My general sense is…once the civil rights movement was over," he said, "there was not enough cement to hold us together."[410]

THE ESTABLISHMENT OF AKIVA ACADEMY

It was during this period that the local Jewish community took important steps toward the realization of a long-term goal: the establishment of a permanent Jewish day school. In previous years, "there always was some type of undercurrent of need [for a full-time Jewish school], but not the commitment," Rabbi Mitchell Kornspan observed.[411] Indeed, Greater Youngstown was one of the few metropolitan areas in North America with more than five thousand Jews that had no private Jewish school. The only Jewish education available outside of a Sunday school environment was an afterschool program offered twice a week by the Commission for Jewish Education at Temple El Emeth.

While local Jewish residents were optimistic, two previous efforts to establish a day school had failed. The first attempt had unraveled fifteen years earlier due to the community's failure to make the project a priority. More recently, in February 1983, plans for another elementary school called Brandeis Academy "went nowhere."[412] Echoing the conflicts that plagued the establishment of a local Jewish center a generation earlier, residents found it difficult to agree on the school's purpose. Some parents envisioned "a strictly parochial Jewish education," while others wanted a private school that offered "a superior secular education," with special instruction for children with learning disabilities or special gifts.[413]

Realistic plans for a permanent Jewish school did not take shape until about 1984, when the commission hired respected Judaic scholar Dr. Lawrence Kutler as its director. A native of New York, Dr. Kutler was previously

employed as the principal of a high school for Jewish studies in San Diego. A noted Judaic scholar with advanced degrees in Judaica education and Hebrew language, Kutler was viewed as someone who could help the school "maximize Jewish education…combat a loss of identity…and develop future leaders." Pragmatic and aware of the community's earlier failures, Dr. Kutler and the commission were careful not to rush the process. They studied population statistics compiled by the Jewish Community Center and determined that only two grades (kindergarten and first grade) could be feasibly implemented, with no more than fifteen children in each class.[414] By 1988, four additional grade levels had been added, and the school's enrollment had risen to sixty-seven. In the wake of the school's success, the federation received more than $500,000 in private donations to expand the institution and build a new ten-thousand-square-foot addition to the Jewish Community Center. Boasting a fifteen-to-one teacher-pupil ratio and outstanding standardized test scores, Akiva Academy emerged, in the words of Dr. Kutler, as "a dream come true."[415]

"The Russians Are Coming"

Throughout the 1970s and '80s, American Jews vigorously protested the Soviet Union's "denial of the rights of its Jewish citizens to emigrate and its persecution of those who dared to try." By the late 1980s, however, the adoption of Soviet leader Mikhail Gorbachev's progressive *Glasnost* policy led to a gradual softening of restrictions on the emigration of "refuseniks." Some Jewish immigrants chose to make the *Aaliyah* ("the Return") to Israel, but a significant number preferred to resettle in the United States.[416] In the late 1980s, HIAS, a U.S. charitable organization founded as the Hebrew Immigrant Aid Society, sponsored a program to facilitate the resettlement of Soviet Jews in America, a project that required cooperation with Jewish federations across the country. The local Jewish community became actively involved in the effort, and by the end of 1990, some 38 households representing 103 individuals had resettled in the Mahoning Valley.[417]

The local resettlement effort was coordinated by the federation's Jewish Family and Children's Services Agency (JFCS), staffed by director Alvin Weisberg and social worker Saragrace Brown. A volunteer committee, known as the Resettlement Committee, was organized under cochairs Irv Lev and Barbara Heimann to oversee the refugees' integration into the

community. Volunteers met the arriving refugees at Youngstown Municipal Airport (now Youngstown-Warren Regional Airport) and determined whether they could communicate with them. "We'd have their apartments all furnished, and when we knew they were coming, we'd get food in the house," Irv Lev explained. "Sometimes we would have people who would actually prepare food."[418] Shortly after their arrival, the Russians were taken grocery shopping, an experience they found exhilarating, since they were accustomed to half-empty store shelves. "Sometimes, they'll be in the middle of the grocery store, and they'll just stop and cry," volunteer Sam Mirkin told a reporter in 1991. "We've had people think it was a joke, that they couldn't really buy anything."[419]

Between the late 1980s and the early 2000s, the JFCS facilitated the resettlement of more than four hundred Russian Jews in the Mahoning Valley. Scores of volunteers assisted in the tasks of locating and renting apartments, donating and moving furniture, providing transportation to supermarkets and medical appointments and teaching English. Jerry Malkin and Anita Shapiro were among volunteers who picked up and delivered furniture and other household furnishings stored in a central warehouse. Bobbi Grinstein oversaw the enrollment of Russian adults in classes sponsored by the English Centers, a nonprofit organization established in Youngstown, in cooperation with the National Council of Jewish Women. Perhaps the most formidable challenge was securing employment for the new arrivals.[420] In an interview with the *Jewish Journal*, one Russian refugee, Dr. Michael Cheloff, indicated that his move to the Youngstown area had "two sides," given that he and his family benefited from involvement in a close-knit community, while at the same time facing the limited economic opportunities of a small city.[421] "For many of the people it worked out well, and for some of the people it worked out adequately," Alvin Weisberg noted. "But their children had…all the opportunities, and almost every single one of them has been…a success story."[422]

Milestones of the Nineties

In May 1990, Rabbi Samuel Meyer, spiritual leader of Temple El Emeth and co-founder of the Jewish-Christian Dialogue Group, announced his retirement after almost twenty years of service. His successor, Rabbi David Steinhardt, was the former spiritual leader of Warren's Beth Israel Temple

Center and the newly elected president of the Jewish Community Relations Council.[423] Months before his installation, Rabbi Steinhardt discussed differences between the Warren and Youngstown communities. "Warren gave me a lot of time to be a 'pastor,' to visit the sick and to counsel with families," he explained. "This has to be done differently when you have five hundred families as opposed to ninety families."[424] Rabbi Steinhardt would remain at Temple El Emeth for four years, after which he was succeeded by Rabbi Barry Baron.[425]

Two years later, Youngstown's oldest Jewish congregation, Rodef Sholom, prepared to mark the 125th year of its founding. On May 1, 1992, a special service was conducted by Rabbi Jonathan Brown and Cantor Merrill Fisher. During the service, Rabbi Alexander Schindler, president of the Union of American Hebrew Congregations, delivered a talk titled "A Mystic Fount." In addition, a "new setting" for Psalm 125 by noted composer Bonia Shur (specially commissioned for the occasion) was performed at the service. Cochairs Josh Blumenthal and Marilyn Oyer organized a yearlong series of events to mark the anniversary, including a lecture by historian Arthur M.

Rabbi Jonathon Brown and Marcy Libby pose with noted historian Arthur Schlesinger Jr., a participant in Congregation Rodef Sholom's Sidney M. Berkowitz Memorial Lecture series. Schlesinger's talk in October 1991 was part of a yearlong series of events to mark the temple's upcoming 125th anniversary. *Courtesy of Mahoning Valley Historical Society.*

Schlesinger Jr. Decades later, Mrs. Oyer recalled that Youngstown bishop James Malone attended the anniversary celebration: "He and I were sitting on the dais together…and all the men were dressed in suits and ties; and he looked at me and he said, 'Oh, look, you and I are the only ones with pretty dresses on,' because he was in full regalia."[426]

Within a few years of the anniversary celebration, Rodef Sholom experienced yet another change in leadership. After serving for six years as the leader of Rodef Sholom, Rabbi Brown left his post in August 1995 and was succeeded by Rabbi Franklin W. Muller, formerly of Roanoke, Virginia.[427] In May 1996, Rabbi Muller indicated to a *Vindicator* reporter that he appreciated the temple's "central city location because it facilitates efforts toward social justice and social action, including a tutoring program for nearby public school children." An avid musician with an interest in reaching out to Jewish youth, he stated, "We really are focusing on the next generation so we can keep the temple stable in numbers."[428]

THE DONAHUE INCIDENT

During the last decades of the twentieth century, the Mahoning Valley drew the attention of the national media in ways that concerned regional leaders. More than a decade of continuous economic decline had contributed to Youngstown's emergence as a symbol of the "Rust Belt" phenomenon. Then, in 1990, nationally syndicated talk-show host Phil Donahue announced he would travel to Youngstown to "listen to what people in the heartland feel," a decision framed as an effort to explore the perspectives of "average Americans."[429] The bulk of the program would feature a question-and-answer session with the Mahoning Valley's controversial congressman, James Traficant.

As the cameras rolled on the morning of October 8, 1990, the congressman received a "rousing show of support" at 2,500-seat Stambaugh Auditorium, packed to capacity "with a cross-section of the region's population." About twenty minutes into the show, Traficant was caught off guard when audience member Vic Rubenstein questioned the congressman's conviction to fight "pseudo-thinkers in the nation's capital." Traficant responded by rising to his feet and identifying the questioner as an individual of "Jewish descent" who worked for an opposing party. Clearly puzzled by the comment, Donahue asked the congressman: "Why the reference to Jews? Why would

you make it a Jewish issue?" Traficant stated that he believed he was being "targeted" by the World Jewish Congress and the American Israeli Public Affairs Committee.[430] Grabbing the microphone from Donahue, Rubenstein denounced the congressman as a "political opportunist" who "cultivated the seeds of hatred and bigotry." The auditorium then exploded into a cacophony of shouting and catcalls. "Sit down, Jew!" yelled one audience member. "They're all the same—Jews, blacks and lawyers!" shouted another. Rubenstein's subsequent comments were drowned out by intense booing from the audience.[431]

The following day, Rabbi David Steinhardt, president of the Jewish Community Relations Council, held a press conference to express his outrage over the Donahue incident. "Taking this man and singling him out as a Jew is irresponsible," Rabbi Steinhardt stated. "He spoke as a citizen of the Valley. He wasn't discussing Israel or any Jewish issue." The rabbi told reporters that the Jewish community expected an apology from Traficant. Likewise, Dr. Saul Friedman released a statement signed by twenty-two religious and community leaders denouncing the "exhibition of racism and demagoguery displayed" on the program.[432] Traficant dismissed all demands for an apology. Denying he was anti-Semitic, the congressman told reporters he would not "sit on my a-- and be steamrolled." When asked for his thoughts on the matter, Vic Rubenstein stated, "I wanted the world to know what and who he is."[433] Ultimately, despite years of high-profile cooperation between local Jewish and Christian leaders, the incident raised disturbing questions about the persistence of anti-Semitism in the Mahoning Valley.

THE RISE AND FALL OF PHAR-MOR

The controversy aroused by Traficant's comments had barely subsided when the Mahoning Valley garnered more unwanted national attention. This time, the news coverage involved the collapse of one of the country's fastest-growing retail chains. Phar-Mor was a discount drug chain established in 1982 by local Jewish businessmen Michael I. "Mickey" Monus and his longtime friend David Shapira. Built on the strategy of "Power Buying," Phar-Mor purchased massive lots of wholesale merchandise and sold them at discounted prices with extremely small profit margins. The concept proved wildly popular with consumers and was copied by competitors. By 1992, Phar-Mor had more than 310 stores across thirty-two states.[434] Indeed,

The former site of Strouss-Hirshberg Company, shown in a late 1920s photograph, became the national headquarters of Phar-Mor in the late 1980s. This symbolic gesture was hoped to signal the Mahoning Valley's long-awaited economic recovery. *Courtesy of Mahoning Valley Historical Society.*

the firm's success led Wal-Mart founder Sam Walton to comment that Phar-Mor was the only business he truly feared.[435] In less than a decade, the forty-five-year-old Monus had turned a tiny discount pharmacy into a $3 billion retail powerhouse, surpassing the Edward J. DeBartolo Corporation as the

area's largest privately owned company, while emerging as the twenty-eighth largest company in the United States.[436]

As Monus grew more successful, he diversified his business holdings and began investing in a variety of sports-related business ventures. Among the most notable was a minority stake in the fledgling Colorado Rockies professional baseball team. In addition, Monus was instrumental in the creation of the World Basketball League, a semipro association that introduced the unique concept of accepting players only six feet, five inches and under. He also founded the Ladies' Professional Golf Association (LPGA) Phar-Mor Million Dollar Championship at Squaw Creek Country Club, an annual event that brought thousands of golf fans from across the country to the Mahoning Valley. Monus's meteoric rise soon led the *Vindicator* to describe him as "the city's fastest-growing corporate citizen."[437] His status within the community was reflected in his presence on prestigious boards, including the Youngstown State University Board of Trustees.

In August 1992, less than a decade after the company's founding, Monus and chief financial officer Patrick Finn were implicated in a massive "fraud and embezzlement scheme" totaling over $500 million. In time, an investigation revealed that financial statements were "falsified to conceal losses and to overstate income," much of which was diverted for Monus's personal use.[438] With damages estimated at almost $1.1 billion, the scandal involved the largest case of embezzlement and corporate fraud in U.S. history at that time. Phar-Mor was eventually forced to seek Chapter 11 bankruptcy, and in 1995, Mickey Monus was convicted of 109 federal felony charges and sentenced to twenty years in prison.[439] The Phar-Mor scandal not only ended the career of one of the region's most prominent Jewish business leaders, but it also fueled the collective pessimism of a community plagued with seemingly intractable economic problems.

Teaching the Holocaust

In the early 1990s, local efforts to promote awareness of the Holocaust in regional classrooms culminated with the Jewish Community Relations Council's establishment of an annual Holocaust Teacher's Conference. The third annual conference, held in October 1994, focused on Steven Spielberg's award-winning film *Schindler's List*, which presents the story of Oskar Schindler, an opportunistic businessman who protects the Jewish workers

at his factory in wartime Poland when he learns they have been targeted for extermination. The conference, held at Boardman's Cinema South, featured a showing of the 1993 film, as well as a talk by Murray Pantirer, a "Schindler survivor." Chaired by Sherry Weinblatt, the conference benefited from the participation of Dr. Saul Friedman, professor of history at Youngstown State University and visiting professor of Holocaust and Jewish history at Kent State University, and attorney Clifford Savren, regional director of the Anti-Defamation League.[440]

Starting in the 1990s, the JCRC's Holocaust Commemoration and Education Task Force organized a flurry of events, including exhibits, lectures, workshops and writing contests to commemorate the Nazis' destruction of European Jewry, with a focus on lessons to be drawn from the tragedy. The taskforce simultaneously promoted the integration of Holocaust-related materials into classroom curricula, encouraging the involvement of local teachers. Few instructors became more passionately involved in teaching about the Holocaust than Boardman High School's Jesse McClain. His direct engagement with the area's Jewish community began when he contacted Holocaust survivor Esther Shudmak. After learning that Ms. Shudmak taught Hebrew at Ohev Tzedek–Shaarei Torah, McClain asked her if she would be willing to talk to his students. She agreed immediately. "I liked the all-inclusiveness of her talk," McClain recalled. "She didn't focus on being Jewish as much as she focused on being a human being, and how human beings should treat one another with respect."

Later, while teaching a research class on diversity at Youngstown State University, McClain approached another survivor, Bill Vegh, a former inmate at the Auschwitz-Birkenau camp in Poland, and asked him to speak to his students. He described Vegh's talk on his wartime experiences as "phenomenal." "I've heard survivors [from] around the world speak… and…the best speaker I ever heard was in Youngstown, Ohio," McClain recalled. "None of them told the story as well as Bill Vegh." He noted ruefully that a university recording of Vegh's talk was subsequently lost, although his testimony has been preserved in a 1998 recording done by Steven Spielberg's Shoah Foundation. Notably, what began as a professional relationship evolved into a friendship. When Bill Vegh died in the late spring of 2009, McClain served as a pallbearer at his funeral.[441]

Toward the end of the 1990s, three area congregations—Rodef Sholom, Temple El Emeth and Children of Israel—commemorated the Holocaust by displaying powerful artifacts of the genocide. With the assistance of donors, the congregations obtained Torahs that had been seized by the Nazis during

World War II. Nazi officials, who intended to display the scrolls in a museum after the extermination of European Jews, stored them in a disused Czech synagogue, where more than 1,500 were discovered in 1964. The scrolls were moved to London's Westminster Synagogue, and in subsequent decades, an organization known as the Memorial Scrolls Trust arranged for many to be placed on permanent loan at religious centers around the world. Suzyn Schwebel Epstein, who assisted in the acquisition of the Torahs, explained that congregations seeking a Holocaust Torah were required to raise $1,500 for the scroll itself, while securing additional funds for a display case and travel expenses.

Rodef Sholom's Rabbi Frankin Muller described the scrolls as symbols of the Jewish people's resilience. "We have survived and the Nazis haven't," he stated.[442] Later, the congregation of Ohev Tzedek–Shaarei Torah also acquired a Holocaust Torah, which ensured that rescued scrolls would be present in every congregation in the Mahoning Valley.

Moving toward the New Millennium

As the century came to a close, the community bid farewell to one of its long-standing leaders. In May 2000, Rabbi Mitchell Kornspan announced that he would leave Ohev Tzedek–Shaarei Torah to take a position at a congregation in Myrtle Beach, South Carolina. The rabbi reflected on his twenty-year tenure at the Boardman congregation, which featured involvement in interfaith and interracial outreach, as well as anti-poverty programs. "There are things we have done here that can equal and perhaps rival things done in larger metropolitan areas," he told the *Vindicator*. "I believe we should be proud of what we do here." The rabbi described his interest in social issues and outreach to various groups as a reflection of his faith: "Judaism as a way of life...calls us to love one another. There's a natural outgrowth from that. If you open up your arms, and other people open theirs, there can be this dialoguing."[443] Rabbi Kornspan was succeeded by Rabbi Simeon Kolko, whose installation coincided with the congregation's seventy-fifth anniversary.[444]

That same year, a significant barrier was broken on the nation's political scene. After securing the Democratic nomination for president, Al Gore announced that he had selected Connecticut senator—and Orthodox

Jew—Joseph Lieberman as his vice-presidential running mate. Known as a hawkish, conservative Democrat, Senator Lieberman was the first person of the Jewish faith to be nominated on a major political ticket. His national profile had risen considerably in the recent past, when he chastised President Bill Clinton at the height of the Monica Lewinsky scandal, in which the president misled the public about an affair with a White House intern. Senator Lieberman's appointment was viewed by some as an attempt by Gore to distance himself from President Clinton.[445]

Local responses to Senator Lieberman's selection were largely positive. Children of Israel's Rabbi Berel Sasonkin described himself as "happy and proud" about the decision, while Ohev Tzedek's Rabbi Simeon Kolko called it "a watershed moment for American Jews." Meanwhile, El Emeth's Rabbi Joseph P. Schonberger, who succeeded Rabbi Barry Baron, expressed cautious optimism, terming the decision as "a major shift from the norm" that "might scare both Jews and non-Jews." Irv Ozer, former director of the Jewish Community Center, agreed with Rabbi Schonberger. "Anti-Semitism still exists," Ozer observed. "It may result in the bulk of the Jews voting for the ticket and the bulk of the anti-Semites voting against the ticket."[446]

While it is unclear what role, if any, anti-Semitism played in the 2000 election, the defeat of the Gore-Lieberman ticket was disappointing to many Jewish Americans. Yet, few observers could have predicted the devastating series of events that would soon radically alter the domestic political scene, while transforming the nation's relationship with the rest of the world.

Challenges of the New Millennium

On September 11, 2001, nineteen members of the Islamic extremist group Al-Qaeda carried out suicide attacks against the United States, utilizing four hijacked airplanes. Two of the planes were flown into the twin towers of the World Trade Center in New York City. Hundreds of miles away, a third plane slammed into the Pentagon building near Washington, D.C., while a fourth crashed into a field near Shanksville, Pennsylvania, after passengers attempted to resist the hijackers. All told, the attacks of September 11, often referred to simply as "9/11," took the lives of more than three thousand people. The following day, hundreds of Mahoning Valley residents gathered in their respective houses of worship and struggled to come to terms with a seemingly incomprehensible series of events. Eight religious leaders from various faiths, including Muslim, Jewish, Catholic, Presbyterian and Episcopalian, met at St. John's Episcopal Church in Youngstown to "[sing] hymns, read prayers, and [offer] blessings to the community, the nation, and the world." Speakers included Rodef Sholom's Rabbi Franklin Muller, who stated, "I stand here this evening as a rabbi, but mostly as a mourner…with all of you."[447] As participants in the ecumenical gathering offered each other words of support, the region's Jewish, Muslim and Christian communities took steps to provide money, services and medical supplies to victims and their families.[448]

While members of the local Jewish community joined representatives of other faiths to mourn the victims of the worst single terrorist attack in American history, the area's congressional representative, James Traficant,

chose a political tack, presenting the tragedy as the product of U.S. policy in the Middle East. On September 12, 2001, Traficant took to the floor of the U.S. House of Representatives, where he delivered a controversial speech suggesting the terrorist attacks were a product of the United States' support of Israel. "It may be unpopular to say," he stated, "but I believe America's policy in the Mideast is so one-sided that we now endanger American citizens." Ira Forman, executive director of the National Jewish Democratic Council, dismissed Traficant's speech as "muddle-headed and disgraceful."[449] Local responses to the speech were largely split along ethnic and religious lines. Ray Nakley, a Palestinian activist and chair of the Coalition for Peace in the Middle East, condemned the terrorist attacks but indicated he supported Traficant "100 percent for what he is saying." Describing the congressman's speech as "an incredibly brave act," Nakley agreed that U.S. foreign policy was endangering American lives. Meanwhile, Bonnie Deutsch Burdman, director of the Jewish Community Relations Council, dismissed this position. "There's simply no justification whatsoever for the act of war that is perpetrated against our country," Mrs. Burdman said, "least of all any sound foreign policies that are supported by the majority of the United States."[450]

ISRAEL'S OPERATION: DEFENSIVE SHIELD

Within a year and a half, tensions between the local Jewish and Palestinian communities rose dramatically over developments in the Middle East. In the years following the Second Intifada, a period of intense Israeli-Palestinian violence that erupted in the wake of Ariel Sharon's controversial visit to Temple Mount in September 2000, the conflict between the two parties reached new heights. The escalating violence was exemplified by an incident the press referred to as the "Passover Massacre." On March 27, 2002, a Hamas-affiliated suicide bomber detonated a bomb inside a hotel in the resort city of Netanya during a Passover Seder, killing 30 civilians and injuring another 140. Two days later, the Israeli government responded by initiating Operation: Defensive Shield, the country's largest military operation in the West Bank since the 1967 Six-Day War.[451] Several weeks into the Israeli siege, a busload of local Jewish residents traveled to Washington, D.C., to join a massive "We Stand with Israel" rally to pressure the administration of President George W. Bush to support Israel and refuse negotiations with Palestinian leader Yasser Arafat.[452] Rally organizers called it the largest pro-

Israel demonstration since the country's establishment in 1948.[453] At the same time, local Muslim and Christian Palestinian groups held meetings at the Arab Community Center in Youngstown to express their outrage over the Israeli offensive, as well as their concern about the safety of family and friends still living in the West Bank.[454]

Two weeks later, in April 2002, Rachel Feinmesser, Philadelphia consulate general of Israel, was invited to talk about the conflict to a pro-Israel group of several hundred at the Youngstown Jewish Community Center. Outside the building, almost one hundred protesters marched peacefully with picket signs to condemn Israeli policies. It was reported to be the largest pro-Palestinian rally in Mahoning Valley history. In her remarks, Feinmesser stressed that Israel was "engaged in a war against terrorism, not against the Palestinian people," but that the current situation was caused by Palestinian leadership's decision to engage in and finance terrorist activities.[455] In a statement, protest leader Ray Nakley said, "While we recognize the right of Israel's supporters to express their feelings in our free society, we object to the implication that all Palestinian resistance to an illegal military occupation is unjustified."[456]

Continued Demographic Decline

Few people were more keenly aware of events in the Middle East than area resident Joseph Hill, who was approaching his centenary at the time of the 2002 Israeli military operation. Hill was one of the last surviving members of a remarkable generation that placed the Mahoning Valley's Jewish community on the map for its outsized support of Zionist and, later, Israeli causes. Unlike his late contemporary Oscar Altshuler, an industrialist who had established seven prekindergarten schools in Israel during the 1960s, Hill was not positioned to act as a major philanthropist. A longtime agent with New York Life Insurance Company, he was known for his tireless promotion of local and international Jewish causes. Apart from his service on various boards and involvement in scores of organizations, Hill was a "major supporter" for the creation of the Holocaust and Judaic studies program at Youngstown State University. His death in February 2005, at the age of 102, saddened the many who appreciated his boundless energy and sharp wit.[457] In some ways, the passing of community leaders like Joseph Hill highlighted a larger phenomenon: the aging of a Jewish population that was already in steep decline.

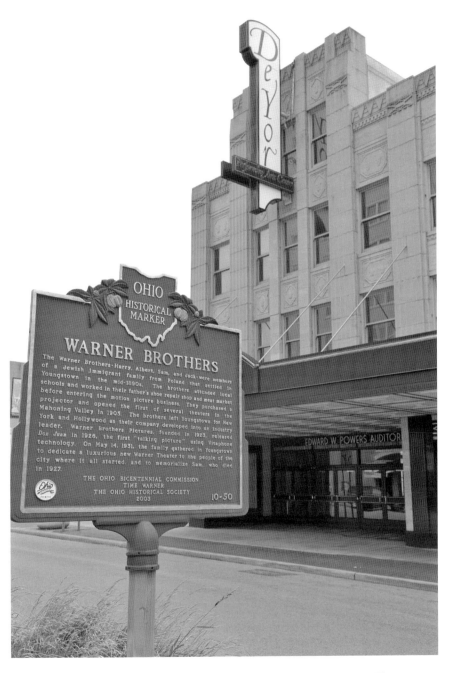

An Ohio Historical Marker calls attention to the site of Youngstown's Warner Theatre, which was built in 1931 by former residents Harry, Albert and Jack Warner. The Warners entered the motion-picture industry in 1906, when their brother Sam purchased a secondhand Kinetoscope projector in Youngstown. *Courtesy of Nea Bristol.*

Contrary to some local histories, which indicate the regional Jewish population peaked in the 1950s, evidence suggests that Jewish residency reached its zenith in the 1930s and declined from there, a pattern consistent with the area's general population.[458] The *American Jewish Yearbook* covering 1930 and 1931 estimated the local population at 8,500.[459] That figure had fallen dramatically by the mid-1970s, when the population was estimated to be 5,500.[460] After the collapse of the region's steel industry in the late 1970s, the Jewish population began to fall steadily. By 1985, local residency was placed at 5,000, representing a 10 percent decline.[461] Five years later, the community's population dropped by another 10 percent, slipping to about 4,500.[462] The year 1996 witnessed yet another 10 percent decrease, which left the community with just 4,000 people.[463] The most precipitous decline, however, occurred in the twenty-first century. While a 2000 report suggested the Jewish population was 3,300, a survey conducted two years later, in 2002, concluded that the actual figure was 2,300 residents.[464] Sam A. Roth, who grew up in a bustling Jewish neighborhood on Youngstown's South Side, cited the decline of family-owned businesses as a factor in this trend. "Our kids just do not come back to the community," he noted.[465] Business leader Paul Schwebel agreed. "They've done a great job with the people that are here, but if you look at the population under 40, it is…extremely small," he said. "It's hard to develop leaders, or to find leaders. The question becomes: 'What leaders, or how many leaders, are going to lead in the Jewish community if there're very few under 30?'"[466] The urgency of this question would grow as the decade continued.

Milestones of the 2000s

As the Jewish population dwindled, the Youngstown-Warren area's three congregations continued to operate with fewer congregants. In June 2004, Boardman's Ohev Tzedek–Shaarei Torah announced the appointment of Rabbi Joel Berman as its twelfth spiritual leader in eighty-two years. Rabbi Berman, who had lived in Israel for more than a decade, acknowledged that this was his first position with a U.S. congregation. His path to the rabbinate was decidedly unconventional, since he had spent years as a stand-up comic, a fixture at Los Angeles's Comedy Store in the 1980s. Disconnected from the religion of his upbringing, he was nevertheless dismayed at the high levels of depression and chemical dependence he saw among entertainers.

This photograph of Warren's Beth Israel Temple Center was taken in August 2008, when the congregation celebrated its ninetieth anniversary. *Courtesy of Louise Shultz.*

"That didn't sit right with me," Rabbi Berman told a *Vindicator* reporter. He ultimately found the ethical framework he desired within his own religious tradition and began to attend services regularly. Meanwhile, his appreciation for Jewish humor, which he explored in talks at temple gatherings, played an indirect role in his decision to become a rabbi. When he told a mentor about his plans to deepen his examination of Jewish humor, he was advised, "That's not going to sell unless you're a rabbi." During his tenure at Ohev Tzedek–Shaarei Torah, Rabbi Berman would become actively involved in the Jewish-Christian Dialogue Group, established decades earlier by Rabbi Samuel Meyer and Father George Balasko.[467]

About four years later, in August 2008, Warren's Jewish community gathered to mark Beth Israel's ninetieth anniversary. Chaired by Louise Shultz, the event featured screenings of footage taken at previous anniversary celebrations, as well as a display of memorabilia. During the celebration, Warren mayor Michael J. O'Brien presented a special proclamation to the congregation, and celebratory speeches were delivered by copresidents Curt Bogen and Dr. Bernard Shultz. Clerical leaders on hand at the event included former spiritual leader Rabbi David Steinhardt, El Emeth's Rabbi Joseph Schonberger and Ohev Tzedek's Rabbi Joel Berman. In a program

developed for the occasion, congregants shared memories of the temple that spanned generations. Congregant Allan Segall, for instance, recalled that his class of five students was the first to be confirmed in the new edifice. "[M]y classmates and I had to have our Confirmation held back a year…for us to be the first class confirmed in the new building…which was still under construction," he wrote.[468]

For many, the celebration took on an elegiac tone, given the hollowing out of Warren's once-vibrant Jewish community. Louise Shultz noted that, in the 1960s, she raised her children in a neighborhood where whole families walked to the temple on the High Holidays, and most Jewish children were enrolled in Beth Israel's religious education program. "They went to Sunday school," Mrs. Shultz explained. "They went to *cheder* [Hebrew school] four days a week….They were immersed in Judaism."[469] Similarly, Dr. William Lippy recalled the period in which Warren's Jewish community enjoyed recognition for its outstanding fundraising efforts. In recent decades, however, many former residents had moved on, while others spent six months out of the year in warmer climes. Dr. Lippy noted that a significant number of former congregants had resettled in Boca Raton, Florida, where many joined B'nai Torah Congregation, whose spiritual leader was none other than Rabbi Steinhardt. "If you don't get there by 9:15 [a.m.], you can't get a seat, and they seat 1,700—one of three services going on," Dr. Lippy explained. Warren's Jewish community, meanwhile, continued to shrink. "Do you know how many Jews Warren has now? There are 60 Jews," he said. "So, when you talk about the spirit and the drive that hold you together… It's a non sequitur…There aren't many Jews left."[470] Although Beth Israel Temple Complex remains officially open, most former members have joined other congregations.

Amid the winnowing of regional congregations, the community witnessed groundbreaking developments in religious leadership. In August 2010, Ohev Tzedek–Shaarei Torah became the first Jewish congregation in the Mahoning Valley to be led by a female rabbi, Daria Jacobs-Velde. Significantly, the young rabbi had been ordained in 2009 at Wyncote, Pennsylvania's Reconstructionist Rabbinical College, making her the first of the Conservative congregation's leaders to espouse Reconstructionist Judaism, a United States–based movement that views Judaism as an evolving civilization. Congregants soon learned that Rabbi Jacobs-Velde had a personal connection to the region, since her grandparents were former Ohev Tzedek president Sidney (Shlomo) Jacobs and temple sisterhood president Shirley Jacobs. In another "first," Rabbi Jacobs-Velde shared her clerical

Attendants at Beth Israel's ninetieth anniversary included longtime congregant Dr. William Lippy and Rabbi David Steinhardt, the temple's former spiritual leader. Dr. Lippy is now an active member of B'nai Torah Congregation in Boca Raton, Florida, where Rabbi Steinhardt serves as spiritual leader. *Courtesy of Louise Shultz.*

duties with her husband, Josh, a rabbinic intern. Together, the couple offered Ohev Tzedek a unique spiritual experience. Apart from her rabbinical training, Rabbi Jacobs-Velde brought experience as a High Holiday cantor and often incorporated chanting, singing and music into her services.[471]

By the spring of 2013, the congregation was interviewing Rabbi Jacobs-Velde's potential successors, and candidates included yet another

Reconstructionist rabbi, Saul Oresky. A native of Washington, D.C., Rabbi Oresky came to the rabbinate later in life, following a successful thirty-five-year career as a writer and editor for the U.S. government and private industry. After shifting to a part-time position at the Naval Research Library, he enrolled as a full-time student at Philadelphia's Reconstructionist Rabbinical College, driving almost three hours from Washington, D.C., to attend classes. Planning to graduate in four to five years, he found his progress delayed by a bout with kidney cancer that ended with a successful chemotherapy treatment. Rabbi Oresky's interview at Ohev Tzedek–Shaarei Torah came less than a year after his ordination in June 2013; he would be hired in August 2014. "It was very different than living in D.C.," the rabbi noted. "In some ways, the smallness of the community makes it possible to know many…more people, and in some ways, it's more intimate."[472]

THE MERGER OF RODEF SHOLOM AND TEMPLE BETH ISRAEL OF SHARON

The vitality of the Jewish communities in western Pennsylvania was reflected in an impressive array of religious institutions, organizations and family-owned businesses. Regional consumers frequented Reyers Shoe Store (owned by Harry Jubililirer), the grocery chain of Golden Dawn Foods (founded by the Rosenblum family), Bolotin's Furniture, Shenango Provisions (established by the Rosenberg family) and a host of other enterprises. By 2013, however, Sharon's Temple Beth Israel saw its membership slip to just one hundred families. During the same period, Youngstown's oldest congregation, Rodef Sholom, found its roster reduced to a little more than three hundred active families. While both institutions were financially solvent, each acknowledged that declining membership was a serious problem. "We have the funds, but not the people," observed Rodef Sholom's copresident Inez Heal.[473] In an effort to preserve the long-term viability of both institutions, Beth Israel and Rodef Sholom announced they would merge in July 2013. Under the terms of the merger, the Sharon synagogue was put up for sale, and its religious artifacts, plaques, artwork and furniture were transferred to Rodef Sholom. In addition, Sharon's Holocaust memorial was transferred from Beth Israel to the grounds of the Jewish Community Center in November 2013.[474]

If the merger inspired a mixture of emotions among those involved, the benefits soon became apparent. The congregation's copresident Jeff

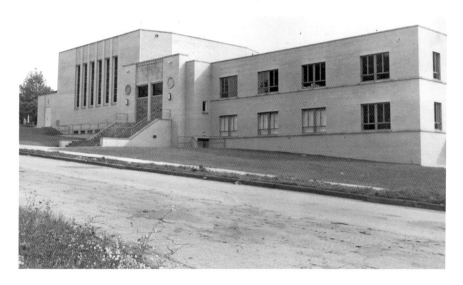

As the Shenango Valley's Jewish community continued to shrink, members of Sharon's Temple Beth Israel recognized that their congregation could not remain independent. In June 2013, Beth Israel merged with Youngstown's Rodef Sholom. *Courtesy of Mercer County Historical Society.*

Simon noted that the merger had "created a synergy whereby the merged congregation is much more active, engaged and vibrant." Apart from "a renewed sense of spirituality and vibrancy," the merger had produced "an infusion of new faces and fresh ideas at Rodef."[475] For Rabbi Franklin Muller, the spiritual leader of Rodef Sholom, the merger was a "natural progression." Accompanied by his wife, Darlene, Rabbi Muller attended "at least half a dozen parlor meetings in people's homes in Sharon, where we could meet with congregants, and they could ask us what they wanted about the temple."[476] At the same time, members of both congregations participated in a series of outdoor religious services, which were held, alternately, in Sharon and Youngstown. "Sharon people said, 'Well, the Youngstown people are never going to come to Sharon,'" recalled Marlene Epstein, a Sharon resident. "But they outnumbered us, in some cases…. There was a bonding process as a result of those [services]."[477] Even those who valued the convenience of a nearby temple soon became accustomed to making the drive to and from Youngstown. "Coming from a small town, we're not used to driving any distance to do things," admitted Beverly Nathan, a resident of Hermitage, Pennsylvania. Yet, at this point, Mrs. Nathan, who is actively involved in Sisterhood and the planning committee for Rodef Sholom's 150th anniversary, makes the trip "four or five times a week."[478]

The Way Forward

Despite the region's continuing economic challenges, few observers deny the Mahoning Valley has seen positive changes. Andrew L. Lipkin, executive vice president of the Youngstown Area Jewish Federation, expressed cautious optimism about trends in Youngstown's traditional center. "I just know that when I go downtown, I don't see many boarded-up buildings. I see some nice things there," he said. "[On] a Saturday night, you might have four or five different places [operating] downtown—Covelli Centre, DeYor [Performing Arts Center], Stambaugh [Auditorium], Butler [Institute of American Art], all doing something at the same time….It's wonderful that that happens." For Lipkin, however, the most telling change has been a shift in residents' collective attitude toward the community. As a student at the University of Buffalo, he learned that residents of Buffalo, New York, refused to tolerate any criticism of their city from "outsiders." "Around here, people who were *born* here bad-mouth Youngstown," he said. "I don't see that as much. I see…much more pride in this community, and I want to be part of it."[479] It remains unclear, however, whether the community's gradual stabilization will prevent the further erosion of the region's Jewish community. Indeed, figures from a 2015 survey project that the area's Jewish population will soon include just 1,700 people—an almost 50 percent decline since the dawn of the millennium.[480]

Given the steady decline of the region's Jewish population, institutions like the Youngstown Jewish Community Center now depend on non-Jewish members to remain viable. *Courtesy of Nea Bristol.*

As population numbers continued to drop, facilities created to serve the Jewish community became more dependent on non-Jewish patrons. In a June 2008 interview, Sandy Kessler, executive director of the Youngstown Jewish Community Center, acknowledged that 76 percent of the facility's membership was non-Jewish. "Attracting non-Jewish members [is] essential to the center's survival," Kessler said.[481] Likewise, Akiva Academy, once 100 percent Jewish, is currently 20 percent Jewish and must now "openly work to attract non-Jewish students" in order "to leverage more dollars to keep the school open."[482] Gary Weiss, executive director of Heritage Manor, similarly acknowledged that "changing demographics" led the facility to open its doors to the general public in 2005.[483] For some local leaders, though, the declining patronage of Jewish residents has raised questions about the long-term viability of these institutions. "The younger generation doesn't seem to have the same feeling about maintaining a Jewish community. They don't see the value in it," observed Bill Benedikt, a former federation president. "If you look at the usage of the center by members of the Jewish community… only 11 percent of the Jewish community comes to the Jewish [Community] Center twice a month or more. That's very, very minimal usage. The needs, apparently, have changed. So where are we going in the future?"[484]

Established as a facility for the care of Jewish senior citizens, Heritage Manor opened its enrollment to the general public in 2005 in response to demographic changes. *Courtesy of Nea Bristol.*

On July 24, 2014, Arby's co-founder Leroy Raffel (*right*) was on hand to mark the chain's fiftieth anniversary at Youngstown's Tyler Center of Mahoning Valley History. Sponsored by Arby's Restaurant Group, Inc., the event drew scores of former corporate employees, franchisees and others. Raffel is shown with Gerald Peskin, president of the Peskin Sign Company, which produced the chain's unique signage. *Courtesy of Mahoning Valley Historical Society*.

While Rodef Sholom's Rabbi Franklin Muller echoed Benedikt's concerns about the community's capacity to maintain these institutions over time, he went on to describe their continued operation as "another way that the Jewish community provides services to the general community." Pointing to signs of recovery in the regional economy, he also stressed the need to be prepared for future growth. "I think that, given the changes that we've seen to make downtown more viable...Youngstown has tremendous potential to be one

of the best small Jewish communities in America, with kids coming back to live here when they see the quality of life here, as opposed to what they're going to experience in larger cities," he said.[485] El Emeth's Rabbi Joseph Schonberger agreed and called for the preservation of the community's infrastructure. "Hopefully, at some point in the future, there will be more people here, and they'll be able to really appreciate it, enjoy it, and thrive," he said.[486]

Lifelong resident Neil Yutkin has lobbied for the recruitment of young Jewish professionals, complaining that "there is no concerted effort at this point to do so." For Yutkin, the introduction of additive manufacturing (informally known as "3-D printing"), the resurgence of the region's steel industry and the presence of auto manufacturing point to new opportunities for well-educated workers. "We have the largest single steel mill under one roof in the nation….one million square feet," he said. "There are engineering jobs, the jobs that Jewish people moved away to get….We've got an incredible medical structure here….We [should] set up a free database job-placement service and advertise…in areas where Jewish people are willing to relocate from."[487] Area boosters like Yutkin are also encouraged by

Plaza Donuts was established on Liberty's Belmont Avenue by brothers Berkeley and Irv Froomkin in 1963. While the chain downsized in the wake of regional deindustrialization—retaining just three of ten locations—the original store has operated on Belmont Avenue for more than fifty years. *Courtesy of Nea Bristol.*

the continuing presence of Jewish-owned businesses like Allen's PharmaServ, B&I Management, Burdman Brothers, Davis Motel, Dinesol Plastics, HD Davis CPAs, Hersh Extermination, Kravitz Deli, Niles Iron & Metal, PSK Steel Corporation, Plaza Donuts, Redlich Transmissions, Reyers Shoe Store, Schwebel's Baking Company, Simco Management, Uniforms Inc. and W3 Wealth Management, to name a few.

They point out that a number of local Jewish-owned businesses have seen dramatic growth in recent years, including B.J. Alan Company, also known as Phantom Fireworks. The business began informally in the 1960s, when a teenaged Bruce Zoldan began selling fireworks out of the trunk of his mother's car.[488] By the 1980s, Zoldan was the owner of two local fireworks companies, B.J. Alan and Diamond Sparkler, that employed more than 450 people. Aided by the legalization of fireworks sales in a growing number of states, the company continued to expand and, by 2011, had shifted the bulk of its Youngstown operations to the former Delphi Packard Plant, in a move estimated to cost $8.1 million. Furthermore, the company operated fifty-four Phantom Fireworks retail chains in thirteen states and Puerto Rico.[489] A major contributor to political campaigns, Zoldan has hosted politicians including Bill and Hillary Clinton, Vice President Joe Biden and Ohio governor John Kasich.[490] Meanwhile, Handel's Homemade Ice Cream & Yogurt, a Youngstown staple since the 1940s, has seen explosive growth since its purchase by Leonard Fisher in 1985. Under Fisher's leadership, the small family-owned business developed a national profile, adding more than forty locations in seven states. In 2013, the company's location in Redondo Beach, California, grossed more than $1 million in revenue.[491]

The optimism of residents like Neil Yutkin is not shared by everyone. Local business leader C. Kenneth Fibus suggested that the area's economic recovery has been too modest to fuel significant population growth. "I think the temples are going to…be forced to further consolidate," he said. "The reason they haven't done so up to now is there are a few members out there who are willing to keep their individual temples going almost by themselves….Pretty soon, it's going to be impossible, because there are going to be fewer and fewer people."[492] Indeed, the phenomenon Fibus described has compelled local Jewish leaders to accomplish more with fewer numbers. "It only takes five good people to run a program—but you have to have the people come," explained civic leader Carol Sherman. Yet, despite the challenges brought on by demographic decline, the Jewish community remains a visible presence in the Mahoning Valley. "I think it's important for the community to know that the Jewish people of Youngstown

Liberty's Kravitz Deli is the area's only Jewish delicatessen since the closing of establishments like Evie's, Nudel's, Spiegle's and the Newport Deli. Under Solomon "Jack" Kravitz's leadership, the business has flourished, and a second branch operates in the suburb of Poland, Ohio. *Courtesy of Nea Bristol.*

are also important people in our Youngstown community," Mrs. Sherman noted. "We really feel that the betterment of the entire community is part of the Jewish cause."[493]

Relatively few of the area's former Jewish residents have returned to live in the Mahoning Valley, but those who have point to the Jewish community's resources as a major draw. Ellen Zlotnick, an editor with Cambridge University Press, was raised on Youngstown's South Side. Her late father, Judge Julius A. Zlotnik, was part of an impressive group of Jewish professionals that included Judge Sidney Rigelhaupt, Dr. Nathan Belinky, attorney Irwin Kretzer, Dr. Samuel D. Goldberg, attorney David Sieman, Dr. Milton E. Greenberg and many others. After a thirty-seven-year absence that involved extended stays in Europe, she resettled in the area, along with her husband, Alexander "Sascha" Lamb, and her two children, Esther and Arthur, both of whom are enrolled at Akiva Academy. "In order to understand Youngstown, you have to leave," she said. "You have to go live in Madrid, or go live in Italy…and then come back and see what we have here….I think the people who haven't done that don't enjoy the richness of Youngstown, from any perspective."[494]

The interior of Power's Auditorium, former site of the Warner Theatre, reflects the elegance of a bygone era. The Art Deco building is currently the centerpiece of Youngstown's DeYor Performing Arts Center. *Courtesy of Nea Bristol.*

As the area's Jewish residents prepare to mark the 150th anniversary of the Mahoning Valley's oldest congregation, Rodef Sholom, their collective pride has been revealed in plans for a flurry of events stretching from July 2016 to May 2017. The celebration will conclude on the weekend of May 12, with a special address by Rabbi Richard Jacobs, president of the Union for Reform Judaism, as well as a celebration of Jewish music featuring Shlomo Carlebach and Joshua Nelson. Longtime area resident Joy Elder, who facilitated the expansion of the Jewish Community Center's Jewish library, would not be surprised to learn of the meticulous planning involved in the celebration. "It's amazing what we accomplish as a Jewish community, considering how few Jews we have," she said. "I'm even surprised that my library still exists, to be honest with you, because we don't have many people reading Jewish books. But they're still reading them occasionally. So, as long as I can hold on to it, I will."[495]

Notes

Introduction

1. Ozer et al., *These Are the Names*, 16–17.
2. *Youngstown Vindicator*, May 4, 1967.
3. Ozer et al., *These Are the Names*, 31.
4. Ibid., 31–32.
5. Friedman, "Jewish," 115.
6. Berlin and Grossman, *Oxford Dictionary of the Jewish Religion*, 617.
7. Ozer et al., *These Are the Names*, 43–44.
8. *Jewish Criterion*, October 29, 1918, 34.
9. Ibid., October 29, 1918, 36–37.
10. *Youngstown Vindicator*, March 27, 1938.
11. Ozer et al., *These Are the Names*, 93–94.
12. Ibid., 98–99.
13. Ibid., 124.
14. Ibid., 301–03.
15. Welsh, "Youngstown, the City that Produced the Warner Brothers," 60–66.
16. Ozer et al., *These Are the Names*, 222.
17. "About Arby's," Arby's: It's Good Mood Food.
18. *Youngstown 2010 Citywide Plan*, 31.
19. Bruno, *Steelworker Alley*, 149.
20. Friedman, "Jewish," 114.
21. Goldstein, *Price of Whiteness*, 211.

Chapter 1

22. *Youngstown Daily Register*, November 7, 1881, 3.
23. *Youngstown Vindicator*, November 11, 1881, 8.
24. *Youngstown Daily Register*, November 7, 1881.
25. Ozer et al., *These Are the Names*, 16.
26. Joseph et al., *Jewish Cemeteries of Mahoning County, OH*, 12.
27. *Youngstown Daily Register*, November 7, 1881.
28. Butler, *History of Youngstown*, 658.
29. Sanderson, *20th Century History of Youngstown and Mahoning County*, 371.
30. *Reform Advocate*, November 1908, 3.
31. Butler, *History of Youngstown*, 322.
32. *Jewish Daily Bulletin*, March 7, 1928, 3.
33. Orth, *History of Cleveland, Ohio*, 377.
34. Sanderson, *20th Century History of Youngstown and Mahoning County*, 371.
35. *Girard Grit*, January 20, 1893.
36. Stephens, "Decline of Steel Making Giant," 198.
37. Safford, *Why the Garden Club Couldn't Save Youngstown*, 44.
38. *Youngstown Vindicator*, November 1, 1926, 1.
39. Williams, *History of Trumbull and Mahoning Counties*, 464.
40. *Youngstown Vindicator*, July 15, 1892, 3.
41. Ibid., March 18, 1903, 3.
42. Ibid., July 15, 1892.
43. Efford, *German Immigrants, Race, and Citizenship in the Civil War Era*, 76.
44. *Youngstown Vindicator*, September 14, 1922, 3. The obituary notes that Hartzell's true surname was Eis; he was partly raised by his maternal grandfather and adopted the surname Hartzell in his honor.
45. Ibid., March 3, 1887, 5.
46. Ibid., April 17, 1903, 3.
47. Ibid., August 31, 1918, 2.
48. Ibid., April 1, 1925, 1.
49. Ibid., August 26, 1925, 1.
50. *Reform Advocate*, 25.
51. *Youngstown Vindicator*, October 14, 1905, 3.
52. Ibid., June 30, 1903, 3.
53. Sanderson, *20th Century History of Youngstown and Mahoning County*, 371.
54. Kaplan, *American Reform Judaism*, 9.
55. *Congregation Rodef Sholom 1867–1992*, 4–5.
56. *Youngstown Vindicator*, January 21, 1918, 2.
57. Ozer et al., *These Are the Names*, 28–30.
58. *Youngstown Jewish Times*, October 1, 1937, 6.
59. Ozer et al., *These Are the Names*, 28–30.

60. *Appleton's Cyclopedia and Register of Important Events of the Year 1890*, 826.

61. Williams, *History of Trumbull and Mahoning Counties*, 77.

62. Sanderson, *20ᵗʰ Century History of Youngstown and Mahoning County*, 184.

63. *Biographical History of Northeastern Ohio: Embracing the Counties of Ashtabula, Trumbull, and Mahoning*, 543–44.

64. *Youngstown Vindicator*, June 28, 1906, 2.

65. Butler, *History of Youngstown*, 430.

66. Ozer et al., *These Are the Names*, 34.

67. *Jewish Observer*, June 8, 1984.

68. Sanderson, *20ᵗʰ Century History of Youngstown and Mahoning County*, 372.

69. *Jewish Observer*, June 8, 1984.

70. Sanderson, *20ᵗʰ Century History of Youngstown and Mahoning County*, 372.

71. Cayton, *Ohio: The History of a People*, 161.

CHAPTER 2

72. *Sacramento Daily Record-Union*, March 1, 1881.

73. *Youngstown Vindicator*, September 23, 1881, 1.

74. Warren, *American Steel Industry*, 56.

75. Safford, *Why the Garden Club Couldn't Save Youngstown*, 44–45.

76. *Youngstown Vindicator*, September 23, 1881, 4.

77. Sachar, *History of the Jews in America*, 117–18.

78. Ibid., 130.

79. Butler, *History of Youngstown*, 263.

80. Linkon and Russo, *Steeltown U.S.A.*, 22.

81. Ozer et al., *These Are the Names*, 40.

82. Sachar, *History of the Jews in America*, 125.

83. Ozer et al., *These Are the Names*, 63.

84. Goldstein, *Price of Whiteness*, 36.

85. Ozer et al., *These Are the Names*, 41.

86. *American Israelite*, July 1, 1870, 6.

87. *Youngstown Vindicator*, August 4, 1890, 1.

88. Ozer et al., *These Are the Names*, 41.

89. Ibid., 42–43.

90. *Youngstown Vindicator*, August 1, 1922, 1.

91. Ibid.

92. Linkon and Russo, *Steeltown U.S.A.*, 27.

93. Ozer et al., *These Are the Names*, 63.

94. Safford, *Why the Garden Club Couldn't Save Youngstown*, 48–49.

95. *Youngstown Vindicator*, April 29, 1893, 27.

96. Ibid., April 29, 1893, 27.

97. *Youngstown Telegram*, March 7, 1925.
98. *Reform Advocate*, November 1908, 17.
99. *Youngstown Vindicator*, August 31, 1918, 2.
100. Ozer et al., *These Are the Names*, 47.
101. *Youngstown Vindicator*, June 30, 1903, 3.
102. *Reform Advocate*, November 1908, 16–17.
103. *Youngstown Vindicator*, January 19, 1932, 1.
104. Ibid., January 20, 1936, 1.
105. Ozer et al., *These Are the Names*, 44.
106. Butler, *History of Youngstown*, 376–77.
107. *Youngstown Vindicator*, November 13 1905, 3.
108. Ibid., October 14, 1905, 3.
109. *Youngstown Telegram*, May 13, 1931, 1.
110. Ozer et al., *These Are the Names*, 53.
111. *Reform Advocate*, November 1908, 17–18.
112. *Youngstown Vindicator*, October 10, 1905, 3.
113. *Reform Advocate*, November 1908, 17.
114. Ibid., 26.
115. Sachar, *History of the Jews in America*, 70–71.
116. Ibid., 113–14.
117. Ibid., 162–63.
118. Ozer et al., *These Are the Names*, 50.
119. *American Israelite*, 1870.
120. Sanderson, *20ᵗʰ Century History of Youngstown and Mahoning County*, 372.
121. Ozer et al., *These Are the Names*, 50.
122. Ibid., 50–51.
123. Ibid., 52.
124. Ibid., 34–36.
125. Ibid., 37–38.
126. Goldstein, *Price of Whiteness*, 29.
127. "Anti-Semitism: A Lecture Delivered at Youngstown, Ohio, February 23, 1891, Under the Auspices of the Literary Society of the Rodef Sholem Congregation."
128. Kanez, *Coming of the Holocaust*, 28.
129. Sachar, *History of the Jews in America*, 246.
130. Ozer et al., *These Are the Names*, 55.
131. Goldstein, *Price of Whiteness*, 31.

CHAPTER 3

132. *Youngstown Vindicator*, September 9, 1901, 2.

133. May, *Issac Mayer Wise*, 317–18.

134. *New York Times*, March 30, 1900, 2.

135. Sachar, *History of the Jews in America*, 228–29.

136. Beach, *Encyclopedia Americana*.

137. Safford, *Why the Garden Club Couldn't Save Youngstown*, 49.

138. Butler, *History of Youngstown*, 48.

139. *Youngstown Vindicator*, June 18, 1953, 46.

140. Safford, *Why the Garden Club Couldn't Save Youngstown*, 49.

141. *Youngstown Vindicator*, November 5, 1942, 1.

142. Ibid., May 10, 1954, 1.

143. Ibid., September 11, 1949.

144. Ibid., February 2, 1915, 3.

145. *Reform Advocate*, November 14, 1908, 6.

146. Ibid., 11.

147. *Youngstown Vindicator*, December 20, 1908, 10.

148. Ibid., July 4, 1909, 24.

149. Ibid.

150. Ibid.

151. Ibid., July 18, 1912, 7.

152. Ozer et al., *These Are the Names*, 97.

153. Ibid.

154. Sanderson, *20th Century History of Youngstown and Mahoning County*, 373.

155. *Temple Emanu-El Dedication Journal*, 20.

156. *Reform Advocate*, November 14, 1908, 5.

157. *Temple Emanu-El Dedication Journal*, 20–26.

158. *Youngstown Vindicator*, May 3, 1912, 27.

159. *Congregation Rodef Sholom 1867–1992*.

160. *Mansfield News*, February 13, 1913, 5.

161. *Temple Bulletin*, November 1917.

162. *Youngstown Vindicator*, June 11, 1915, 32.

163. Ibid., June 5, 1915.

164. *Youngstown Telegram*, August 24, 1914.

165. Ibid., undated.

166. *Youngstown Vindicator*, December 5, 1914, 2.

167. *Mansfield News*, June 15, 1917, 16.

168. *Warren Tribune Chronicle*, September 11, 1968.

169. *Fiftieth Anniversary, Beth Israel Temple Center, September 1918–1968*, 5.

170. Ozer et al., *These Are the Names*, 36.

171. Berlin and Grossman, *Oxford Dictionary of the Jewish Religion*, 184.

172. Ozer et al., *These Are the Names*, 93–94.
173. Goldberg, *Discontented America*, 13.
174. Ibid., 40.
175. Ibid., 119.

CHAPTER 4

176. *Youngstown Vindicator*, June 9, 1921, 1.
177. Grief, *Legal Foundation and Borders of Israel Under International Law*, 39.
178. *Youngstown Vindicator*, June 3, 1920, 1.
179. Ibid., August 15, 1922, 3.
180. Helen Shagrin, interview by Irving Ozer.
181. Sachar, *History of the Jews in America*, 294–98.
182. *International Jew*, 180. The book erroneously states that the school board's actions occurred in 1907, not 1919.
183. *Youngstown Vindicator*, January 7, 1921, 2.
184. Ibid., January 9, 1922, 17.
185. Ibid., April 11, 1926.
186. Ibid., April 16, 1926, 30.
187. Ibid., January 8, 1923, 7.
188. Ibid., January 7, 1923.
189. Ibid., March 16, 1926, 8.
190. Louis and Marlene Epstein, interview by Thomas Welsh.
191. "Fiftieth Anniversary, Beth Israel Temple Center, September 1918–1968."
192. Ozer et al., *These Are the Names*, 138.
193. *Youngstown Vindicator*, October 23, 1927.
194. Ozer et al., *These Are the Names*, 127.
195. Ibid., 85.
196. Ibid., 161–62.
197. Ibid., 117.
198. Ibid., 143.
199. Ibid., 117.
200. Ibid., 155.
201. Ibid.
202. *Youngstown Vindicator*, November 1, 1926, 1.
203. Sperling, Millner and Warner, *Brothers Warner*, 26–27.
204. *Youngstown Vindicator*, May 13, 1931, 2.
205. Ibid., August 21, 1928, 1.
206. Ibid., May 15, 1931, 1, 14.
207. Ibid., January 9, 2013.
208. Ozer et al., *These Are the Names*, 149–51.

209. Ibid.
210. Ibid., 302–03.
211. *Youngstown Vindicator*, April 3, 1968, 1.
212. Ibid., December 10, 1974, 1.
213. Sam A. Roth, interview by Thomas Welsh.
214. *Youngstown Vindicator*, April 8, 1981, 54.
215. Ibid., August 8, 1964, 1.
216. Paul Schwebel, interview by Thomas Welsh.
217. Ozer et al., *These Are the Names*, 302–03.
218. Kurt Malkoff, interview by Thomas Welsh.
219. *Youngstown Vindicator*, May 4, 1928, 1.
220. Ibid., January 6, 1930, 6.
221. *Jewish Daily Bulletin*, February 26, 1930, 3.
222. Ibid., August 28, 1933, 1, 16.
223. *New York Times*, August 28, 1933, 5.
224. "Fiftieth Anniversary, Beth Israel Temple Center."
225. Ozer et al., *These Are the Names*, 153.
226. *Youngstown Vindicator*, December 28, 1934, 3.
227. Ibid., October 25, 1935, 1.
228. Ozer et al., *These Are the Names*, 132.
229. *Youngstown Vindicator*, January 13, 1937, 1.
230. Ozer et al., *These Are the Names*, 163–65.
231. Sachar, *History of the Jews in America*, 533–35.
232. Edith Peskin, interview by Thomas Welsh.

CHAPTER 5

233. Thomas, *Sea of Thunder*, 57–59.
234. *Youngstown Vindicator*, December 8, 1941, 6.
235. *Youngstown Jewish Times*, May 28, 1948, 1–3.
236. *Washington Times*, March 29, 2005, 23.
237. *Milwaukee Journal*, December 27, 1945, 1.
238. Ozer et al., *These Are the Names*, 222.
239. Berman, *Nazism, the Jews, and American Zionism, 1933–1948*, 65–67.
240. Cohen and Kolinsky, *Britain and the Middle East in the 1930s*, 210–15.
241. *Youngstown Vindicator*, November 2, 1943, 3.
242. Ibid., December 3, 1942, 22.
243. Telegram, February 24, 1943.
244. "Minutes of the First Meeting of the Sons and Daughters of Zion," October 27, 1909.
245. Telegram, April 10, 1928.

246. "The Palestine Friends of the Hebrew University Society," April 18, 1933.
247. *Youngstown Vindicator*, September 24, 1974, 1.
248. Ibid., February 28, 1957, 1.
249. Ozer et al., *These Are the Names*, 189.
250. *Youngstown Vindicator*, February 15, 1944, 2.
251. Ibid., May 6, 1942, 8.
252. *Youngstown Vindicator*, June 8, 1943, 1–6.
253. Ibid., November 6, 1942.
254. "Installation of Abraham Haskel Feinberg as Rabbi of Rodef Sholem Congregation," November 6–8, 1942.
255. *Youngstown Vindicator*, September 18, 1944, 16.
256. Epstein, interview.
257. "Excerpt: Temple Beth Israel," Ancestry.com.
258. *Youngstown Vindicator*, August 15, 1945, 1.
259. Bulletin, Congregation Rodef Sholom, January 25, 1946, original, Jewish Archives, Mahoning Valley Historical Society.
260. *Youngstown Vindicator*, February 25, 1946, 1.
261. Ibid., September 18, 1944, 16.
262. Ibid., March 8, 1947, 1.
263. Ibid., March 9, 1947, 1.
264. *Pittsburgh Press*, March 6, 1948, 7.
265. "Rodef Sholom Temple, 1867–1947, A Heritage…and a Responsibility," April 15, 1947.
266. *Youngstown Vindicator*, August 20, 1946.
267. Ibid., October 19, 1947.
268. Ibid., December 27, 1947, 7.
269. Ibid., July 15, 1946, 1, 3.
270. Ibid., July 16, 1946, 3.
271. Karsh, *Arab-Israeli Conflict*, 23.
272. Ozer et al., *These Are the Names*, 180.
273. *New York Times*, January 28, 1948.
274. Photo caption, United Jewish Appeal, undated.
275. *Youngstown Vindicator*, February 20, 1948.
276. Flyer, "Behind the Headlines…in Europe…in Palestine," May 1948, original copy, Jewish Archives, Mahoning Valley Historical Society.
277. Marilyn Oyer, interview by Thomas Welsh.
278. Hirsch, Housen-Couriel and Lapidoth, *Whither Jerusalem?*, 1–5.
279. *Youngstown Vindicator*, September 11, 1948, 1.
280. Ibid., September 12, 1948.
281. Ibid., 1.
282. Joseph Hill, interview by Thomas Welsh.

CHAPTER 6

283. *Youngstown Vindicator*, July 17, 1948.

284. "Resolution Adopted by the Youngstown Interracial Committee Upon the Death of the Reverend Dr. I.E. Philo, Rabbi," undated.

285. *Youngstown Vindicator*, February 3, 1951, 4.

286. *Tallahassee Democrat*, December 8, 1991.

287. Sugrue, *Origins of the Urban Crisis*, 127.

288. Gerstle, *American Crucible*, 241.

289. Heinze, *Jews and the American Soul*, 217.

290. *Youngstown Vindicator*, August 8, 1948, 1.

291. Ibid., March 31, 1949, 57.

292. Ibid., September 15, 1951, 3.

293. *Sharon Herald*, September 10, 1950.

294. "Excerpt: Temple Beth Israel," Ancestry.com.

295. *Warren Tribune*, March 16, 1951.

296. Ibid., September 11, 1952.

297. Ibid., March 16, 1951.

298. Louise Shultz, interview by Thomas Welsh.

299. Ozer et al., *These Are the Names*, 198.

300. Ibid., 101.

301. *Youngstown Vindicator*, September 26, 1957, 25.

302. Florine and Robert Rusnak, interview by Thomas Welsh.

303. *Youngstown Vindicator*, May 17, 1958, 3.

304. Ibid., May 3, 1965.

305. Ozer et al., *These Are the Names*, 192.

306. *Youngstown Vindicator*, June 13, 1960, 2.

307. Ozer et al., *These Are the Names*, 186.

308. *Youngstown Vindicator*, November 20, 1984, 22.

309. Alan Engel, interview by Thomas Welsh.

310. Ibid., April 23, 1963, 8.

311. Ozer et al., *These Are the Names*, 225.

312. Merabeth Lurie, interview by Thomas Welsh.

313. James Pazol, interview by Thomas Welsh.

314. Baum, Cohen, Jacobs, Kessel, eds., *Antisemitism in North America*, 78.

315. Sachar, *History of the Jews in America*, 791.

316. Ibid., 799–801.

317. *Challenge…to the People of Youngstown*, 8.

318. Alice Lev, interview by Gordon F. Morgan and Thomas Welsh.

319. Florence Harshman, interview by Thomas Welsh.

320. *Youngstown Vindicator*, December 19, 1951, 5.

321. Ibid., September 25, 1945, 8.

322. Ibid., July 7, 1949, 20.

323. Lev, interview.

324. *Youngstown Vindicator*, November 23, 1963, 3.

325. Ibid., November 23, 1963, 4.

326. Sachar, *History of the Jews in America*, 800.

327. Ibid., 804–05.

328. *Youngstown Vindicator*, May 13, 1967, 11.

329. David and Jeffrey Mirkin, interview by Thomas Welsh.

330. Neil Yutkin, interview by Thomas Welsh.

331. William Lippy, interview by Thomas Welsh.

332. *Youngstown Vindicator*, June 6, 1967, 1.

333. Ibid., 6.

334. Montefiore, *Jerusalem*, 523.

CHAPTER 7

335. *Youngstown Vindicator*, April 6, 1968, 2.

336. Ibid., June 8, 1968, 11.

337. *Newsweek*, May 10, 1969, 65.

338. *Times-News*, November 29, 1968, 10.

339. *Pittsburgh Post-Gazette*, November 18, 1968.

340. *Youngstown Vindicator*, October 23, 1968, 10.

341. Ibid., April 24, 1969, 29.

342. *Bryan Times*, October 7, 1969, 10.

343. Judith and Michael T. Gross, interview by Thomas Welsh.

344. Ted Powell, interview by Thomas Welsh.

345. Beauregard, *When America Became Suburban*, 85.

346. Malkoff, interview.

347. Stan Nudell, interview by Thomas Welsh.

348. Donia Kravitz, interview by Thomas Welsh.

349. *Youngstown Vindicator*, February 25, 1968.

350. Mervyn Hollander, interview by Thomas Welsh.

351. *Youngstown Vindicator*, December 15, 1974.

352. Ibid., May 15, 1968, 1.

353. Raffel, "I've Got No Beef."

354. Edith Peskin, interview by Thomas Welsh.

355. Leroy Raffel, interview by Thomas Welsh.

356. *Youngstown Vindicator*, March 31, 1992.

357. Ibid., July 7, 1968.

358. Ibid., August 4, 1968.

359. *Youngstown Vindicator*, January 29, 2012.

360. *Newsweek*, May 18, 1970, 31–33.

361. *Youngstown Vindicator*, May 6, 1970, 28.

362. Ibid., May 5, 1970, 14.

363. Troy, *Moynihan's Moment*, 134.

364. Ibid., 145.

365. *Youngstown Vindicator*, November 11, 1975, 17.

366. *Free Lance-Star*, November 15, 1986, 19.

367. Ozer et al., *These Are the Names*, 231.

368. Alan Mirkin, interview by Thomas Welsh.

369. *Youngstown Vindicator*, August 9, 1973, 13.

370. "Sharon and Farrell," Rauh Jewish Archives.

371. Alan and Beverly Nathan, interview by Thomas Welsh.

372. *Youngstown Vindicator*, May 24, 1975, 7.

373. George Balasko, interview by Thomas Welsh.

374. Ibid., October 18, 1975, 7.

375. "Statement on Catholic Jewish Relations: National Conference of Catholic Bishops 1975," UCCB.org.

376. *Catholic Exponent*, February 8, 1976, 1.

377. *Youngstown Vindicator*, 1, October 5, 1974.

378. Ozer et al., *These Are the Names*, 227.

379. Fuechtmann, *Steeples and Stacks*, 42–43.

380. Ibid., 1–2.

381. *Wall Street Journal*, September 23, 1980.

382. Bruno, *Steelworker Alley*, 149.

383. *Youngstown Vindicator*, July 8, 1980, 6.

384. Jerold Haber, interview by Thomas Welsh.

CHAPTER 8

385. Gary Weiss, interview by Thomas Welsh.

386. William Benedikt, interview by Thomas Welsh.

387. Rusnak, interview.

388. *Youngstown Vindicator*, February 15, 1988, 1.

389. Ibid., February 23, 1983, 3.

390. Ibid., February 7, 1983, 2.

391. Ibid., March 29, 1982, 4.

392. Ibid., March 29, 1982, 4.

393. Ibid., October 19, 1983, 44.

394. Ozer et al., *These Are the Names*, 234.

395. *Youngstown Vindicator*, March 6, 1981, 10.

396. Ibid., February 7, 1983, 1.

397. Ibid., February 7, 1983, 2.
398. Gross, interview.
399. Sam Kooperman, interview by Joshua Foster.
400. Brian Engel, interview by Thomas Welsh.
401. *Ohio Jewish Chronicle*, October 1, 1984, 5.
402. Schiff, *Holocaust Poetry*, 184.
403. *Youngstown Vindicator*, October 1, 1984, 19.
404. Ibid., October 3, 1982, A-27.
405. Ibid., November 25, 1985, 6.
406. Ibid., May 17, 1986, 5.
407. Ibid., October 6, 1986.
408. *Warren Tribune Chronicle*, October 31, 1988, B-1.
409. *Youngstown Vindicator*, July 15, 1989, 7.
410. Ibid., July 28, 1989, 6.
411. Ibid., February 20, 1983, A-14.
412. Ibid., March 10, 1985, A-2.
413. Ozer et al., *These Are the Names*, 250.
414. *Youngstown Vindicator*, March 10, 1985, A-2.
415. Ibid., May 16, 1988, 5.
416. Haj, *Immigration and Ethnic Formation in a Deeply Divided Society*, 84.
417. Ozer et al., *These Are the Names*, 252.
418. Irving Lev, interview by Thomas Welsh.
419. *Warren Tribune Chronicle*, June 5, 1991.
420. *Youngstown Vindicator*, December 22, 1991, A-1.
421. *Jewish Journal*, August 18, 1989, 14–15.
422. Alvin Weisberg, interview by Thomas Welsh.
423. *Youngstown Vindicator*, May 5, 1990, 8.
424. Ibid., October 27, 1990, 8.
425. Ibid., April 1, 1996, 1.
426. Oyer, interview.
427. *Youngstown Vindicator*, May 25, 1995, B5.
428. Ibid., May 25, 1996, B-5.
429. Ibid., October 6, 1990, 1.
430. *Cincinnati Enquirer*, October 10, 1990, 36.
431. *Youngstown Vindicator*, October 8, 1990, 1.
432. Ibid., October 12, 1990, 1, 4.
433. Ibid., October 9, 1990, 1,4.
434. *Pittsburgh Post-Gazette*, June 24, 1994, A-12.
435. Cohan, *Value Leadership*, 112.
436. Albrecht and Albrecht, *Fraud Examination*, 373.
437. *Youngstown Vindicator*, July 8, 1990.
438. Ibid., August 4,1992.

439. Ibid., December 2, 1995, 1.
440. Ibid., October 2, 1994, B-5.
441. Jesse McClain, interview by Thomas Welsh, July 1, 2015.
442. *Youngstown Vindicator*, April 8, 1998, B-4.
443. Ibid., May 13, 2000, B-8.
444. Ibid., November 4, 2000, B-5.
445. Ibid., August 7, 2000, A3.
446. Ibid., August 8, 2000, A2.

CHAPTER 9

447. Ibid., September 12, 2001, A13.
448. Ibid., September 13, 2001, A6.
449. Ibid., September 17, 2001, 1.
450. Ibid., September 18, 2001, A3.
451. Ibid., March 29, 2002, 1, A3.
452. Ibid., April 16, 2002, 1.
453. *New York Times*, April 16, 2002.
454. *Youngstown Vindicator*, April 8, 2002, 1.
455. Ibid., April 26, 2002, 1, A3.
456. Ibid., April 25, 2002, A3.
457. Ibid., February 2, 2005, B4.
458. Ozer et al., *These Are the Names*, 186.
459. *American Jewish Year Book 1930–31*, 224.
460. *American Jewish Year Book 1974–75*, 310.
461. Gurock, *Orthodox Jews in America*, 312–13.
462. *American Jewish Year Book 1990*, 289.
463. *American Jewish Year Book 1996*, 184.
464. *American Jewish Year Book 2012*, 5.
465. Roth, interview.
466. Schwebel, interview.
467. *Youngstown Vindicator*, June 19, 2004, A10.
468. "Beth Israel Temple Center 90th Anniversary Celebration," 7–8.
469. Shultz, interview.
470. Lippy, interview.
471. *Youngstown Vindicator*, July 9, B3.
472. Saul Oresky, interview by Gordon F. Morgan and Thomas Welsh.
473. *Youngstown Vindicator*, August 24, 2013, A12.
474. Ibid., November 11, 2013, A3.
475. Ibid., August 24, 2013, A12.
476. Franklin W. Muller, interview by Thomas Welsh.

477. Epstein, interview.
478. Nathan, interview.
479. Andrew L. Lipkin, interview by Thomas Welsh.
480. *American Jewish Year Book 2015*, 252.
481. *Forward*, January 14, 2016.
482. Bonnie Deutsch Burdman, interview by Joshua Foster.
483. *Youngstown Vindicator*, May 25, 2015, A3.
484. Benedikt, interview.
485. Muller, interview.
486. Joseph P. Schonberger, interview by Thomas Welsh.
487. Neil Yutkin, interview.
488. *Forward*, July 2, 2015.
489. *Youngstown Vindicator*, July 12, 2011.
490. *Forward*, July 2, 2015.
491. *Youngstown Vindicator*, January 3, 2015.
492. C. Kenneth Fibus, interview by Thomas Welsh.
493. Bruce and Carol Sherman, interview by Thomas Welsh.
494. Ellen Zlotnick, interview by Thomas Welsh.
495. Joy Elder, interview by Thomas Welsh.

Bibliography

BOOKS

Albrecht, Chad O., and W. Steve Albrecht. *Fraud Examination*. Mason, OH: Thomson South-Western, 2003.

Baum, Stephen K., Neil J. Kessel, Florette Cohen and Steven Leonard Jacobs, eds. *Antisemitism in North America: Old Hate*. Leiden, NL: Brill Publishers, 2016.

Beach, Frederick Converse. *The Encyclopedia Americana: A Universal Reference Library*. New York: Scientific American Compiling Department, 1905.

Beauregard, Robert A. *When America Became Suburban*. Minneapolis: University of Minnesota Press, 2006.

Berlin, Adele, and Maxine Grossman. *The Oxford Dictionary of the Jewish Religion, Second Edition*. Oxford, UK: Oxford University Press, 2011.

Berman, Aaron. *Nazism, the Jews, and American Zionism, 1933–1948*. Detroit: Wayne State University Press, 1990.

Bruno, Richard. *Steelworker Alley: How Class Works in Youngstown*. Ithaca, NY: Cornell University Press, 1999.

Butler, Joseph G. *History of Youngstown and the Mahoning Valley, Ohio*. Vol. 1. Chicago: American Historical Society, 1921.

Cayton, Andrew R.L. *Ohio: The History of a People*. Columbus: Ohio University Press, 2002.

Cohan, Peter S. *Value Leadership: The 7 Principles That Drive Corporate Value in Any Economy*. San Francisco: Jossey-Bass, 2003.

Cohen, Michael Joseph, and Martin Kolinsky. *Britain and the Middle East in the 1930s: Security Problems, 1935–39*. New York: St. Martin's Press, 1992.

Efford, Alison Clark. *German Immigrants, Race, and Citizenship in the Civil War Era.* Cambridge, UK: Cambridge University Press, 2013.

Friedman, Saul. "Jewish." In *An Ethnic Encyclopedia: The Peopling of the Mahoning Valley*, edited by George D. Beelen, PhD, and Martha I. Pallante, PhD. Youngstown: Ohio Cultural Alliance, 1996, 115.

Fuechtmann, Thomas G. *Steeples and Stacks: Religion and Steel Crisis in Youngstown.* Cambridge, UK: Cambridge University Press, 1989.

Gerstle, Gary. *American Crucible: Race and Nation in the Twentieth Century.* Princeton, NJ: Princeton University Press, 2001.

Goldberg, David J. *Discontented America: The United States in the 1920s.* Baltimore, MD: Johns Hopkins University Press, 1999.

Goldstein, Eric L. *The Price of Whiteness: Jews, Race, and American Identity.* Princeton, NJ: Princeton University Press, 2006.

Grief, Howard. *The Legal Foundation and Borders of Israel Under International Law: A Treatise on Jewish Sovereignty Over the Land of Israel.* Jerusalem: Mazo Publishers, 2008.

Gurock, J.S. *Orthodox Jews in America.* Bloomington: Indiana University Press, 2009.

Haj, Majid Al. *Immigration and Ethnic Formation in a Deeply Divided Society: The Case of the 1990s Immigrants from the Former Soviet Union in Israel.* Leiden, NL: Brill, 2004.

Heinze, Andrew R. *Jews and the American Soul: Human Nature in the Twentieth Century.* Princeton, NJ: Princeton University Press, 2004.

Hirsch, Moshe, Deborah Housen-Couriel and Ruth Lapidoth. *Whither Jerusalem?: Proposals and Positions Concerning the Future of Jerusalem.* New York: Springer Publishing, 1995.

Joseph, Louis, Sarah Joseph and Rachel Joseph Kujala. *Jewish Cemeteries of Mahoning Valley, OH: Their Histories and Tombstone Readings.* Apollo, PA: Closson Press, 1999.

Kanez, Peter. *The Coming of the Holocaust: From Antisemitism to Genocide.* Cambridge, UK: Cambridge University Press, 2013.

Kaplan, Dana Evan. *American Reform Judaism: An Introduction.* New Brunswick, NJ: Rutgers University Press, 2003.

Karsh, Efraim. *The Arab-Israeli Conflict: The 1948 War.* New York: Rosen Publishing, 2009.

Linkon, Sherry Lee, and John Russo. *Steeltown U.S.A.: Work and Memory in Youngstown.* Lawrence: University Press of Kansas, 2002.

Lynd, Staughton. *The Fight against Shutdowns: Youngstown's Steel Mill Closings.* San Pedro, CA: Singlejack Books, 1982.

May, Max B., AM. *Issac Mayer Wise: The Founder of American Judaism.* New York: Knickerbocker Press, 1916.

Montefiore, Simon Sebag. *Jerusalem: The Biography.* New York: Alfred A. Knopf, 2011.

Orth, Samuel Peter. *A History of Cleveland, Ohio*. Chicago: S.J. Clarke Publishers, 1910.

Ozer, Irving E., Harry Alter, Lois Davidow and Saul Friedman. *These Are the Names: The History of the Jews of Greater Youngstown, Ohio, 1865 to 1990*. Youngstown, OH: I.E. Ozer, 1994.

Sachar, Howard M. *A History of the Jews in America*. New York: Vintage Books, 1993.

Safford, Sean. *Why the Garden Club Couldn't Save Youngstown: The Transformation of the Rust Belt*. Cambridge, MA: Harvard University Press, 2009.

Sanderson, Thomas W. *20th Century History of Youngstown and Mahoning County, Ohio, and Representative Citizens*. Chicago: Biographical Publishing Company, 1907.

Schiff, Hilda. *Holocaust Poetry*. New York: St. Martin's Press, 1995.

Sperling, Cass Warner, Cork Millner and Jack Warner Jr. *The Brothers Warner: The Intimate Story of a Hollywood Dynasty*. Rocklin, CA: Cass Warner Sperling, 1998, 2008.

Stephens, David T. "Decline of Steel Making Giant." In *A Geography of Ohio*, edited by Leonard Peaceful. Kent, OH: Kent State University Press, 1996.

Sugrue, Thomas J. *The Origins of the Urban Crisis: Race and Inequality in Postwar Detroit*. Princeton, NJ: Princeton University Press, 1996.

Thomas, Evan. *Sea of Thunder: Four Commanders and the Last Great Campaign, 1941–1945*. New York: Simon & Schuster, 2007.

Troy, Gil. *Moynihan's Moment: America's Fight against Zionism as Racism*. Oxford, UK: Oxford University Press, 2013.

Warren, Kenneth. *The American Steel Industry, 1850–1970: A Geographical Interpretation*. Oxford, UK: Clarendon Press, 1973.

Welsh, Thomas. "Youngstown, the City that Produced the Warner Brothers." In *Remembering Youngstown: Tales from the Mahoning Valley*, edited by Mark C. Peyko. Charleston, SC: The History Press, 2009.

Williams, H.Z., and Bro. *History of Trumbull and Mahoning Counties*. Cleveland, OH: H.Z. Williams, 1882.

CORRESPONDENCE

Telegram. April 10, 1928. Jewish Archives. 92. Mahoning Valley Historical Society. Youngstown, OH.

Telegram. February 24, 1943. Jewish Archives. 92. Mahoning Valley Historical Society. Youngstown, OH.

INTERVIEWS

Burdman, Bonnie Deutsch. Interview by Joshua Foster, August 5, 2015.

Engel, Alan. Interview by Thomas Welsh, October 14, 2015.

Engel, Brian. Interview by Thomas Welsh, October 2, 2015.

Fibus, C. Kenneth. Interview by Thomas Welsh, July 2, 2015.

Haber, Jerold. Interview by Thomas Welsh, December 14, 2015.

Hollander, Mervyn. Interview by Thomas Welsh, January 21, 2013.

Kooperman, Sam. Interview by Joshua Foster, July 24, 2015.

Lev, Irving. Interview by Thomas Welsh, August 21, 2015.

Lurie, Merabeth. Interview by Thomas Welsh, September 17, 2015.

McClain, Jesse. Interview by Thomas Welsh, July 1, 2015.

Muller, Franklin W. Interview by Thomas Welsh, May 15, 2016.

Nathan, Alan and Beverly. Interview by Thomas Welsh, June 24, 2015.

Nudell, Stan. Interview by Thomas Welsh, February 2, 2013.

Oresky, Saul. Interview by Gordon F. Morgan and Thomas Welsh, November 19, 2015.

Peskin, Edith. Interview by Thomas Welsh, November 17, 2015.

Powell, Ted. Interview by Thomas Welsh, May 8, 2016.

Raffel, Leroy. Interview by Thomas Welsh, April 21, 2016.

Schonberger, Joseph P. Interview by Thomas Welsh, November 16, 2015.

Weisberg, Alvin. Interview by Thomas Welsh, August 21, 2015.

MINUTES

"Minutes of the First Meeting of the Sons and Daughters of Zion." October 27, 1909. Jewish Archives. 92. Mahoning Valley Historical Society. Youngstown, OH.

NEWSPAPERS AND PERIODICALS

American Israelite (1870).

Bryan Times (1969).

Catholic Exponent (1976).

Cincinnati Enquirer (1990).

Forward (2015, 2016).

Free Lance-Star (1986).

Girard Grit (1893).

Jewish Criterion (1918).

Jewish Daily Bulletin (1928).

Jewish Journal (1989).

Mansfield News (1913, 1917).

Milwaukee Journal (1945).
Newsweek (1969).
New York Times (1933, 2002).
Ohio Jewish Chronicle (1984).
Pittsburgh Post-Gazette (1968, 1994).
Pittsburgh Press (1948).
Reform Advocate (1908).
Sacramento Daily Record-Union (1881).
Sharon Herald (1950).
Tallahassee Democrat (1991).
Times-News (1968).
Wall Street Journal (1980).
Warren Tribune (1951).
Warren Tribune Chronicle (1988, 1991).
Washington Times (2005).
Youngstown Daily Register (1881).
Youngstown Jewish Times (1948).
Youngstown Telegram (1914, 1925).
Youngstown Vindicator (1881–2015).

ORAL HISTORIES

Balasko, George. Interview by Thomas Welsh. April 21, 2015. Transcript. Ethnic Heritage Society Collection. 385. Mahoning Valley Historical Society. Youngstown, OH.

Benedikt, William. Interview by Thomas Welsh. June 25, 2015. Transcript. Ethnic Heritage Society Collection. 385. Mahoning Valley Historical Society, Youngstown, OH.

Elder, Joy. Interview by Thomas Welsh. April 2, 2015. Transcript. Ethnic Heritage Society Collection. 385. Mahoning Valley Historical Society, Youngstown, OH.

Epstein, Louis and Marlene. Interview by Thomas Welsh. April 13, 2015. Transcript. Ethnic Heritage Society Collection. 385. Mahoning Valley Historical Society, Youngstown, OH.

Gross, Judith and Michael T. Interview by Thomas Welsh. June 17, 2015. Transcript. Ethnic Heritage Society Collection. 385. Mahoning Valley Historical Society, Youngstown, OH.

Harshman, Florence. Interview by Thomas Welsh. October 16, 2014. Transcript. Ethnic Heritage Society Collection. 385. Mahoning Valley Historical Society, Youngstown, OH.

Hill, Joseph. Interview by Thomas Welsh. October 6, 2002. Transcript. Hogan-Cullinan Family Collection. 314. Mahoning Valley Historical Society, Youngstown, OH.

Kravitz, Donia. Interview by Thomas Welsh. February 7, 2013. Transcript. Ethnic Heritage Society. 385. Mahoning Valley Historical Society, Youngstown, OH.

Lev, Alice. Interview by Gordon Morgan and Thomas Welsh. August 28, 2015. Transcript. Ethnic Heritage Society Collection. 385. Mahoning Valley Historical Society, Youngstown, OH.

Lipkin, Andrew L. Interview by Thomas Welsh. March 12, 2015. Transcript. Ethnic Heritage Society Collection. 385. Mahoning Valley Historical Society, Youngstown, OH.

Lippy, William. Interview by Thomas Welsh. October 20, 2014. Transcript. Ethnic Heritage Society Collection. 385. Mahoning Valley Historical Society, Youngstown, OH.

Malkoff, Kurt. Interview by Thomas Welsh. February 11, 2013. Transcript. Ethnic Heritage Society. 385. Mahoning Valley Historical Society, Youngstown, OH.

Mirkin, Alan. Interview by Thomas Welsh. June 25, 2015. Transcript. Ethnic Heritage Society 385. Collection. Mahoning Valley Historical Society, Youngstown, OH.

Mirkin, David and Jeffrey. Interview by Thomas Welsh. April 8, 2015. Transcript. Ethnic Heritage Society 385. Collection. Mahoning Valley Historical Society, Youngstown, OH.

Oyer, Marilyn. Interview by Thomas Welsh. February 10, 2015. Transcript. Ethnic Heritage Society Collection. 385. Mahoning Valley Historical Society, Youngstown, OH.

Pazol, James. Interview by Thomas Welsh. May 27, 2015. Transcript. Ethnic Heritage Society Collection. 385. Mahoning Valley Historical Society, Youngstown, OH.

Roth, Sam A. Interview by Thomas Welsh. March 30, 2015. Transcript. Ethnic Heritage Society Collection. 385. Mahoning Valley Historical Society, Youngstown, OH.

Rusnak, Florine and Robert. Interview by Thomas Welsh. May 15, 2015. Transcript. Ethnic Heritage Society. 385. Mahoning Valley Historical Society, Youngstown, OH.

Schwebel, Paul. Interview by Thomas Welsh. April 30, 2015. Transcript. Ethnic Heritage Society. 385. Mahoning Valley Historical Society, Youngstown, OH.

Shagrin, Helen. Interview by Irving Ozer. August 4, 1986. Transcript. Jewish Project. O.H. 564. Youngstown State University Oral History Program, Youngstown, OH.

Sherman, Bruce and Carol. Interview by Thomas Welsh. June 29, 2015. Transcript. Ethnic Heritage Society Collection. 385. Mahoning Valley Historical Society, Youngstown, OH.

Weiss, Gary. Interview by Thomas Welsh. May 7, 2015. Transcript. Ethnic Heritage Society Collection. 385. Mahoning Valley Historical Society, Youngstown, OH.

Yutkin, Neil. Interview by Thomas Welsh. June 19, 2015. Transcript. Ethnic Heritage Society Collection. 385. Mahoning Valley Historical Society, Youngstown, OH.

PAMPHLETS AND PROGRAMS

"Beth Israel Temple Center 90th Anniversary Celebration, Sunday, August 3, 2008." Program. Jewish Archives. 92. Mahoning Valley Historical Society. Youngstown, OH.

Challenge…to the People of Youngstown. Youngstown, OH: Royal Printing Company, 1958.

"Installation of Abraham Haskel Feinberg as Rabbi of Rodef Sholem Congregation." November 6–8, 1942. Program. Jewish Archives. 92. Mahoning Valley Historical Society. Youngstown, OH.

The International Jew; the World's Foremost Problem. Dearborn, MI: Dearborn Publishers, 1920.

"The Palestine Friends of the Hebrew University Society." April 18, 1933. Program. Jewish Archives. 92. Mahoning Valley Historical Society. Youngstown, OH.

"Rodef Sholom Temple, 1867–1947, A Heritage…and a Responsibility." April 15, 1947. Program. Jewish Archives. 92. Mahoning Valley Historical Society. Youngstown, OH.

The Temple Bulletin. November 1917. Jewish Archives. 92. Mahoning Valley Historical Society. Youngstown, OH.

REFERENCE VOLUMES

American Jewish Year Book 1930–31. New York: American Jewish Committee, 1932.

American Jewish Year Book 1974–75. New York: American Jewish Committee, 1975.

American Jewish Year Book 1990. New York: American Jewish Committee, 1990.

American Jewish Year Book 1996. New York: American Jewish Committee, 1996.

American Jewish Year Book 2012: The Annual Record of the North American Jewish Communities. Berlin, Germany: Springer Verlag Books, 2013.

American Jewish Year Book 2015: The Annual Record of the North American Jewish Communities. Berlin, Germany: Springer Verlag Books, 2016.

Appleton's Cyclopedia and Register of Important Events of the Year 1890. New York: Appleton and Company, 1891.

Biographical History of Northeastern Ohio: Embracing the Counties of Ashtabula, Trumbull, and Mahoning. Chicago: Lewis Publishing Company, 1893.

REPORTS

City of Youngstown. *Youngstown 2010 Citywide Plan*. Youngstown, OH, 2005.

Pew Research Center. *A Portrait of Jewish Americans: Findings from a Pew Research Center Survey of U.S. Jews*. Washington, D.C., 2013.

UNPUBLISHED TEXTS

"Anti-Semitism: A Lecture Delivered at Youngstown, Ohio, February 23, 1891, Under the Auspices of the Literary Society of the Rodef Sholem Congregation." Manuscript. 63682. Hebrew Union College—Jewish Institute of Religion, Cincinnati, OH.

Raffel, Leroy B. "I've Got No Beef." Memoir. May 1997.

"Resolution Adopted by the Youngstown Interracial Committee Upon the Death of the Reverend Dr. I.E. Philo, Rabbi." Document. The Jacob Rader Marcus Center of the American Jewish Archives. Cincinnati, OH.

WEBSITES

"About Arby's." Arby's: It's Good Mood Food. http://www.arbys.com/about.html.

"Excerpt: Temple Beth Israel." Ancestry.com. http://www.rootsweb.ancestry.com/~pamercer/PA/PL/Church/Temple/temple-11b.htm.

"Sharon and Farrell." Rauh Jewish Archives. http://www.jewishfamilieshistory.org/town/sharon-farrell/.

"Statement on Catholic Jewish Relations: National Conference of Catholic Bishops 1975." UCCB.org. http://www.usccb.org/beliefs-and-teachings/ecumenical-and-interreligious/jewish/upload/Statement-on-Catholic-Jewish-Relations-1975.pdf.

YEARBOOKS

Congregation Rodef Sholom 1867–1992. Courtesy of Carol Sherman.

Fiftieth Anniversary, Beth Israel Temple Center, September 1918–1968. Courtesy of Louise Shultz.

Temple Emanu-El Dedication Journal, Fifth and Fairgreen, Youngstown, Ohio. Courtesy of Carol Sherman.

About the Authors

Thomas Welsh is a professional writer and editor who grew up in the industrial center of Youngstown, Ohio. He is the author of *Closing Chapters: Urban Change, Religious Reform, and the Decline of Youngstown's Catholic Elementary Schools* (Lexington Books, 2011), which describes factors that led to the collapse of an urban parochial school system. Thomas went on to coauthor *Strouss': Youngstown's Dependable Store* (The History Press, 2012), a historical overview of one of the city's landmark businesses, and *Classic Restaurants of Youngstown* (The History Press, 2014), which tracks changes in the community's restaurant industry. Before completing a doctorate in Cultural Foundations of Education at Kent State University in 2009, he worked as a journalist in the United States, South Korea and Cambodia.

*J*oshua Foster is an independent scholar and professional writer who grew up in a family that has been part of Youngstown, Ohio's Jewish community for more than a century. As a fine arts and religious studies major at Youngstown State University, he established the YSU Jewish Students Organization and served as its first president. Joshua completed his graduate studies in urban history at Youngstown State University and produced several academic papers, including a historical examination of the Romaniote Jewish community of Ioannina, Greece. He has served as a featured speaker on local and regional television and radio programs.

*G*ordon F. Morgan is a professional writer and editor who grew up in the industrial town of Campbell, Ohio, located just east of Youngstown. After completing a graduate degree in professional writing and editing at Youngstown State University, he served as program director and newsletter editor for the Mahoning Valley Civil War Round Table, a group of more than 150 people who attend monthly presentations by leading experts on the Civil War. Gordon's articles have appeared in regional periodicals including the *Metro Monthly* and the *Vindicator*. He is the coauthor of *Classic Restaurants of Youngstown* (The History Press, 2014), a historical overview of the community's restaurant industry.